mas shinseko
'7/72'

MANUAL OF PHOTOGRAPHIC LIGHTING

Manual
of
Photographic Lighting

by

EDWARD S. BOMBACK

FOUNTAIN PRESS LTD.

First Published 1971.

© Fountain Press Limited,
46-47 Chancery Lane,
London, w.c.2.

ISBN 0 852 422 30x

Printed by The Whitefriars Press Ltd., London and Tonbridge

Contents

Contents

6

CHAPTER 1
Visual and Photographic Lighting

The human eye has evolved as an organ of perception chiefly adapted to full sunlight and its maximum sensitivity to the colour spectrum corresponds to the region in which sunlight has its maximum energy after passing vertically through the earth's atmosphere. In other words primitive man confined his activities pretty much to the daytime and preferred to sleep away the hours of darkness. This daylight vision is provided chiefly by a very small area of the retina known as the fovea which provides both sharp or acute vision and also colour vision. However, the eye is also adapted to much lower levels of light intensity, a characteristic known as twilight vision, thus providing primitive man with a kind of warning system under conditions of semi-darkness. This twilight vision is provided by the remaining area of the retina which offers a wide field of view having a very high sensitivity much nearer the blue region of the spectrum. At very high intensity levels this region becomes inactive, whereas at very low levels the fovea becomes inactive. At intermediate levels both regions play a part in visual perception. The light-sensitive cells of the retina are connected to the optical centres of the brain by a most complex nerve system. Just how complex can be judged by the fact that the optic nerve of each eye carries over a million separate fibres, each carrying to the brain impulses which are interpreted into all the aspects of visual perception —colour, shape, lightness, detail, movement, distance and so on. Furthermore, a reflex nerve system is continually modifying the sensitivity of the retina depending on the nature of the image, while at the same time other nerves control the focus of the eye, the iris diaphragm and the general rioentation of the eyes.

Adaptation of the eye

Changes in the response of the eye under different conditions of illumination are known as adaptations and the two that concern us most in photography are those of brightness adaptation and colour adaptation. As a physical receptor of light the eye is capable of adapting itself to brightness levels over a range in excess of 1 to 1,000,000. This range extends from complete dark adaptation to brightness levels which are almost too painful to observe. Part of the brightness adaptation is obtained through the two kinds of visual receptors, the rods and the cones. At low brightness levels vision is obtained exclusively through the large area of rods and results in a bluish, low contrast and indistinct image which is, however, highly sensitive to movements over the field of view. As the brightness level increases the cones begin to respond as well, thereby adding colour differences and greater

visual acuity, plus increasing perception of contrast. At considerably higher levels the eye changes almost fully to cone vision thus obtaining full differentiation of colours, full visual acuity and perception of contrast. The photo-sensitive pigments in both rods and cones are themselves capable of building up or reducing their sensitivity according to the requirements of the situation. This is clearly demonstrated every time we enter a cinema during the daytime. The first reaction is that of total darkness except for the screen, though after we have been sitting there for a few minutes, it seems there is almost enough light to read a book. The reverse happens when we leave a darkened room and enter full sunlight. The initial sensation is a painful dazzle which causes us to half-close the eyes. But the eye rapidly loses its sensitivity and in a short time the brightness appears quite normal.

Part of the brightness adaptation is achieved by adjustments to the size of the pupil of the eye which provides a change in area over a ratio of about 1 to 16. But the pupil also serves as a means of stopping down the lens of the eye to give increased depth of field at close distances and except when the brightness level is fairly low is rarely to be found fully open. This point should be borne in mind when taking flash portraits in a poorly illuminated room when the eyes may be recorded with very large pupils (see page 170).

While this brightness adaptation is extremely valuable to the normal function of vision, it makes the eye an unreliable guide to assessing actual brightness levels and hence in estimating the exposure for a photographic material which has a fixed sensitivity of much smaller range.

A form of brightness adaptation which is often confusing to the inexperienced photographer is that known as local adaptation. This is associated with the very narrow angle of acute vision which causes the eye to build up the brain image of what is being observed by a process of scanning the scene. During this process the eye tends to adapt itself to local brightness levels, thereby reducing the apparent contrast between different levels of brightness. The lens of a camera and the film on which the image is recorded show no such discrimination and under normal conditions of exposure, processing and printing will record the actual contrast. As the print is rarely viewed under anything like the same conditions as the original scene, the contrast usually appears excessive, namely the shadows are darker than they appeared to be. This applies particularly to interiors, see page 104. The existence of local adaptation can be demonstrated by looking fixedly at a lamp filament for a few moments and then transferring the eyes to a sheet of white paper. The desensitised part of the retina which corresponded to the lamp will then appear as a dark image of the lamp against the white background. This will gradually fade as that part of the retina recovers its sensitivity.

Yet another effect is that known as simultaneous contrast whereby two adjacent areas of differing brightness appear to have a greater difference owing to the adaptation of the eye to the larger area. Thus a grey square viewed with a white surround appears darker than an identical grey patch viewed against a black background—see Fig. 1.1.

As well as adapting to brightness differences, the eye adapts itself to differences in the colour of illumination so as to make it appear 'white' or colourless. Thus various changes in the colour of daylight tend to pass unnoticed in terms of the

objects observed. This can even occur at sunset, when the actual yellowness of the light may often pass unobserved unless there happens to be a direct comparison with similar objects lit with light from the sky which is, of course, much bluer. Indoors, the yellowness of a tungsten lamp may barely be noticed, though if a direct comparison can be made with noonday sunlight it at once becomes almost unbelievably yellow. When a scene is lit with two light sources of different colour quality, the eye tends to adapt itself to an intermediate value.

Local colour adaptation also occurs and after we have observed a strong colour for a short time, by transferring our gaze to a white surface we can observe an after image of the 'opposite' or complementary colour. Thus although we are not always aware of it, the various colours in a brightly coloured scene or painting tend to modify each other as the eye moves from one part to the other. A similar effect is that of simultaneous colour contrast where the effect of two adjacent colours is a strengthening of the colour contrast. Experienced artists and photographers are aware of these effects and frequently make good use of them.

Constancy effects

Another characteristic of visual perception which should be kept in mind by the photographer is that of brightness constancy. This can be one of a number of mental adjustments which are made, whereby a previous experience or series of experiences of similar scenes or objects will tend to be imposed on the actual image transmitted by the eye. For example, if an object is taken to be a sheet of

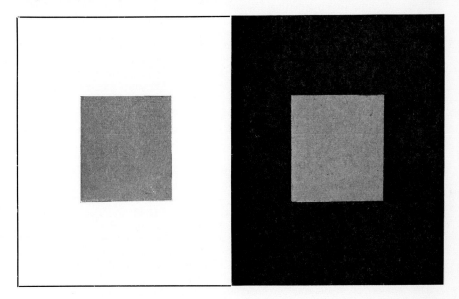

FIG. 1.1 Two grey squares of the same tone which demonstrate how the apparent greyness is influenced by the background.

white paper, it will tend to appear white even when seen in shadow. Indeed, it is possible to set up a scene where a sheet of white paper reflecting less light than a sheet of grey paper—the former being in shadow and the latter in full lighting—appears 'whiter'. Similarly, the walls of a uniformly toned room will tend to appear of the same tone in fact the illumination may vary as much as 1 to 16. Unfortunately, brightness constancy does not apply nearly as much to the viewing of a photograph with the result that shadows and non-uniform lighting are often far more apparent in a photograph. Another 'constancy' of interest to photographic lighting is that of colour constancy, but as it applies only to colour photography it is discussed in Chapter 4 with other problems peculiar to the reproduction of colour.

Illumination for visual purposes

Until the beginning of the present century daylight was the only major source of illumination. Artificial sources included the candle, oil and gas lamps and carbon filament incandescent electric lamps. It was not until the development of high efficiency tungsten filament lamps and later, fluorescent strip lighting, that satisfactory levels of illumination became possible in shops, offices, factories and the home. Today interior illumination is now an important branch of engineering and architecture, and the modern photographer is fortunate in that with the combination of the highly sensitive films now available, existing lighting systems designed for visual purposes are often adequate for exposure times of 1/50 sec. or less, thus permitting the use of hand-held cameras or the taking of subjects in which there is some degree of movement. In fact this has given rise to the now popular 'available' light photography, see page 103.

However, interior lighting still falls far short of daylight in its intensity level, though the impression, after the eyes are accommodated to artificial lighting, is that it closely approaches daylight levels. Lighting units designed for photography normally provide a much higher level of illumination and may even equal or exceed that of daylight if we take into account the high intensity batteries of lighting units often employed in film making or the use of flash lighting in still photography.

Intensity levels possible in photography

In the early stages of photography exposures of an hour or more in broad daylight were required to obtain a satisfactory image. The progress of photography has largely been that of the development and production of increasingly light-sensitive materials. Present day high speed films are many million times 'faster' or more sensitive than those available a hundred years ago. Parallel progress in lens design and manufacture now makes a large aperture lens of f/2 and greater the standard equipment for the majority of better class cameras, thus adding further 'speed' to that of the film. And all this has led increasingly to the feasibility of photographing a black cat in a dark coal cellar.

The ability of photographic materials to react to accumulated light action was all important to the early photographer. If he wanted to photograph the dimly lit interior of a church, he set up his camera, went off to have his lunch

and returned some hours later reasonably confident that the shot was in the bag. Light intensities far lower than that of a dimly lit church are encountered in astronomy. The light arriving from stars too weak to be detected by the eye can be recorded on a photographic plate and it is fair to say that most modern astronomers now rely on photography for their observations and records of the heavens. At the other end of the time scale, the development of high intensity light sources, such as the electric spark and electric discharge tube, makes it possible to record images having a duration of less than 1/1,000,000 sec., thereby making it possible to 'freeze' movements far too rapid to be observed by the eye.

Photographic materials

The early photographer had only one type of emulsion which he coated himself on to a glass plate immediately before he wanted to take a photograph. The modern photographer has a whole range of films and plates covering a vast field of activities, all perfectly packed and of highly stable and consistent characteristics. Discounting the existence of competitive materials of similar characteristics, the range of materials available for general photography is by no means excessive. Indeed in respect of colour films, there are still some important gaps to be filled. Thus while there are four types of film suitable for making black-and-white negatives—they may be classed as slow, medium, fast and very fast films—there is only a medium speed colour negative film generally available. This is to some extent counterbalanced by the availability of medium speed and fast reversal colour films, but the colour photographer is still far more concerned with the need for special photographic lighting than his fellow worker using black-and white.

While it is sometimes convenient to classify films in terms of their speed, this is not the only characteristic for choosing one type of film rather than another. To some extent the faster the film the coarser the grain of the negative and if a small format camera is to be used, graininess in the negative becomes a disadvantage. This is obviously less important when a large format camera is to be used and in this case the speed of the film may be the deciding factor in its choice. The extra speed under existing lighting conditions may permit short exposure times (if there is the possibility of movement either in the subject or of the camera), or to use smaller lens apertures to obtain increased depth of field. The higher speed in the studio may serve to reduce the wattage of lighting units, usually, in the case of portraiture, with some advantage to the comfort of the subject.

With colour films the choice hardly exists and the intensity level of the illumination as well as its colour quality, should be such as to avoid the need for exceeding exposure times of more than a few seconds because of reciprocity effects, see page 81.

Summary

Generally speaking the need for special lighting in black-and-white photography has steadily decreased in recent years owing to the availability of faster films and the more efficient use of artificial lighting for interiors and at night. This has encouraged a new 'mode' of photography commonly referred to as 'available'

light photography in which subjects are presented under conditions of natural lighting even when this may fall far short of the erstwhile 'ideal' photographic lighting which ensures that all parts of the subject are clearly visible and there is a proper balance between highlights and shadows. There is, as yet, far less scope for this treatment in colour photography. The chief obstacle is that of achieving an acceptable colour rendering, particularly with colour reversal films which offer no subsequent possibility of correcting the colour of the resulting transparencies equivalent to that possible with colour negative films at the printing stage. At the same time, no really fast colour negative films are yet available and this, in itself, restricts the possibilities of available light photography. Thus colour photography still has considerable need for controlled lighting both in terms of 'natural' light sources and in the use of special photographic sources.

CHAPTER 2

Reproduction of Lighting Effects

The basis of photography, monochrome and colour, is the sensitivity of certain silver salts—silver bromide, chloride and iodide (known collectively as the halogens)—to the action of light. The exact nature of this light action is still not completely understood, but its effect is to make the crystals of silver salts, of which a photographic emulsion is composed, more or less susceptible to the reducing action of a developer depending on the amount of light action they have received. Development converts the crystalline salts to grains of silver, the conversion being roughly proportional to the amount of light action the crystals have received. The grains may be of a coarse or fine nature depending on the size and distribution of the crystals in the layer of gelatin which may be coated on any suitable base such as glass, film and paper. These grains of silver act as a barrier to light, the amount of light absorption depending on their density—the extent to which the original silver salts have been converted to silver. For any given photographic emulsion there is a useful range of sensitivity over which increasing light action produces a roughly proportional increase in the density of the silver grains and hence in the amount of light absorption. This is the basis of a photographic negative which records the relative brightnesses of the subject as a silver image whose light transmission is inversely proportional to the subject brightness. When such a negative is printed on to a sheet of sensitive material, a further reversal of image density occurs giving a tone reproduction roughly similar to the brightnesses of the subject. By means of an alternative method of development known as reversal processing, the initial exposure made in the camera can be made to yield a positive image. In this case the negative image is first developed and then eliminated by chemical means so as to leave the undeveloped emulsion intact. This remains in inverse proportion to the negative image and thus represents a potential positive image which can be made developable either by exposure to light or chemical means and then developed to produce a positive image. Films intended for such treatment have special characteristics and are known as reversal films, see page 33.

Both processes, negative/positive and reversal, are used in colour photography. However, in this case the silver image or rather its formation, is used to control the density of a dye image which is formed in each of the three layers of a modern colour film. Having served this purpose the silver is eliminated to leave either a negative dye image or, in the case of a reversal colour film, a positive colour transparency. Thus in many respects a colour film can be regarded as a special kind of black-and-white panchromatic film designed to yield a colour photograph.

15

In practice, photographic emulsions may have very different exposure and development characteristics depending on the purpose for which they have been prepared. They may differ in over-all sensitivity (speed) and in their sensitivity to different regions of the colour spectrum: they may differ in contrast or gamma: they may differ in their exposure scale and exposure latitude: they may differ in graininess and acutance: and with colour films, their balance to different sources of 'white' light. To understand the nature and purpose of these different characteristics it is useful to know something about the science of sensitometry which, among other things, is concerned with the measurement of photographic sensitivity and the behaviour of photographic emulsions to light and their subsequent treatment in developers and other processing solutions.

Sensitometry

The first requirement of any technique involving precise measurements is that all stages of the process must be based on standards of known and constant value. For the first stage of sensitometry, that of exposure, an instrument known as a sensitometer is used. It consists basically of a standard light source which is run at a constant intensity and colour temperature, a device for giving a series of exposures of equal increments in time or intensity and a holder for the strip of photographic material under test. The instrument is normally enclosed with a light-proof body to enable exposures to be made in a normally illuminated room. The light source is usually a tungsten filament lamp run at a controlled voltage to give a colour temperature of 2,850°K. and hence also at a constant intensity. Such a light source is suitable for testing the behaviour of materials to average artificial illumination such as that given by domestic lamps. For tests designed to simulate other qualities of illumination—daylight, flash, photoflood lamps, etc.—the colour temperature of the lamp can be raised by means of filters. Thus the standard filter for testing materials which are to be exposed with daylight converts the colour temperature of the light source to 5,400°K. which is equivalent to noon-day sunlight.

Exposure modulation

This may take the form of a series of exposures which vary in time usually by a ratio equal to $\sqrt{2}$ (1·4) and cover a range considerably in excess of the sensitivity response of the materials under test. The exposures are made simultaneously by a shutter of linear or sector type having slits or segments of varying dimensions as shown in Fig. 2.1. Thus, given a constant speed of movement of the shutter, the sample is exposed to a range of times determined by the width of the slits or segments. Such a sensitometer is known as a time-scale sensitometer and is used commonly for the routine testing of emulsions during manufacture and for the sensitometric control of continuous processing plants. However, it does not represent normal conditions for camera or printing exposures since these are based on different brightness or intensities of the light reaching the sensitive material. In using a time-scale, it is possible to introduce variations in sensitivity due to the failure of the reciprocity law, see page 81. For this reason

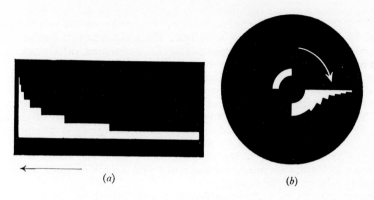

FIG. 2.1. Time scale exposure shutters: (*a*) a linear shutter often used as a 'falling' plate, (*b*) a sector shutter which revolves at constant speed.

materials normally exposed in a camera are tested with an intensity-scale sensitometer in which intensity differences are produced by placing the film in contact with a step tablet in which successive steps have an opacity which increases by a ratio of $\sqrt[3]{2}$ or a density of 0·1. Such a step-tablet can be made by casting a dispersion of carbon in gelatin in steps of increasing thickness or it can be made photographically by the controlled exposure of a sensitive material having an extremely long exposure scale and high maximum density. With an intensity-scale sensitometer the shutter is designed to give a specific exposure time which is based on that normally given in practice. For daylight exposures this is usually taken as 1/60 sec. (the average snapshot exposure) or 1/10 sec. for films to be used with tungsten studio lighting. Tests for reciprocity failure would thus be based on exposures at different times using an intensity-scale sensitometer. see page 81.

Other conditions, besides those of illumination, have to be taken into account. The density produced may be affected by the temperature and humidity of the material at the time of exposure, on the interval between exposure and development, on the conditions under which the material has been stored and on its age. The conditions of processing must also be standardised in respect to the composition of the developer and on the time, temperature and method of development. On the other hand, sensitometric tests may have as their objective the comparison of different developers or the effect of different times, temperatures and methods of development. Even the conditions of fixing, washing and drying must be accurately controlled if results are to be strictly comparative.

Measurement of the silver deposit

A sensitometric test strip shows a series of steps ranging from a just perceptible deposit of silver to the maximum useful deposit obtainable. With the majority of negative materials, the emulsion is coated on a transparent base of glass or

cellulose acetate film and the silver image used to control the light which is transmitted through it on to the printing paper. The image on the printing paper is viewed by light reflected by the white base. There are thus two distinct values in the measurement of a silver deposit, that of transmitted density and that of reflected density. Let us deal first with the transmitted density.

The blackness or opacity of a silver deposit is measured by a type of photometer specially adapted for the purpose and known as a densitometer, see page 19. It measures the opacity as the ratio of the incident light to that of the transmitted light. Thus if the intensity of the transmitted light is only 1/4 that of the incident light, the opacity is said to be 4. In practice, however, opacity is usually expressed as a logarithmic value known as the density. An opacity of 4 thus becomes a density of approximately 0·3. The chief reason for using log. values is that equal differences in density (in the numerical sense) also appear as equal differences in blackness or density of the deposit.

The measurement of transmitted density is complicated by the fact that some of the transmitted light is scattered by the silver grains. That is to say, when parallel light falls normally on to the image a small percentage is deviated sideways while the remainder proceeds in the normal direction. If the measurement is based only on the transmitted parallel light, the value of the transmitted light will be smaller than that of a measurement of the whole of the transmitted light, and hence the density will be greater. A measurement of the parallel light only is called the specular density (or D parallel), while the measurement of the whole light is termed the diffuse density (or D diffuse). In the printing of a negative either one or the other density or an intermediate value may apply depending on the nature of the printing light. For example a print made with the negative in contact with the printing paper makes use of the diffuse density, whereas a print made with a projection printer or enlarger employing a point light source combined with a condenser system makes use of the specular density. An identical negative would thus give a more contrasty image in the latter method of printing.

Reflection Density

When the photographic image is on a white base, as in the case of an ordinary print, the light falling on the print passes through the image and is reflected back through the image again. The density of the deposit is therefore doubled in comparison with its transmission density. The reflected density is measured as a brightness compared with the brightness of the white base, the log. of this ratio being the reflection density as expressed in the following formula:

$$\text{reflection density} = \log. \frac{\text{intensity reflected from plain paper base}}{\text{intensity reflected from density}}$$

As the amount of reflected light varies with the direction of the incident and reflected light, measurements of the reflected light are made at right angles to the sample, with the incident light striking the paper at 45°.

The Densitometer

The measurement of photographic density is made with an instrument known as a densitometer. There are various types for measuring either transmission or reflection densities but they are basically specialised kinds of photometer. Modern densitometers fall into three groups.

(1) Visual densitometers in which the density to be measured is compared with a calibrated density scale. This works well enough for most observers and reliable results can be obtained by taking the mean of three different measurements of the same patch.

(2) Densitometers employing a light-sensitive cell used in conjunction with a calibrated scale and a galvanometer.

(3) Automatic photo-electric recording densitometers which are used in the photographic industry for large-scale sensitometry.

Colour Densities

The image of a colour photograph, although initiated by the formation of a silver image, consists of three dye images, the silver deposit having been dissolved away. In order to determine the sensitivity characteristics of each layer, density measurements of the image of a grey scale are made separately through red, green and blue colour separation filters. The densities obtained through the red filter give the densities of the cyan image, those made through the green filter, the magenta image and those through the blue filter the yellow image. Such measurements are made for the sensitometric control of processing, but may also serve to assess the printing value of a colour negative which incorporates a grey scale.

The Characteristic Curve

Having established the means of exposing and measuring the densities of sensitometric strips, we can now consider the usefulness of the information which can be extracted from these data. The normal method of evaluating a series of density measurements is to construct a graph in which density is plotted against the logarithm of the exposure, the exposure being the product of intensity and time. Thus with a series of densities obtained from a time-scale sensitometer, the log. exposure scale indicates differences in the duration or time of exposure for a given intensity, whereas with an intensity-scale sensitometer the exposure scale represents differences in intensity for a given time of exposure.

Such a graph is shown in Fig. 2.2 and is known as the characteristic curve of the material under test. In this case it is the characteristic curve of a typical negative film. It shows that the formation of a silver image begins very gradually —the region of the curve known as the toe—then reaches a stage where equal increases in exposure produce equal increases in density. This is known as the straight-line portion. Finally, the increase in density with increasing exposure tails off to a maximum density where further increases produce no useful effect. This upper portion of the curve is known as the shoulder.

The shape of the characteristic curve may vary a great deal from one emulsion to another and even among emulsions of the same class, for example, those

19

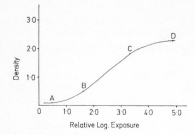

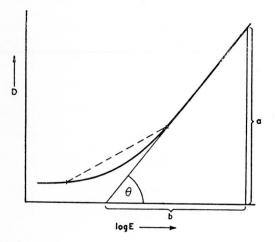

Fig. 2.2 Characteristic curve of a typical negative material showing the three regions of sensitivity: A-B the toe or foot, B-C the straight line, C-D the shoulder.

intended for normal black-and-white photography, and loosely described as black-and-white negative materials. In some cases the toe may extend almost to the shoulder with no marked straight-line portion. There may also be considerable differences in the maximum density and hence the range of intensities to which the emulsion responds. There is also a certain residual deposit of silver due to chemical action. This is known as chemical fog and can be measured and indicated on the graph by taking zero density to be that of a sample of the material which has been thoroughly fixed without being developed, the fog density being made from an area which has received no exposure.

Interpretation of a characteristic curve

Various characteristics of the emulsion can be determined from the characteristic curve. Firstly, an assessment of the speed can be made. A great many systems have been used since that originally devised by Hurter and Driffield towards the end of the last century, which was based on an extension of the straight-line of the curve to a point where it intersected the log. exposure axis. The most recent system is based on the exposure needed to reach a density of 0·1 above fog with

Fig. 2.3. The measurement of contrast or gamma is taken as the ratio a/b or the tangent of the angle θ. In practice the optimum exposure lies partly on the toe of the curve where the slope is lower and hence the average negative contrast is lower than the gamma value. This is shown by the broken line.

20

the film so developed that the density at 1·3 log. units greater than the log. E is 0·9. This is of no particular interest to the photographer except in so far as it explains the basis for the A.S.A. and D.I.N. speed numbers attributed to a given film and intended as a guide to exposure when using an exposure meter calibrated for these numbers.

Secondly, the straight-line portion of the curve permits the contrast or 'gamma' of the emulsion to be determined. This is done by continuing the straight-line of the curve until it meets the log. exposure axis and then dividing the height at any point—see Fig. 2.3—point (a) by the intercept (b). The ratio a/b is a constant no matter where the measurements are taken, and the value is a characteristic of the angle θ or gamma. Thus if the densities of the straight-line portion are exactly proportional to the increases in exposure, the gamma will be 1. If such a negative is printed on a printing material having the same gamma, the original brightness of the image of the subject inside the camera would be represented by equivalent tonal differences. As we shall see later in this chapter such a simple solution to tone reproduction is neither practical nor necessarily desirable, see page 24. In practice the gamma represents the contrast of the negative only when the exposure has been full enough to record all the brightnesses of the subject on the straight-line

FIG. 2.4. A family of characteristic curves of the samn emulsion developed at different times. It can be seee that after 8 min. there is little increase in speed or gamma.

FIG. 2.5. A curve plotted from gamma measurements of a series of curves such as those in Fig. 2.4. It shows that after 30 min. there is no appreciable increase in gamma. Such curves are useful to determine the time of development for a particular contrast.

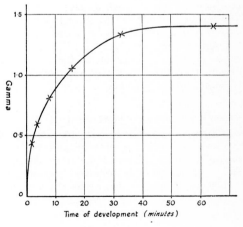

portion of the curve. It is, however, usually an advantage to utilise at least a part of the toe where the contrast is of diminishing value, see Fig. 2.3.

The contrast characteristics of a film can be shown by making a series of characteristics curves at different times of development, other conditions being constant. From such a 'family of curves'—see Fig. 2.4—it is possible to construct a second curve in which gamma is agotted taainst the time of development. Such a curve is known as the time-gamma curve, see Fig. 2.5.

Thirdly, the characteristic curve will give an indication of the exposure latitude of the emulsion. This can be based on the brightness or intensity range of the image formed in a camera of an average subject, namely a ratio of 32:1. This is equivalent to about 1·3 on the log. exposure scale. If we apply this to the two curves shown in Fig. 2.6, it can be seen that sample A, which can be taken as typical of a fine grain emulsion of thin coating and moderate speed, would allow

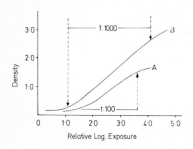

FIG. 2.6. Curves of two different negative films compared for exposure latitude. Curve A is a fine-grain emulsion of thin coating whereas curve B represents a fast, double-coated emulsion.

exposures over a range of 2 stops without serious loss of shadow detail in a negative receiving the least exposure, or loss of highlight detail in that receiving 2 stops more exposure. With sample B, representing a fast, double-coated emulsion designed for exposures under widely ranging conditions of lighting, the exposure latitude is much greater permitting exposures over a range of 5 stops. The greater latitude of the second film also enables the photographer to record subjects having a much greater brightness range.

Fourthly, the characteristic curve of a negative film can be applied in the manner shown in Fig. 2.9, page 25, to the curve of a suitable printing material with the object of constructing a tone reproduction curve. The usefulness of this exercise, is discussed later, page 24.

Characteristic curves of printing papers

An essential difference between transmission densities, such as those of a negative and reflection densities of a printing paper, is that the former are progressively increased with increases in the silver deoposit (whether due to increased exposure or by adding two or more images together), while the maximum density obtcinable with a print image is limited by the fact that the silver itself reflects an amount equal to between 1 and 2 per cent of the light reflected by the plain paper base. Hence, no matter how heavy the deposit of silver, there will be at least 1 per cent

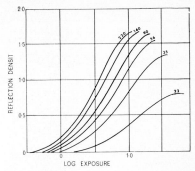

FIG. 2.7. Curves of a printing paper showing the effect of increasing the time of development. The time is given in seconds and the curves show that maximum density is only reached after 90 sec. development.

reflection from the silver grains and the maximum density that can be obtained from a printing paper is therefore log. 100/1 or a density of 2.

The maximum density also depends on the surface of the printing paper. One having a high gloss surface will reach a density of 2, while one having a matt surface a maximum of only about 1·4. This means that a glossy finish to a printing paper permits a tone range of 100:1, whereas one having a matt surface could have a range of only 25:1—barely enough to reproduce the brightness range of an average subject. This explains why prints intended for photo-mechanical reproduction are normally required to be printed on glossy paper.

However, if we are to make use of the full tone range of a printing paper from white base to deepest black, we shall automatically make use of the entire region of the characteristic curve. It will be seen from Fig. 2.7 that a printing paper emulsion has a very pronounced toe and shoulder region so that even if we have made a 'perfect' negative in the sense that all the densities fall on the straight-line portion, the printing paper will inevitably introduce tonal distortions in the shadows and highlights. This is not a particularly serious failing since the print is rarely intended as an exact reproduction and, if a monochrome print of a coloured subject, is, at best, only a representation. Furthermore, the person viewing a print is very rarely in a position to judge the accuracy of the tones. What is usually more important is that the print contains some areas of maximum black and some areas of white even if they are no more than touches of black in the deepest shadow or no more than catch-lights in the eyes making use of the maximum white on the paper.

However, to achieve this with a printing paper of fixed contrast would mean producing negatives having near enough the same exposure scale or density range. This, in fact, is the practice in exposing motion picture negatives, the lighting being so balanced that the range between highlights and shadows is roughly constant. It is thus possible to print all the negatives on the same type of print film. To a large extent this also applies to the making of colour prints since only one type of colour print paper is normally available. Many professional photographers also work to the same rule in black-and-white photography in spite of the existence of a range of printing paper contrasts. Also the photographer who confined his activities to average subjects and avoided errors in exposure and processing would rarely have need of anything but a 'normal' grade of printing paper.

23

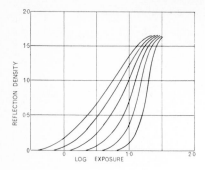

FIG. 2.8. Curves of a range of printing paper grades. The steeper the curve, the more contrasty the paper.

Nevertheless exceptional lighting conditions, errors in exposure, subjects of unusually high or low brightness range give rise to negatives of widely different quality and exposure scale. To provide for this, printing papers for black-and-white photography are available in several grades of contrast. A typical range of grades is shown in Fig. 2.8. A contrasty grade—one having a short exposure scale—will 'expand' the density range of a low contrast or flat negative, often the result of under-exposure, whereas a low contrast paper will 'compress' the density scale of a contrasty negative which may be the result of an excess lighting ratio in the subject or over-development.

To obtain the maximum density of a printing paper requires that it be developed very nearly to finality. Further development will produce only a small increase in contrast, while reduced development, with the object of reducing the contrast of the paper, will also involve a loss in maximum density, see Fig. 2.7. It follows also that attempts to correct serious under- or over-exposure of the printing paper by prolonged or curtailed development may result in some loss of print quality.

Tone Reproduction

The definition of a perfect black-and-white photograph could be taken as one in which all the brightness differences of the subject are represented by proportional differences of tone in the print. As we have seen, a negative can be exposed so that all the brightnesses are recorded on the straight-line of the characteristic curve. The perfect print from such a negative would require a printing paper having an exposure response represented by a straight-line from the minimum to the maximum density. Such a printing paper has not yet been realised and it is thus impossible to produce a perfect print as defined above. Nevertheless it is interesting to see how near we can approach the ideal and also how a typical negative film and printing paper can best be matched.

For normal photography, the most acceptable prints are those which utilise the full tone range of the printing paper. This is usually desirable even if the subject brightness range does not call for the full tone range of the paper. A notable example is that of a high-key portrait, namely, one in which the tones are predominantly light and delicate. To be effective it requires some touches of the deepest black obtainable with the paper. The first step, therefore, is to choose a printing paper which closely matches the density range of the negative or to

24

make a negative whose density range matches the exposure scale of a particular printing paper. Clearly it is better to adopt the latter approach since the photographer usually has considerable control over the lighting of the subject and can also vary the exposure so as to utilise different regions of the characteristic curve. In addition he can also develop the negative to a contrast which best matches a particular grade of printing paper. As many of the subsequent chapters of this book are devoted to the problems of achieving balanced lighting and the development of the negative is normally standardised to that which suits particular printing conditions. it remains for the moment to deal with the question of exposure. It turns out that the closest match between the negative and printing materials is obtained by adjusting the exposure so that the darker tones of the subject fall on part of the toe region of the curve with the medium and light tones falling on the straight-line region. The validity of this statement can best be demonstrated with a diagram of the kind shown in Fig. 2.9 and 2.10. Here the characteristic curves of the negative and positive materials are so orientated that, points on the negative curve representing the density range of the negative, when

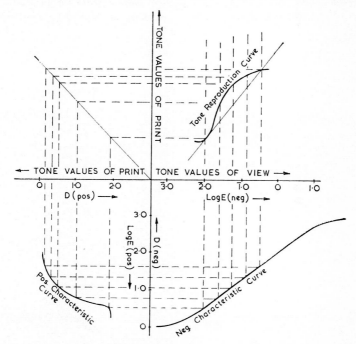

FIG. 2.9. Tone reproduction curve. The brightness range of the subject falls on the straight line region of the negative material and is shown intersecting the curve of a printing paper on the left. The resulting print densities are then compared with the subject brightness in the upper curve where the thin straight line represents exact tone reproduction. Now refer to Fig. 2.10.

extended to meet the positive curve, also represent the subject brightness range when extended vertically to meet the tone reproduction curve. The equivalent tones reproduced in the print can be compared with those of the subject by extending the points on the positive curve vertically and then at right angles through a line at 45° (gamma of 1) to meet those representing the subject brightnesses. The curve based on the intersection of these lines is known as the tone reproduction curve. The thin straight line represents perfect tone reproduction.

In the two examples given, it can be seen that the best match with a negative exposed to utilise only the straight line region of the characteristic curve, Fig. 2.9, is considerably inferior to that given by a negative which has utilised most of the tone region and only a part of the straight-line, see below.

This might appear rather like splitting hairs were it not for the fact that exposures utilising the toe are advantageous in other respects. Firstly they make use of the maximum speed of the negative material. In practice this could mean the possibility of using a somewhat slower film, and hence one with finer grain, or a shorter exposure time which could be advantageous when using a hand-held camera or when photographing live subjects, or a smaller lens aperture for increased depth of field or improved definition if one is working at near maximum aperture.

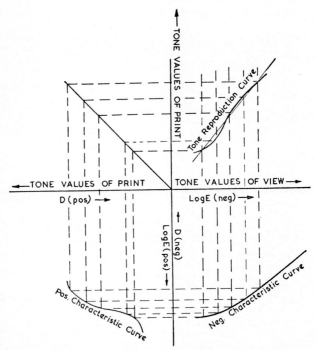

FIG. 2.10. Tone reproduction curve when the brightnesses of the subject are recorded partly on the toe of the negative: the curve is appreciably closer the 'ideal'.

26

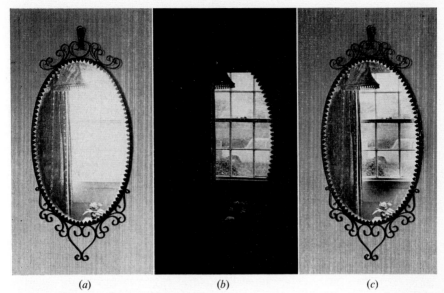

(a) (b) (c)

Fig. 2.11. The reflection in the mirror of an outside window presents an unusually great brightness range when combined with the tones of the interior. (*a*) Exposed and printed to give acceptable tones of the interior, (*b*) exposed and printed for the scene in the mirror, (*c*) the two tone ranges combined in one print by giving the mirror reflection a much longer printing exposure time.

Secondly, since graininess in a negative increases with density, a thinner negative offers a greater enlarging potential. Thirdly a thinner negative requires less printing exposure.

Tone Reproduction of abnormal brightness ranges

So far we have mainly considered subjects of average brightness range and negatives with a density scale suitable for printing on a normal grade of printing paper. What happens when the subject brightness range as recorded in the negative exceeds the normal? There are a number of ways by which such a negative can be made to yield an acceptable print.

(1) By using a less contrasty or softer grade of printing paper.
(2) By using diffuse light to print the negative (see page 18).
(3) By using local control in the exposure of the print, an operation labelled by such terms as 'dodging', 'shading' and 'holding back' (page 218).
(4) By using a diffusing disc in front of the enlarging lens (page 219).
(5) By controlled development of the print (page 217).

One of the major problems of tone reproduction arises from a subject having an unbalanced range of brightness. A typical example is that of a subject which includes part of an interior plus a view through a door or window of a brightly lit exterior, see Fig. 2.11. The brightness range may be as high as 1000:1, but it is not merely a case of compressing a long exposure scale in the negative by using a

27

very low contrast printing paper: the brightness consists of two main zones, one of which may fall on the foot of the curve and the other towards the shoulder with a kind of empty no-man's land in between. In effect, it might be considered as two negatives, one which has received the minimum exposure and the other which has received about 5 stops more exposure! If the printing exposure is adjusted to give the best result of the interior, then the area containing the exterior view will be grossly under-exposed and will, in fact, be almost completely lacking in detail, see Fig. 2.11 (*a*). In the reverse case the interior will be grossly over-exposed and may appear little more than a silhouette to the view through the door or window, Fig. 2.11 (*b*).

The best approach to this problem is to avoid producing such a negative by using a supplementary light for the interior so that its brightness range closely approaches that of the view outside. If this is not possible, the alternative is to control the printing exposure by shading the thinly exposed area by an amount which will allow the densely exposed area to record a satisfactory image, see Fig. 2.11 (*c*).

A yet more tricky problem is that of rendering a 'brightness' lighter than white. This can arise when a scene contains both a full white as well as a brightness such as the reflection of sunlight on water, as could be the case with a scene containing sailing boats with white sails in bright sunlight. In the absence of such reflections the area of the white sails in full sunlight would be represented by the whiteness of the paper base, but if this is to be used to depict the sparkle of sunlight on water (a much greater intensity), then the white of the sails will be reproduced as a grey. This rendering of the sails is the more unacceptable if the print has a white border or is mounted on a white card, since the person viewing the photograph has an adjacent standard of whiteness which would tend to make the sails seem dirty. However, the print becomes more acceptable if it is trimmed to the image or better still, mounted on a dark grey card. The viewer is then able to accept the greyness in the sails as 'white' and the white sparkle in the waves as an intensity greater than white. An even more satisfactory effect can be obtained from the same print if it is strongly illuminated with directional light so that the surrounding area is seen in half-light. It then approaches the appearance of a projected image, see page 219.

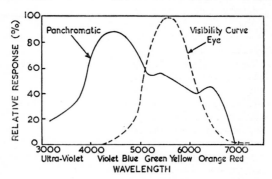

Fig. 2.12. Sensitivity curves of the eye and a panchromatic film to an equal energy spectrum.

Subjects of inherently low brightness range combined with the use of diffused lighting present a somewhat different problem. If the negative is made on a normal grade of paper with the object of preserving a correct tonal relationship, only part of the density range of the paper will be used. If the lightest tones of the subject are reproduced as white, the heavier densities of the paper will not be used. In the reverse case the print will contain no lighter densities. Neither print is likely to be aesthetically acceptable and in both high-key and low-key lighting techniques it is necessary to allow for at least touches of black and white. The use of a high contrast printing paper to 'expand' the tone range of a low contrast subject is rarely successful as it gives a false tonal separation.

Flat, 'muddy' prints, lacking in sparkle are often the result of a careless printing technique. It is a good rule to assume that there is no exposure latitude with a printing paper and that a correctly exposed print should receive full development in an active developer, see page 217.

Tone reproduction of colour in black-and-white

Photographic emulsions may be classified according to their sensitivity to the colour spectrum. The silver halides are basically sensitive to the blue, violet and ultra-violet region of the spectrum and emulsions of this class are extensively used for printing, the copying of black-and-white originals, and in various types of recording. With the addition of dyes the sensitivity can be extended to other regions of the spectrum including infra-red. Most negative films for general photography are fully colour-sensitised and are classified as panchromatic films to distinguish them from films sensitised for green but not red light and known as orthochromatic.

The colour sensitivity of a photographic material is measured sensitometrically by an instrument known as a wedge spectrograph. The result can be plotted as a curve of the kind shown in Fig. 2.12. Here the curve of a typical panchromatic film is compared with the visibility curve of the normal human eye. It can be seen that while the film has its maximum sensitivity in the violet region, the eye has a peak response to green. For this reason the blue sky in a landscape usually appears too light in a black-and-white photograph even when made with a panchromatic film. A more balanced tone rendering will result by placing a yellow filter in front of the camera lens with the object of absorbing some of the blue light without interfering with the transmission of green and red. Such a filter is called a correction filter. As panchromatic films vary somewhat in the colour sensitivity, the type of correction filter needed will vary: it will also vary for different kinds of lighting. When exposed with tungsten lighting, a panchromatic film, which appears over-sensitive to blue in daylight, may appear over-sensitive to red since tungsten light is relatively weak in the blue region of the spectrum. In this case a more balanced colour reproduction would be obtained with a pale blue filter which absorbs some of the red light.

Contrast filters

To speak of correct colour rendering in black-and-white photography is something of a paradox, since colour is an entirely different attribute to white, grey or black.

Black-and-white photography is concerned more with differences of light and shade than those of colour and unless we happen to know the colour of a particular object, it is usually impossible to deduce what the actual colours are. Thus we are familiar with the colour of a clear sky, of grass and foliage, of certain flowers and also have a rough idea of the colour of human complexions and other living creatures. Yet unless we are already familiar with the colours, we can gain little idea about the colour of clothes, colour-washed houses or painted fishing boats. Indeed, it would be possible to select a range of different colours whose brightnesses were equal to a particular panchromatic film and produce a photograph having a uniform grey colour.

Nevertheless occasions arise when differences in colour in terms of their greyness in a black-and-white photograph may be an important factor in the success of the photography. For example, two strongly contrasting colours such as orange and green may have very nearly the same brightness and would thus produce little or no contrast in a monochrome photograph exposed in the normal way. Yet if we are to give an impression of the contrast, one of the two colours must be rendered lighter or darker in respect to the other. It might be felt that the orange should be the lighter tone in which case we can darken the green by using a filter which absorbs green but transmits orange. Such a filter would itself appear deep yellow or orange in colour and if held for a few moments in front of one eye will give some idea of its darkening effect on green or, for that matter its lightening effect on the orange. In fact varying degrees of contrast can be obtained by using filters which absorb varying amounts of green without affecting the orange. If the reverse effect were desired, a green filter which absorbs yellow, orange and red would darken the orange in relation to the green, see Fig. 2.13. Such filters are commonly known as contrast filters, and may serve a useful purpose in the copying of coloured line diagrams, paintings, carpets and other subjects having patterns in different colours. Other applications are to be found in pictorial photography, see page 191.

Contrast

As applied to photography, the term usually means the separation between different brightnesses of a subject or different tones in a photograph. Contrast in the subject is usually a combination of the actual brightnesses of different parts of the scene and the distribution of light—commonly referred to as the lighting contrast, see Fig. 2.14. However, it is possible to have a subject of uniform brightness, such as a plaster cast, see page 47, which depends entirely on lighting contrast for its tonal differences in a photograph. Conversely, the subject itself may consist of a painting or carpet with a brightness range of 30:1 or more under perfectly uniform lighting.

The actual brightness range of a subject—and this can be determined by photometric measurements—may be considerably greater than that of the image formed by the lens inside the camera. For example direct measurements show that an average subject has a brightness range of the order of 150:1, whereas the brightness range of the camera image is around 30:1. This reduction in brightness range is due to inferior reflections in the camera and to the scattering of light by the lens, known as lens flare, Both spread some of the highlight illumination over

No filter.

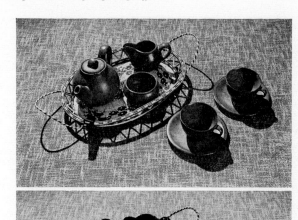

Red filter.

Dark green filter.

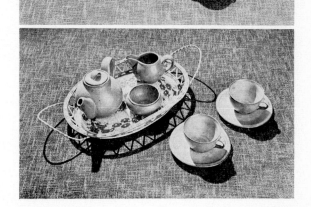

Fig. 2.13. A subject consisting of a green tea set on an orange table cloth and thus presenting a strong colour contrast. The upper version photographed with a panchromatic film shows very little tonal difference. By using a red filter, which strongly absorbs green and blue, the tea set appears black. A complete reversal of tones is obtained by exposing through a green filter. For comparison, the orange table cloth has been kept at about the same tone of grey in each version.

FIG. 2.14. Two photographs made on the same film and location. The combination of sunlight and shadow gives a lighting contrast too great for ordinary printing. The second version has very nearly zero lighting contrast but would give satisfactory results with colour film.

the surface of the sensitive material. This additional light has no significant effect on the brighter parts of the image, but becomes important in the shadows. The introduction of coated lenses helped to reduce this loss of contrast. Loss of contrast will also result from the use of a dirty lens or can be deliberately introduced by placing a diffusion disc in front of the lens, see Fig. 2.15.

In continuous tone photography the photographer will aim to preserve the original contrast of the subject unless he has some special reason for distorting the contrast for pictorial effect, see page 219. There are, however, occasions when it is desirable to increase the contrast, either because the subject contains only two tones, as in a line drawing, or because a two-tone effect is required from a continuous tone subject. Negatives materials of inherently high contrast are available for this purpose. Such materials have a very short exposure scale and high maximum density and must therefore be exposed very accurately. Alternatively, the contrast of a two-tone negative of normal contrast can be greatly increased by using a high contrast printing material.

Another method of controlling contrast consists in preparing positive masks from the negative which are then combined with the negative during the printing exposure, see page 219.

Tone reproduction by reversal processing

Reversal processing is extensively used in colour photography to produce positive colour transparencies from the film exposed in the camera. It has a more limited application in black-and-white photography, chiefly in producing narrow gauge cine films and 35 mm. slides.

The principle of reversal processing is the same for colour and black-and-white film, except that with colour film, the silver images are eliminated. When an exposed film is developed, but not fixed, the silver salts in the emulsion layer or layers have been partly converted into silver by an amount which is roughly proportional to the exposure which the film has received. The remaining silver salts will, therefore, be inversely proportionate to the amount of light action and thus represent a potential positive image. This second image can be made developable by further exposure to light or by chemical fogging. However with a black-and-white film, it is first necessary to dissolve away the negative image. A second

FIG. 2.15. Two versions of the same subject, the first without diffusion and the second with a diffusing disc over the lens. The effect of the disc becomes greater as the lens aperture is opened up.

development then produces a black-and-white positive image. With a colour reversal film, the by-products of this second development combine with couplers in the emulsion to form dyes. Thus two images are formed in each layer of the film simultaneously, a positive silver image and a dye image. At this stage the film contains a combined negative/positive silver image and a dye image. The remaining steps of the process consist of removing all trace of the silver image along with any still-undeveloped silver salts. The image that remains consists solely of dyes.

If the resulting transparency is to be satisfactory, the highlights of the original scene must be reproduced as clear film, that is to say, the original exposure must be such that the highlights expose practically the whole of the silver salts in that area so that the developed negative reaches maximum density. To allow for this, emulsions intended for reversal processing are usually thinner than normal so that their exposure scale is only slightly greater than the brightness range of the average subject. This, of course, has the effect of restricting the exposure latitude to an amount represented by little more than ½ stop over- or under-exposure. Since the dye image of a colour transparency is proportionate to the positive silver image which was formed at the same time, the same restriction in exposure latitude holds good for reversal colour films.

Reciprocity failure

Studies on the nature of light action on certain chemical reactions by the two scientists, Bunsen and Roscoe, led them to postulate a law known as Photochemical Equivalence, which states that the amount of chemical produced depends on the value of the intensity of light multiplied by the time of exposure and that the two factors are equivalent. This is to say that the same result would be produced if the intensity were halved and the exposure time doubled.

A similar relation holds good over a limited range for the density produced in a photographic emulsion and thus makes it possible to interchange the factors of intensity and time while still obtaining a negative of the same density. However, if marked changes are made, as for example 1/100 or 1/1000th of the intensity

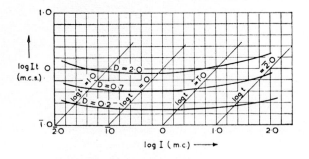

FIG. 2.16. Curves showing the effect of reciprocity failure.

acting for 100 or 1000 times as long, the density produced is considerably less, even though the product of intensity and time remains the same. This phenomenon, which varies with different emulsions is known as reciprocity failure.

It can be established for a particular emulsion by making a series of sensitometric exposures on an intensity scale sensitometer for a range of different exposure times. From these it is possible to plot curves which show how the density varies with different intensities at constant exposure, i.e. intensity \times time, see Fig. 2.16.

Reciprocity failure is chiefly notable in terms of loss of speed, though it may also have an effect on the contrast of the material. For this reason, reciprocity failure with a colour film, which contains three distinct emulsion layers, usually involves a change in colour balance as well as loss of speed, see page 61.

In practice, reciprocity failure becomes a serious problem only when the intensity of the image is so low as to require exposure times of several seconds or more. This commonly occurs in photomacrography and photomicrography where the selected aperture of the lens may be extremely small, see page 196.

Solarisation

To complete our survey of the chief characteristics of a photographic emulsion, it is worth briefly mentioning the phenomenon known as solarisation as it is occasionally of value in producing tonal distortions of a pictorial nature in both black-and-white and colour photography. From illustrations of characteristic curve so far shown in this chapter, it has been shown that increasing exposure produces increasing density which eventually tails off to a maximum. If the exposure is increased well beyond that which gives maximum density, it is frequently found that lower densities result. This effect is known as solarisation and varies with the type of emulsion, the method by which the increased exposure is given and the processing conditions. Effects similar to solarisation may be obtained by interrupting the development of the negative or print and giving a flash exposure to red light of pre-determined intensity and duration. The effect is known as the Herschel Effect, after Sir John Herschel who first noted it.

CHAPTER 3

Light Sources

In the first half century of photography, daylight was the only light source suitable for exposing the relatively slow materials available and even so exposures of several minutes or more were necessary to produce a satisfactory image. Today, not only are photographic materials vastly more sensitive, but a wide range of light sources has been developed for the special needs of the photographer. These include high-efficiency tungsten filament lamps, electronic discharge lamps and flashbulbs. At the same time artificial illumination generally has been vastly improved since the days of the oil amp land candle, and with the high-sensitivity films available, the photographer is able to make hand-held camera exposures with what has become the normal artificial lighting in the home, shops and stores and public buildings generally.

Light sources may be classified in a number of ways from the point of view of photography, that is to say, in terms of their intensity and size, their spectral composition or colour temperature, whether they give directional light as from a point source or parallel light as that of sunlight, whether diffused and multi-directional as in the case of skylight and light reflected from walls and ceiling, and if taking the form of flashbulbs and electronic flash, their duration. In addition they may be considered in terms of lighting systems, the degree of facility by which they may be controlled, their portability and their relative cost.

Naturally, daylight remains the only practical light source for general outdoor photography of landscapes, and the normal photography of buildings and outdoor activities. Nevertheless, artificial light sources can provide useful supplementary lighting to sunlight as fill-in for shadows and, on occasions, entirely replace daylight in small sets and in close-up photography. In the studio, artificial light can also be used to reproduce various qualities of daylight when it is either inconvenient or impossible to obtain such effects naturally.

Intensity of light sources

Measurements of the luminous intensity of a light source are based on an arbitrary standard known as the candela. The magnitude of the candela is such that the luminance of a full radiator (black body) at the temperature at which platinum freezes (2,042·2°K.) is 60 candelas per square centimetre. This approximates very closely to the light output of the erstwhile standard candle which was made of wax to specified dimensions and burning characteristics. However, the photographer is more concerned with the intensity of the illumination falling on a surface and

for this purpose the standard adopted is the metre-candle, which is the intensity of illumination reaching a surface at a distance of 1 metre from a light source equal to 1 candela. Thus 100 metre-candles is the amount of light falling on a surface 1 metre away from a 100 c.p. lamp. Such a measurement is similar to an incident light measurement made with an exposure meter and should not be confused with a measurement of the light reflected from a surface, since this depends on the reflectance of the surface.

Propagation of light from a point source

It has long been established that the intensity of light falling on a flat surface at right-angles to a point source is inversely proportional to the square of the distance. This law is roughly valid to small-area light sources, such as flashbulbs and tungsten filament lamps, used for photography and thus makes it possible to calculate changes in intensity when a light source is placed at different distances from the subject. The diminishing intensity of a point source at increasing distance is shown in Fig. 3.1.

The extent of light fall-off with distance is an extremely important factor in photography. Unfortunately the mechanism of the eye is such that the actual difference appears a great deal less than that recorded in a photograph. For example, in the three photographs on page 38, Fig. 3.2, there appeared to be very little difference in the uniformity of the illumination at the three lamp distances. When flash is used, there is no possibility of a visual assessment and the dark backgrounds so common to flash photography often come as a surprise to the photographer.

The inverse square law is applied to the exposure of flashbulbs and electronic flash in terms of the guide number system. This takes advantage of a similar relationship between the intensity of the image formed by a lens and the f/number

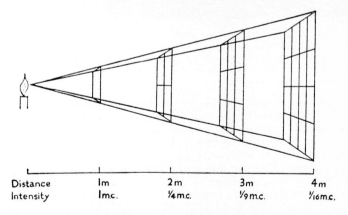

| Distance | 1m | 2m | 3m | 4m |
| Intensity | 1m.c. | ¼m.c. | ⅑m.c. | ⅟₁₆m.c. |

FIG. 3.1. Diagram showing how the intensity of a point source falling on a flat plane diminishes with distance. The distance is shown in metres and the intensity in metre-candles.

37

Lamp distance
3, 4 and 5 feet.

Lamp distance
6, 7 and 8 feet.

Lamp distance
9, 10 and 11 feet.

Fig. 3.2. The three tins were separated by 1 ft. and the three photographs were made with the lamp at distances of 3, 6, and 9 ft. from the nearest tin. It can be seen that the fall-off of illumination is far less at the greatest lamp distance. The differences are less than might be expected on the basis of the inverse square law because of light reflected from the walls of the studia.

at which the lens is used, namely, that intensity is inversely proportional to the square of the f/number. As the f/number is also an inverse value, i.e., the greater the f/number the smaller the aperture, lamp-to-subject distance and f/number can be multiplied together to give 'a constant' which can be used to calculate equivalent combinations of distance and f/number. Thus if tests with a particular flash unit and film show that the correct exposure with a lamp-to-subject distance of 10 ft. is given at a lens aperture of f/8, then the guide number 80, found by multiplying 10 by 8, indicates that at 20 ft. the lens must be set to f/4. However, certain other factors have to be taken into consideration when applying exposure guide numbers with flashbulbs and electronic flash, but these are dealt with fully in a later chapter, see page 127.

The inverse square law of light propagation applies only to light sources having a relatively small area and its effect is only of interest to the photographer over a

certain range of distances. For example, the sun may appear to be a small-area light source, but this is because it is 93,000,000 miles away! At this distance the light reaching the earth may be regarded as parallel light having a constant intensity in terms of terrestrial distances. The same holds good for parallel or near parallel light produced by means of a lens system such as that used in a spotlight.

Lamp reflectors

The light emitted by the filament of a lamp is propagated in all directions. This is useful in a lamp intended for general illumination, as for example, a lamp suspended from the ceiling for the purpose of lighting a room. However, the photographer is normally interested in the illumination of a given area and it is thus an advantage to concentrate as nearly as possible the total light emitted by the lamp on to this area. This can be achieved by mounting the lamp in front of a concave reflector, see Fig. 3.3, which reflects back practically all the light which would otherwise be dispersed away from the plane of photography. Under certain conditions a properly constructed reflector can increase the intensity of the illumination by as much as 3 times over a field of about 60°. With a polished aluminium reflector, the shape and distance of the reflector behind the lamp can

FIG. 3.3. An efficient lamp reflector can increase the intensity of light falling on the subject plane by as much as three times.

be such that a much greater concentration of light is given over a narrow angle and at a certain distance. At other distances such a reflector may give a 'hot' spot owing to the focusing characteristics of the reflector. For this reason, general-purpose reflectors are given a matt or satin finish which diffuses the reflected light. A similar effect can be obtained using a polished reflector by placing a diffusing screen in front of the lamp. This is the method used with reflector type photoflood lamps which incorporate a mirror reflector in the glass envelope, the glass being given a matt finish.

The reflectors incorporated in flashbulb holders and electronic flash units vary considerably in their efficiency and covering power at different distances. Generally speaking they are designed to give their maximum efficiency at distances of from 2 to 4 yards or metres from the subject. At closer distances, the illumination will tend to decrease. Professional type electronic flash units often incorporate a dual reflector system, one position giving a normal angle and the other a wide angle to provide for the use of a wide-angle lens.

Reflector boards

It is often possible to substitute a direct light source, which may be needed as a fill-in for the shadows, with a reflector board which is placed to receive light from

39

the main light source and reflect it on to the shadows. The efficiency of such a reflector depends on its surface and tone, as well as its size and distance from the subject. With a parallel light source, such as clear sunlight, a mirror-like surface, whether an actual mirror or a sheet of polished aluminium, will reflect parallel light of very nearly the same intensity. The area covered will depend on the size of the mirror. If the light source is a lamp or flashbulb (small-area light source), the reflected light follows the inverse square law. Thus if the mirror is placed so that the distance from lamp to mirror and mirror to subject is about 1½ times that of from lamp to subject, the reflected light will have approximately half the intensity. If the surface of the reflector is matt or textured (as in the case of embossed aluminium foil), some light will be dispersed over a wide angle and the efficiency of the reflector will diminish with both area and distance.

If the reflector board has a matt white surface, it will itself absorb about 10 per cent of the light falling on it and reflect the remaining 90 per cent in all directions over an angle of 180°. To be effective, the dimensions of the reflector must be roughly equal to the distance at which it is to be used.

Focused light sources

These are used in photography chiefly in the form of spotlights in which a lamp embodying its own reflector is used in conjunction with a fresnel condenser lens. The distance between the lamp and the condenser lens can be varied to give a full-focused narrow beam and a range of semi-focused and wider angle beams. The area covered by the spotlight can be still further controlled by placing screens in front of the condenser. These go by such names as funnels, barndoors, shoots and gates. In addition the light may be partly diffused, either with the use of a matt-surface condenser or by placing a diffusing medium in front of it. One advantage of a spotlight is that it can be used at a considerable distance from the subject with relatively little loss in intensity when focused to give a narrow beam.

Focused light sources are also used to obtain high intensity illumination in the photography of very small objects and in photomicrography.

Spectral composition of a light source

By measuring the energy in the spectrum of a light source at various wavelengths and plotting these values against wave-length we can obtain a curve showing the

FIG. 3.4. Special energy curves for (1) light from a blue sky, (2) noonday sunlight, and (3) a tungsten filament lamp. The curves are plotted so that the relative energy in the visually brightest part of the spectrum (550 mμ) is the same.

spectral composition of the light source. Taking noon-day sunlight as an ideal form of white light, we can compare the spectral curve of this with those of northern sky light and an ordinary tungsten filament lamp, see Fig. 3.4. The curves are plotted so that the relative energy in the brightest region of the spectrum is roughly the same; the curves thus show the relative energy distribution for approximately the same amount of visual sensation. The curve for sky light shows a preponderance of blue light, while that of the tungsten lamp shows far more red light. However, such curves are of limited interest to the photographer using colour film, and it is customary to indicate the colour quality of illumination in terms of its colour temperature.

Colour temperature of light sources

Strictly speaking, colour temperature applies only to the spectral emission of a black body heated in a furnace, but it can be applied to tungsten lamps with reasonable accuracy, and as a rough guide to other light sources having a continuous spectrum.

FIG. 3.5. Curves of the operating characteristics of a 24-volt, 150-watt tungsten iodine lamp.

41

Colour temperature is given in degrees of the absolute scale of temperature, commonly known as degrees Kelvin or °K. On this scale zero equals —273° Centigrade. When the temperature of a black body is raised to about 750°K. it appears a dull red, becoming cherry red at 1,000°K. and yellow at 1,500°K. Enclosed in a glass envelope filled with an inert gas, a tungsten filament can be heated to a temperature of 3,400°K. before the metal begins seriously to vaporize. Nevertheless, it has a burning life of only a few hours compared with the 1,000 hours of an ordinary household lamp which operates at a temperature of about 2,800°K. Lamps designed for a commercial studio are designed to run at 3,200°K., a compromise which gives a mean burning life of 100 hours.

However, not only does the light emitted become 'whiter' at higher temperatures, but the total light emitted by the filament increases rapidly with increasing temperature. This is shown in Fig. 3.5, page 41. The efficiency of a tungsten lamp in terms of light output is usually given in terms of lumens per watt.

The following table gives colour temperatures for a range of light sources.

Light Source	Colour Temperature, °K.
Candle	1,900
Tungsten lamp, 100 watt	2,840
,, ,, 250 watt	2,900
,, ,, 1,000 watt	3,000
Tungsten projection and colour controlled studio lamps	3,200
Photoflood and similar	3,400
Quartz iodine	3,200 and 3,400
Clear flashbulb	3,800 to 4,200
White flame carbon arc	5,000
Sunlight at sunrise and sunset	2,000 to 4,000
Sunlight plus clear blue sky	5,500
Blue flashbulb	5,500
Electronic flash	6,000 to 7,000
'Daylight' fluorescent tubes	5,000 to 6,500
Light from clear blue sky	12,000 to 27,000

Conversion of colour temperature with filters

The spectral composition or colour temperature of a light source is chiefly of importance to colour photography and, in particular, with the use of reversal colour film where the best colour rendering requires an accurate match between the spectral composition of the lighting and the colour balance of the film. Reversal films intended for use with daylight are balanced for a colour temperature of 5,500°K., namely clear sunlight plus light from a blue sky. Blue flashbulbs and electronic flash are designed to give a similar colour temperature. However, in exposures made with blue sky (objects in open shade), the colour rendering

may appear excessively blue and more acceptable results will be obtained by using a filter which lowers the colour temperature. Conversely, if the same film is exposed with photoflood lamps which have a much lower colour temperature than standard daylight, the colour rendering would appear excessively yellow. In this case a filter which raises the colour temperatures is needed. However, as the jump from 3,400°K. to 5,500°K. is a large one, such a conversion filter will involve a substantial loss in effective speed (an average of 2 stops). For this reason and also because an exact conversion is not possible with a simple filter, certain brands of reversal colour film are available having a colour balance suited for lamps of 3,200°K. and, in one instance—Kodachrome II, Type A—to lamps of 3,400°K. If used with lamps of lower colour temperature, it may be necessary to use filters which raise the temperature. Conversely, if a film balanced for artificial light is to be exposed with daylight, a filter giving a substantial reduction in colour temperature will be needed.

Mired system
The filters required to modify the colour temperature of light sources can be conveniently calculated on the basis of the mired system. The mired value is the reciprocal of the colour temperature multiplied by 1,000,000 and the table below gives the mired values for a range of colour temperatures.

Mired Values of Colour Temperature from 2,000°-6,900°K

°K.	0	100	200	300	400	500	600	700	800	900
2,000	500	476	455	435	417	400	385	370	357	345
3,000	333	323	312	303	294	286	278	270	263	256
4,000	250	244	238	233	227	222	217	213	208	204
5,000	200	196	192	189	185	182	179	175	172	169
6,000	167	164	161	159	156	154	152	149	147	145

At the same time it is possible to allocate mired-shift values to filters designed to modify colour temperatures, the effect of the filter being roughly the same, irrespective of the initial temperature of the light source. A filter which lowers the colour temperature is said to have a positive shift-value and one which raises the colour temperature a negative shift-value. Values for the Kodak Wratten series of light-balancing and conversion filters are given in the table below. When two or more filters are combined, the shift-value of the combination is found by adding the values. Thus the combination of a Wratten 85 with an 81A becomes 112 + 18 = 130, and is thus the equivalent of an 85B.

Mired-shift values for Wratten Light-balancing and Conversion Filters

No.	85B	85	85C	81EF	81C	81B	81A	81	82	82A	82B	82C	80B
Mired-shift	+130	+112	+81	+53	+35	+27	+18	+10	−10	−18	−32	−45	−112

Colour temperature meters

To make full use of the mired system a reliable colour temperature meter is necessary. Such instruments are based on a photo-electric meter which indicates the relative proportions of blue and red light emitted by a light source. Generally speaking a colour temperature meter is more reliable when applied to tungsten light sources.

Directional characteristics of illumination

The illumination reaching a surface may come directly from a light source or indirectly by means of a reflecting surface or medium. Direct lighting from a near-point source may be said to be strongly directional in the sense that only a very narrow beam of light reaches any given point on a surface. The shadows cast by a point source, if we exclude any light reflected from surrounding surfaces, will have a sharp outline, the size of the shadow for any given background distance, depending on the distance of the light source from the subject. A small area source such as a flashbulb used with a small reflector, closely approaches a point source when used at a distance of several feet from the subject. Thus the shadows will also have a fairly sharp outline. When a light source, such as a flashbulb or tungsten lamp, is used with a large reflector, the light becomes less strongly directional depending on its distance from the subject and the shadows thus have less-defined edges. If a number of lamps—often referred to as a bank or broad—are used together, see page 113, Fig. 7.8—the light reaching any given point arrives from a range of directions, and the same is true if a large diffusing screen is placed some distance in front of a single lighting unit. In this case any shadows will have no discernible outline. If a number of light sources are used to illuminate the outside of a photographic tent, the illumination reaching the subject is now multi-directional and as all points of the subject receive the same amount of light, there will be no shadows of any kind, see Fig. 3.6. Multi-directional light is referred to as diffused light.

Indirect lighting may vary in a similar way depending on the nature of the reflecting surface, as well as the nature of the light falling on it. Thus a mirror will have no effect on the quality of the incident light and will merely change its direction. If the reflecting surface is irregular, directional light will be reflected in different directions, becoming more or less diffused depending on the nature of the irregularities. A uniform matt surface, such as a sheet of white paper, will convert directional light to totally diffused light. In the normal way, reflected light from walls, ceiling or special reflector boards having a matt surface, may be regarded as diffused light which will produce no appreciable shadows.

Clear sunlight is not only strongly directional, but is also virtually parallesl after arriving from a distance of 93,000,000 miles. In the normal way it is accompanied with a proportion of diffused light coming from the sky. In the presence of haze, sunlight is partially diffused and with an overcast sky, it becomes totally diffused. Strong sunlight can be locally diffused by placing a screen of diffusing material, such as cheese cloth, between the sun and the subject.

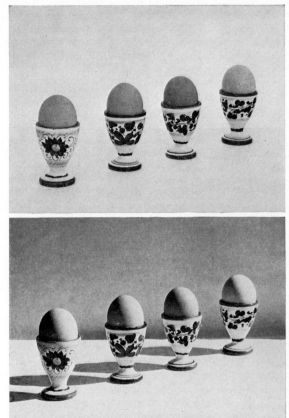

FIG. 3.6. The upper version was photographed inside a photographic tent giving diffused multi-directional illumination and the lower version with a single light source. It can be observed how important shadows are as a clue to depth and solidity.

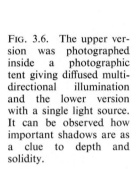

Angle of incident light on a flat surface

Strongly directional light falling on a flat, mirror-like surface is reflected from the surface at an angle equal to the angle of incidence, see Fig. 3.7. Such reflections are known as specular reflections and frequently represent the highlights of a subject, e.g. reflections from water, catch-lights in the hair and eyes, reflections from glassware and porcelain. If the incident light is more or less diffused, that is, arrives from a range of angles, the reflected light will show the same characteristics. The reflected light of a directional light source will be partly or fully diffused from a non-polished surface, the degree of diffusion depending on the nature of the surface. With a smooth, matt surface there will be a peak reflection at an angle equal to the angle of incidence plus a slight spread of diffused light over a narrow angle. With a rough matt surface, the incident light

will be reflected over a wide angular range and the surface will show no appreciable reflections. The polarization of reflected light is discussed later in this chapter.

The intensity of light reflected from a matt surface varies with the angle of incidence. If we take the intensity of reflected light from a surface at right-angles to the light source as 100 per cent, the intensity of reflected light when the incident light arrives at an angle of 60° will be about 75 per cent, at an angle of 40° it will be about 44 per cent, while at 20° only about 13 per cent, see Fig. 3.8. This

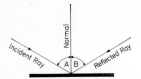

FIG. 3.7. The angle (B) at which a ray of light is reflected from a flat polished surface is the same as that of the incident ray (A).

factor only becomes important when dealing with flat subjects such as paintings or the facade of a building which occupies most of the picture area. With three-dimensional objects having surfaces at different angles to the source of illumination, the variation in the reflected light produces tonal differences which indicate the shape of the object. A light source used for this purpose is often referred to as a modelling light, see Fig. 3.9.

Very oblique incident light will tend to emphasise the texture or irregularity of a flat surface. Examples are shown on pages 143 and 187.

Effect of lighting on contrast and colour saturation

The surfaces normally encountered in photography may be considered as having two stages of reflection, the first from an outer layer and the second from the inner layer representing the body of the object. Reflections from the outer layer tend to reveal the texture or nature of the surface since they reflect the incident light unchanged. Light reflected from the inner layer becomes more or less changed both in intensity and colour depending on the absorption characteristics (tone and colour) of the surface. Thus if the surface has a mirror-like finish, such as varnished paint, glazed ceramic and polished wood, it will give strongly specular reflections

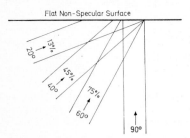

FIG. 3.8. Diagram showing how the intensity of light reflected from a surface varies with the angle at which it strikes the surface.

46

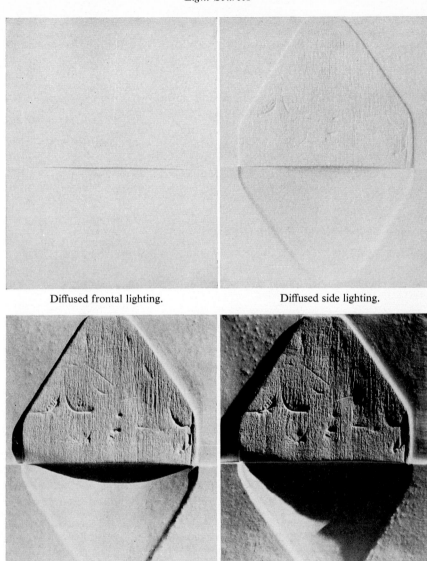

Diffused frontal lighting. Diffused side lighting.

Directional light 10°. Directional light 70°.

FIG. 3.9. A white plaster cast which depends entirely on lighting differences for its appearance.

from the outer layer at an angle equal to the angle at which the light strikes the surface, while the light reflected at other angles will more or less change in tone and colour depending on the amount absorbed. If the absorption is roughly the same for all wavelengths of light, the surface will appear white, grey or black depending on the amount absorbed. If the absorption is different in different regions of the spectrum, then the surface will appear coloured. Thus a surface which strongly absorbs blue and green will appear red and one which absorbs only blue will appear yellow, and so on.

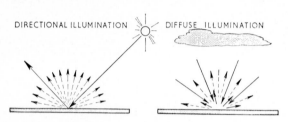

DIRECTIONAL ILLUMINATION DIFFUSE ILLUMINATION

FIG. 3.10. Most surfaces reflect part of the light falling on them unchanged. With strongly directional lighting this occurs at a certain angle, but with diffused lighting some of the un- changed light is reflected in all directions. With colour photography the effect is to give less saturated colours.

If the surface is matt or rough in texture, then the outer layer will reflect some of the light unchanged at all angles. Thus at no matter what angle an object is viewed or photographed, the light reflected from the inner layer which determines the tonal and colour attributes of the object will be combined with some white light, see Fig. 3.10. This has the effect of reducing the contrast of the dark tones, which explains why a print on glossy paper gives a fuller tone range than one on matt paper. It also has the effect of diluting the colours, see page 63.

If the illumination itself is diffused (multi-directional), then the outer layer will reflect some white light in all directions and there will again be some reduction in contrast and colour saturation.

Polarized light

'Natural' or non-polarized light has the characteristic of vibrating in all directions in a plane at 90° to the direction of propagation, see Fig. 3.11. If such a beam of light is made to pass through a filter which absorbs all the vibrations except those in a single plane, the transmitted light will have an electrical field of fixed direction and is said to be polarized. Such a filter is known as a polarizing filter. If a similar filter is placed in the path of polarized light, it will transmit the maximum amount of polarized light when its plane of polarization coincides with the plane of vibration of the polarized light. If the filter is rotated about its axis, it will absorb an increasing amount of polarized light reaching maximum absorption (zero transmission) at 90°, thereafter decreasing to a minimum again at 180°.

Natural light also becomes polarized in the process of reflection from a non-metallic surface. Polarization is at a maximum when the angle of incidence is

approx. 34° and is less so as the angle approaches 0° or 90°, becoming zero at these angles. It thus becomes possible to eliminate part or whole of the polarized light by using a polarizing filter through which to view or photograph the subject. Reflections at 34° can be totally eliminated if the filter is used at 90° to the plane of polarization, Fig. 3.12.

The light from a blue sky in an area around 90° to a line between the sun and the observer or camera is also strongly polarized and may be similarly absorbed with a polarizing filter.

Polarized light offers certain advantages in photography as a means of selectively controlling reflections. Firstly, reflections from non-metallic surfaces arising from unpolarized light can be partly or fully controlled by using a polarizing filter in front of the camera lens. Thus reflections from glass and water which would otherwise interfere with objects behind or below this outer surface can be eliminated by pointing the lens at an angle of 34° to the surface. Similarly, reflections from polished wood which would interfere with the colour and graining of the wood can be reduced or eliminated by shooting at the same angle. There are, of course, many other instances where a polarizing filter will improve contrast and colour saturation: as the visual and photographic effect are similar, it is sufficient to view the subject through the filter to decide whether its use is worth while, bearing in mind that it will require an exposure increase of 1-1½ stops.

In studio photography, far more effective control of reflections will be given by using polarizing filters over the light sources, plus a polarizing filter over the lens. In this case the light reaching the subject from the light source will already be polarized and any reflected light from the outer layer of the surface will remain

Fig. 3.11. Light waves usually vibrate in all planes at right angles to the direction of travel. After passing through a polarizing filter P.1 light becomes plane polarized vertically. With a second filter having a horizontal polarizing plane, it becomes completely obstructed.

Fig. 3.12. Light reflected from a glass non-metallic surface is strongly polarized at an angle of about 34° with the surface and can thus be almost totally absorbed with a polarizing filter.

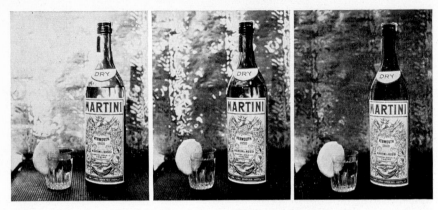

Fig. 3.13. A subject with a metallic foil background lit with polarized light and showing the effect of a second polarizing filter over the lens rotated through 90°.

polarized whereas that reflected by the second layer will become depolarized as well as modified in tone and colour. Thus the polarizing filter over the lens can be orientated to absorb varying amounts or all of the surface reflections irrespective of their angle, see Fig. 3.13. This means that a camera can be used at right angles to a surface, as when copying an oil painting, while maintaining full control of the reflections. If two light sources are used, as with copying, the plane of polarization must be the same for both sources. However, with objects such as porcelain, it is possible to retain the reflections from one light source by rotating the filter in front of that lamp through 90°, or by a smaller amount if only restrained reflections are required. Practical applications of polarizing filters are discussed more fully in Chapter 11, page 164.

Daylight

In the widest sense, the term daylight can be taken to include any form of light direct or indirect which originates from the sun. In this sense it is an extremely variable source of light, especially in those parts of the world where the weather is very variable. For this reason, daylight is both the delight of the amateur photographer in search of artistic effects and the bane of the professional on some routine outdoor assignment.

When the sun is unobscured, it provides a powerful source of parallel light which moves in an arc across the sky at the rate of about 15° an hour (or, at least appears to move from a terrestrial point of view), between the hours of sunrise and sunset. The height of the sun above the horizon varies with geographic latitude, the season of the year and the time of day. Thus even if we ignore the effect of the earth's atmosphere for the moment, the illumination falling on a flat horizontal surface will vary in intensity according to the altitude of the sun above the horizon. However, as the photographer is usually more concerned with vertical surfaces. this variation is of minor importance. Of much greater importance is the effect of the atmosphere through which sunlight passes before it reaches the particular

scene we wish to photograph. It can be seen from Fig. 3.14, that the depth of atmosphere through which sunlight passes depends on its altitude above the horizon, being at a maximum just after sunrise or just before sunset. Because the shorter wavelengths of light (violet and blue) are scattered to a much greater amount than the longer wavelengths, the colour composition of sunlight becomes increasingly deficient in blue, that is, appears yellower, at lower altitudes. The degree of scattering also depends on the nature of the atmosphere, being considerably less with a very clean atmosphere (one which contains very little moisture or fine dust) than with a hazy atmosphere (one containing a good deal of moisture and fine dust arising from smoke, etc.). The variation in the colour of sunlight can be shown in terms of colour temperature: overhead sunlight on a clear day has a temperature of 5,400°K. and one of between 2,000°K. to 4,000°K. just after sunrise and just before sunset. At the same time there is a substantial decrease in the intensity at low altitudes, a fact very obvious from the ease by which we are able to look into the sun at low altitudes and the discomfort arising from looking into an overhead sun.

The light scattered by the atmosphere, the sky light, may be regarded as a second source of light of an entirely different nature to direct sunlight. Because it arises chiefly from the scattering of the shorter wavelengths, it contains a great deal more blue and appears so in comparison with sunlight. On a very clear day, the colour temperature of sky light may be as high as 27,000°K. and as low as 10,000°K. with strong atmospheric haze, with a ratio of intensity to overhead sunlight varying from 1:7 to 1:3 between very clear and very hazy atmospheric conditions. Finally it is a highly diffused light source.

FIG. 3.14. Diagram showing how the depth of atmosphere through which sunlight passes increases as the sun approaches the horizon.

Photography in the open on a clear day thus makes use of two different light sources: strongly directional sunlight acting as the principal light source and blue sky light coming from all directions. Any areas not receiving direct sunlight appear as strong, clearly defined shadows which receive light from the sky. Areas of white or light neutral tones in the shadow thus appear bluish, and may appear excessively blue in a colour photograph, see page 64.

In the presence of a strong haze, sunlight becomes somewhat diffused, while the light from the sky becomes relatively whiter and more intense. Thus shadows become weaker and less defined and there is less tendency for them to appear blue. With the existence of a light mist, the diffusion is much stronger and the much softer contrast and colours obtained with landscape photography are the delight of anyone who practises the art.

51

However, 'typical' daylight for many parts of the world or at certain seasons, is that coming from an overcast sky. A heavy layer of cloud acts as a complete diffusing medium so that the same amount of light comes from all areas of the sky. It has a colour temperature of around 8,000°K. and thus gives a somewhat 'colder' colour rendering with a colour film than that given by sunlight. The intensity of the light reaching the subject from a heavily overcast sky is only about 1/10 of that given by direct overhead sunlight. With a substantially thinner cloud layer, the position of the sun may be clearly indicated by a brighter region. Though there will be no distinct shadows, the light coming from this area will give appreciably brighter tones than that coming from other areas.

Cloud may also take the form of isolated areas or a scattering of separate clouds thus permitting periods of clear sunlight plus light reflected from the clouds. This is equivalent to clear sunlight but with the difference that the light coming from the sky will be 'whiter' and possibly more intense than that from a clear sky.

Restricted daylight

In many cases only part of the light available from the hemisphere of the sky may reach the area to be photographed. For example, direct light from the sun may be isolated from most of the light from the sky when it enters a window or shines down a narrow street bordered by tall buildings. In this case the shadows will receive only the light reflected from adjacent walls and may thus become very much darker. At the same time the light may give somewhat 'warmer' colour rendering with a colour film since the colour temperature of sunlight on its own is somewhat lower than when mixed with blue sky light or light reflected from broken clouds. Conversely, the only light reaching the subject may come from a very blue sky and in this case the colour rendering would be distinctly bluish. Restricted sky light, whether entering narrow streets or illuminating interiors through windows and doors tends to take on a semi-directional nature. However, its colour quality may vary considerably if it has been reflected from coloured walls or has passed through foliage or glass.

Sunrise and sunset

During the two hours after sunrise and the two hours before sunset both the intensity and colour of sunlight vary considerably. As the intensity of the sun decreases, the light from the sky becomes more effective, and the contrast between yellow sunlight and blue sky light more apparent. Also with low altitude sunlight, the shadows cast by the sun become much longer and more extensive, see also page 87.

Twilight

Before sunrise and after sunset there is a period of daylight which varies in length according to latitude. In clear atmospheric conditions it consists mainly of blue sky light, but with haze and broken cloud there may also be a strong afterglow of sunlight as well as sky light. In overcast conditions there is no noticeable difference immediately before sunrise or after sunset, and the twilight merely consists of a diminishing intensity of sky light.

However, the colour sensitivity of the eye, as well as its ability to distinguish detail and contrast, falls at very low levels of illumination—for example at dusk and on a moonlit night—to give the impression of a vague and almost colourless landscape. But a colour photograph exposed sufficiently to give an image of normal density will reproduce both the colours and the contrast perceived in full daylight, allowing for some deviations which might arise from prolonged exposures (reciprocity failure) or differences in the colour temperature of the prevailing light. Indeed to reproduce the visual effect at twilight would require a colour film which is predominantly sensitive to the blue region of the spectrum. Thus a more convincing 'moonlight' shot can be made by shooting a sunlight landscape with a colour film balanced for artificial light (and therefore of higher blue sensitivity) with 1-2 stops under-exposure, than by giving a prolonged exposure of up to an hour, to an actual moonlit landscape.

High efficiency tungsten lamps

The high melting point of tungsten (3,700°K.) makes it possible to operate tungsten filament lamps at a temperature as high as 3,400°K. while still obtaining a useful working life. The advantage in terms of working life lies with lower voltage lamps, since for the same wattage a more robust filament is possible. This explains why most slide projectors now employ low wattage lamps. From typical values given below, it can be seen that a 24-volt lamp will give twice the life of a 240-volt lamp of the same wattage even when the former is operated at a much higher temperature so as to give almost twice the output in lumens.

Volts	Watts	Nominal lumens	Average life (hours)
24	150	4700	50
240	150	2700	25

One of the limiting factors at very high temperatures of particular importance in colour photography, is the deposition of evaporated tungsten on the glass envelope causing a blackening of the glass. This blackening not only reduces the efficiency of the lamp but as it also absorbs more heat raises the temperature of the glass envelope which must therefore be large enough to allow for this. An ingenious answer has been found to this problem by the introduction of iodine in the lamp. At a temperature of about 250°C. iodine combines with the tungsten to form tungsten iodide, but above 2000°C. the reverse action takes place with dissociation into tungsten and iodine of the tungsten iodide. The tungsten is redeposited on the filament, though not, preferentially to the hottest (and hence thinnest) parts of the filament, so that lamp failure still occurs when a point in the filament becomes thin enough to reach a temperature in excess of the melting point. However, such lamps have their life extended because of the iodine cycle and can be run at a higher colour temperature than ordinary lamps for the same average life. By making the envelope of quartz, which withstands a higher temperature than glass, it can be kept very compact. Since blackening does not occur, the light emission of the lamp remains constant throughout its life.

The advantage of operating a tungsten lamp at high temperature is a two-fold one: it gives a whiter light, more suited to the requirements of colour photography, and its efficiency in lumens per watt is greatly increased. This can be seen in Fig. 3.5 which gives the characteristics for a typical tungsten-iodine lamp.

Tungsten lamps designed for photographic use often incorporate an internal reflector thus dispensing with the need of a separate one. Lamps designed for colour photography are available in two classes. Class P1 for use with colour film balanced for 3,400°K. and Class P2 for use with colour films balanced for 3,200°K. In general, Class P2 lamps have a much longer working life and are therefore

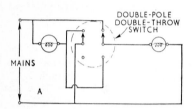 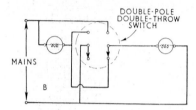

FIG. 3.15. Wiring diagram for a series-parallel wsitch for two photoflood lamps. (A) shows the switch position for full light output, (B) for reduced output.

more economical where considerable use is made of studio lighting. However, the relatively short life of Class P1 lamps can be extended when they are used in pairs by using a switch panel which allows the lamps to be run in series for setting up the lighting and in parallel only for measuring (by meter) and making the exposure. A suitable switch system, using a double-pole, double-throw switch, is shown in Fig. 3.15. It is particularly useful for 3,400°K. photoflood lamps which have a burning life of only a few hours.

Characteristics for a typical range of photoflood lamps are given in the table facing. It will be seen that those in Class P1 are available with both Bayonet type caps (B.C.) and Edison screw caps (E.S.). It is thus possible to choose those with B.C. caps for use in ordinary household lamp sockets as a means of raising the level and colour temperature of an existing lighting set-up without making use of photographic lighting stands. However, it should be borne in mind that the much greater light output is also accompanied with more heat which could well cause damage to small lamp shades. Both classes of lamps are also available with built-in reflectors, while the Class P2 is also available as a Reflector Photo Spot to give a concentrated beam of light.

Voltage fluctuations

The output and colour temperature of tungsten lamps will be significantly affected with the degree of voltage fluctuation which can occur on mains voltage supplies. For example, a 10-volt drop in a 240-volt supply at the lamp socket reduces the colour temperature by about 50°K., and the light output by about 15 per cent. For critical work it is thus necessary to check the voltage while the lamps are

being run and if it is less than the specified voltage, to make use of light balancing filters as described on page 43. One approach to the problem, if voltage fluctuations are a frequent occurrence, is to operate lamps via a suitable variable resistance, by which the voltage can be maintained at the level of the minimum voltage fluctuation. In this way the light balancing filter appropriate to the lower colour temperature can be left permanently over the lens. Where only a small wattage lamp is used (as in an enlarger), it is simpler to use a constant voltage regulator.

Tungsten-halogen lighting units

Tungsten-halogen lamps for photographic lighting are mostly of tubular shape with external electrodes suitable only for use in special lighting units which also embody reflectors. Though primarily of interest to cine photographers, their high-efficiency and portability can be equally useful to the still photographer working outside the studio. These lamps are available for operating at colour temperatures of 3,200 or 3,400°K.

These lamps are designed for operation at fixed voltages. A flood lamp (Class P4) which operates at a normal voltage of 120, giving a colour temperature of 2,850°K., can be operated when required at 185 volts to give a colour temperature of 3,400°K.

Photoflood lamps Class P1, 3,400°K

Type of lamp	Ref.	Volts	Watts	Nominal lumens	Base	Average life (hours)
Photoflood	P1/1	240/250	275	8,300	B.C. B22d or E.S. E27s	3
Photoflood Reflector	P1/2	240/250	500	15,000	as above	6
Photoflood	P1/6	240/250	375	13,000*	as above	4

Photoflood lamps, Class P2, 3,200°K

Photoflood	P2/1	115	500	12,500	E.S. E27s	100
Photoflood Reflector	P2/1	240/250	500	11,000	as above	100
Photoflood Reflector	P2/4	115	500	7,200*	as above	20
Photoflood Reflector	P2/4	240/250	500	7,200*	as above	12
Photo Spot Reflector	P2/5	115	500	12,000	as above	20
Photo Spot	P2/5	240/250	500	12,000*	as above	12

*Light output measured in Centre Beam Candles

Fluorescent lamps

These lamps, which usually take the form of long tubes, provide a highly efficient and relatively cool source of illumination suitable to covering large areas with soft uniform lighting. Basically, this type of lamp is a low-pressure mercury vapour discharge tube generating ultra-violet radiation, and contains phosphors which convert ultra-violet to visible light having an almost continuous spectrum. Such lamps are available in a variety of colour qualities, and for general illumination in large stores, etc., may be used in two different colours to give a more pleasing quality of lighting. The variety known as 'daylight' is a fairly close match to daylight and gives acceptable results with a daylight type colour film. Being a cool light source, the fluorescent lamp provides a very suitable illumination for viewing large transparencies.

Flash light sources

The light emitted by burning a quantity of magnesium powder was used for photography as far back as 1870 and is still occasionally used by some professional photographers. However for the majority of photographers, flash photography represents the use of flashbulbs, which have long taken the place of flash powder. Over the last two decades enormous strides have also been made in the development of electronic flash units, and although initially more costly, many photographers now make use of them. These two sources of light, although both labelled 'flash', have quite different characteristics.

Flashbulbs

The flashbulb is a logical development of the use of flash powder. The combustible material is enclosed in a glass envelope containing oxygen and is ignited by means of a small electric filament. The combustible material most commonly used is finely shredded aluminium which emits a light of about 3,800°K. Small bulbs now make use of zirconium which emits more light and gives a colour temperature of 4,200°K. Flashbulbs having a colour temperature equivalent to daylight (5,500°K.) are made by coating the glass envelope with blue dye which acts as a conversion filter.

Flashbulbs are available in a range of sizes which differ chiefly in light output, the smallest bulbs having an output of 7,500 lumen-seconds and the largest an output of nearly 100,000 lumen-seconds. Some idea of the enormous intensity produced by flashbulbs will be gained from the following comparison with other light sources in terms of luminous flux:

Standard candle	12·5 lumens
100-watt lamp	1,200 ,,
275-watt photoflood	8,000 ,,	
Small flashbulb	1,000,000 ,,

Flashbulbs also differ in respect of their burning characteristics. The smaller bulbs, usually classified as 'M', deliver their total light in about 25 millisec. (1/40 sec.) with a delay from the moment of electrical contact of about 15 millisec.

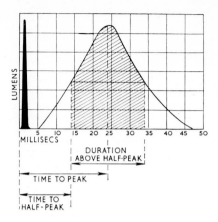

Fig. 3.16. Light output curve of a typical Class M flashbulb. The steep curve shown in black represents electronic flash.

before reaching a useful light output. A typical burning curve is given in Fig. 3.16 where the intensity is plotted against the time in millisec. A second class, known as 'F.P.', has an extended and uniform burning period of about 40 millisec. for use with a camera having a focal plane shutter of the type that employs a variable slit for the faster speeds. Thus although the effective exposure time of the shutter may be only 1/200 sec., the time taken for the slit to move across the film is around 1/30 sec. A third type, known as type 'S' (slow burning), gives an even more extended burning period for large focal plane cameras.

The light emitted by a flashbulb may be utilised in two different ways. Firstly it may be used on the basis of 'open' flash whereby the camera shutter is opened manually, the bulb is then fired and the shutter closed manually. While this method makes use of the total light output of the bulb, it places severe limitations on the use of flashbulbs. The second method is based on the use of a mechanically synchronized shutter in which the release is combined with electrical contacts for firing the bulb. With simple cameras having a single instantaneous shutter giving an exposure time of about 1/40 sec., the contacts of the flash circuit are closed at the same time as the shutter is released, the duration of the exposure being sufficient to make use of most of the light emitted by the bulb. With shutters having a range of times which include speeds shorter than 1/30 sec., an additional setting is provided which takes into account the delay of 15 millisec. before the flash reaches its peak output. The two positions of the synchronising lever are indicated by the letters 'X' (shutter speeds of 1/30 or longer) and 'M' (shutter speeds shorter than 1/30 sec.). The subject of flash synchronisation is dealt with more fully in the chapter on flash photography, page 123.

In the normal way flashbulbs require the use of a holder which provides a reflector for the bulb and contains a small battery and condenser for supplying the electricity needed to fire the bulb. The large professional bulbs are fitted with a screw cap to enable them to be fitted to standard tungsten lamp reflector units and may be operated with full mains voltage. Small flashbulbs are also

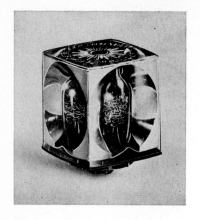

FIG. 3.17. Flashcube containing four bulbs each with its own reflector. It was designed for use with the Instamatic camera, which incorporates a socket which revolves through 90° when the film is advanced. The battery for firing the flash is also housed in the camera.

available in the form of flash cubes which contain four bulbs each set against its own reflector, see Fig. 3.17. These have been developed for use with cameras which incorporate the equivalent of a flash holder.

Electronic flash

This is basically a discharge tube filled with xenon gas and supplied with electricity stored in a condenser, the flash being triggered off by means of a current which ionises the gas. The output of the flash in watt-seconds or joules depends primarily on the voltage and the capacity of the condenser, but its efficiency as a light source will also depend on the design of the reflector. The gas xenon has been chosen as it gives a continuous spectrum approaching the quality of sunlight plus light from a blue sky.

The duration of the flash is very short and may range from 1/500 sec. to as short as 1/100,000 sec. depending on the characteristics of the unit. However, most portable units give a flash duration of between 1/500 to 1/1,000 sec. Synchronisation with a diaphragm camera shutter presents no particular problem as the tube emits the flash immediately the contacts are closed and has a duration shorter than the shortest speed given by the shutter. Synchronisation with a focal plane shutter is limited to exposure times in which the whole of the film is exposed at one time, see page 124.

Electronic flash units may range in size and output from very small units of pocketable dimensions and giving an output of about 30 watt-sec. to large studio units with a capacity of 1,000 or more watt-sec. which consist of a power-pack from which several flash tubes may be operated at one time.

On the average, a flash tube is capable of delivering several thousand flashes before it needs to be renewed and may thus be far more economical than flash-bulbs to anyone making considerable use of flash. The power packs for generating and storing the electricity may be operated from dry batteries, accumulators or directly from a mains supply.

Practical aspects in using electronic flash are dealt with in Chapter 8.

FIG. 3.18. A small electronic flash unit which is easily carried in the pocket. It is extremely useful for fill-in and also for close-ups.

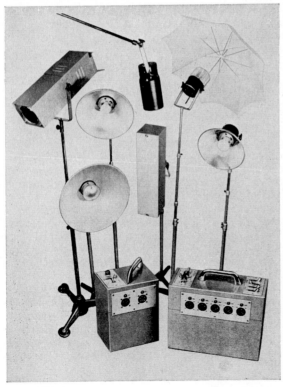

FIG. 3.19. The Multilec Electronic Flash provides a comprehensive and highly versatile lighting system for professional use.

CHAPTER 4

Lighting Problems in Colour Photography

One of the major problems of colour photography is that the eye readily adapts itself to changes in the colour of the prevailing illumination so that it continues to appear colourless or 'white' in relation to the colours and neutral tones of objects being viewed. If there is more than one source of illumination and these differ in colour quality, the eye also adapts itself to some intermediate value thus tending to minimise the difference between the two sources. Another characteristic is that known as colour constancy whereby our memory of familiar colours as seen in daylight causes us to identify these colours (see them as constants) even under lighting conditions which substantially modify their appearance.

These and other characteristics of visual perception are considerably less responsive to a colour photograph unless it is viewed under conditions in which it can almost be taken for the original scene. This occurs when the photograph is viewed so that it occupies almost the whole of the visual field, since the eye is then able to adapt itself to the colour rendering of the photograph. This applies also to the viewing of a projected image or a colour print which is strongly illuminated in comparison with its surroundings. Even so, the degree of adaptation does not equal that achieved when viewing an actual scene. In viewing a succession of projected photographs, visual adaptation only holds good if they are reasonably well-matched in colour rendering. However, quite small differences will be detected if the subject matter is similar, since the eye will have adapted itself to the previous picture and will require a few seconds to re-adapt itself. These and other aspects of the presentation and viewing of photographs are dealt with in the final chapter of this book.

This lack of adaptation to a colour photograph makes it necessary to achieve a kind of standard colour rendering which corresponds to the normal daylight adaptation of the eye. For this and other reasons, the majority of colour films are sensitised or balanced to give their best colour rendering in daylight—daylight being represented by clear sunny conditions with the sun well above the horizon. As the colour sensitivity of the film may be regarded as constant, other conditions of daylight and any kind of artificial lighting which differs in colour quality from that of 'ideal' daylight will, of necessity, yield a different colour rendering. The extent to which this may be acceptable depends on viewing conditions, the nature of the subject, and to some extent, the intention of the photographer, but if the same colour rendering is to be obtained, some form of filtration will be necessary or, if it is available, a colour film which has a colour sensitivity more nearly

approaching the type of lighting to be used. In 'practice the sensitising of a colour film has to be based on the most likely sources of illumination to be used. With some types of colour film only a daylight version is available. This applies to negative type colour films since changes in the colour rendering can be made at the printing stage. However, with certain reversal type films an alternative version is available which is balanced for lighting from a tungsten filament lamp run at a colour temperature of 3,200°K. There still exists one film—Kodachrome II, Type A—which is balanced for photoflood lamps (3,400°K.), and one film—Agfacolor CK 20—which is balanced for 3,100°K. At one time certain reversal colour films were available which were balanced for clear flashbulbs, but with the increasing availability of blue-tinted bulbs and electronic flash, both of which correspond very closely to daylight, these have been discontinued.

Other factors which may affect colour rendering

While the variation in the quality of illumination is the principal cause for differences in colour rendering, there are a number of other factors which should be borne in mind. In the interests of standardisation, many of these can be avoided.

Brand of film: considerable variation may be found with exposures made under the same conditions between various brands of the same type of colour film. For this reason it is advisable to keep to a particular brand of colour film which gives acceptable colour rendering under normal working conditions. The lighting conditions, whether in the studio or outdoors, may be determined by the nature of the subject, i.e. portraits, commercial products, copying and so on, in the studio, fashion, reporting and pictorial photography outdoors.

Batch-to-batch variation: the film manufacturer naturally endeavours to produce a standard product and variations in fresh stock are normally quite small. In some cases where the film is likely to be used under exacting professional conditions which require comparative results, departures from the standard product may be indicated in a special leaflet packed with the film.

Age and storage: colour films are liable to more rapid deterioration if stored at temperatures above 70°F. and under high humidity. Ideally, films should be stored in a dry atmosphere at temperatures lower than 55°F. However, film characteristics can be stabilised for an indefinite period at temperatures below freezing. Films are date-stamped to indicate the period over which, if properly stored, they can be expected to give consistent results. When a considerable volume of work is envisaged, it is worth obtaining an adequate supply of film of the same emulsion number.

Exposure: considerable variation in colour rendering and speed may be encountered if the exposure time differs a great deal from the normal. Thus daylight type films are usually adjusted for an exposure time of 1/100 sec. and a time of 1 second or longer may produce different colour rendering. Films intended for artificial light are adjusted for longer exposure times within the range 1/10 to 1 sec., but times in excess of 5 sec. may give rise to a change in colour balance.

This effect is known as reciprocity failure, see page 81. For critical work it is therefore advisable to select a level of lighting which permits 'normal' exposure times.

Processing: this calls for accurate standardisation since variations in the time of development, its temperature and degree of exhaustion can effect both the speed and colour balance. Unfortunately even the processing undertaken by professional laboratories is not always beyond reproach and this must be accepted as one of the unpredictable hazards of colour photography. A number of films are suitable for consumer processing and if this is carried out with care, highly consistent results may be obtained. Exposed films should be processed as soon as possible, but if extended delays are unavoidable, the films should be stored at low temperature.

Printing: this applies to the use of colour negative films. Even assuming a 'perfect' colour negative has been produced, it is possible to obtain widely different colour rendering in the print depending on the amount of individual treatment it has received. Under mass-produced conditions, reprints will often be found to have a substantially different colour rendering.

Viewing conditions: this applies more to colour prints than transparencies since the latter are normally viewed by projection with roughly the same kind of illumination and under conditions which favour colour adaptation. However, a print which has been colour-balanced to appear correct in artificial lighting will probably appear too blue in daylight. If viewing conditions are known, the print should be made for these conditions.

Exposure and lighting contrast

The exposure latitude that exists with black-and-white negative materials, see page 22, whereby negatives of different density levels can be made to give satisfactory prints, also exists, but to a more limited extent, with colour negative films. However, whereas the former may amount to as much as 8 stops, the latter would barely exceed 3 stops. With reversal colour films the situation is very different. The exposure made in the camera determines the overall density of the image (assuming standard processing) and if transparencies are to be viewed together, as for example over an illuminated panel or as a series of projected slides, the exposure must be correct to within $\frac{1}{2}$ stop if reasonable uniformity is to be obtained. However, whereas over-exposure with a negative material produces denser negatives (still printable but requiring longer exposure times), over-exposure with a reversal film produces a thin image, lacking in colour saturation, even with only 1 stop in excess of the 'correct' exposure. Still further exposure merely produces a 'ghost' image. Under-exposure of 1 stop will produce a denser image with increased colour saturation, but still further under-exposure will normally result in loss of detail and colour in the darker areas of the subject.

This restricted exposure latitude also makes it desirable to avoid strong lighting contrasts. Areas strongly illuminated will become desaturated, while areas in shadow excessively dense. Such lighting may, of course, be used for special effects, as in shots taken against the light and certain kinds of portrait, but when it is desired to obtain good overall colour rendering in both the lighter and darker

tones of the subject, the lighting contrast should rarely exceed a ratio of 2:1. Indeed with subjects having a wide brightness range almost flat lighting may be needed to retain the full range of tone and colour. It is for this reason that indirect lighting such as 'bounced' flash has proved so popular among colour photographers working indoors and that a lightly overcast sky is often preferred to unobscured sunlight.

From what we have just said, it will be obvious that considerable care is needed in estimating the correct exposure. Except when exposing under constant levels of illumination for which the correct exposure has already been determined by practice, a good exposure meter must be regarded as indispensable to avoid waste of material and time. Even so, there are occasions when the best exposure can only be achieved by making three exposures; one based on the meter recommendation, plus one at ½ stop more and one at ½ stop less. Various methods of using an exposure meter are dealt with in Chapter 5, page 74.

Colour saturation

Mention has already been made of the effect of exposure on the colour saturation of the image, moderate degrees of under-exposure giving a high saturation. This increase can be valuable if the transparency is to be used for photomechanical production or is to be used to make direct duplicates using a reversal type of duplicating film. It is worth noting that the reverse is true of the eye: the more brightly a colour is illuminated, the more saturated it will appear. This has a bearing on the use of colour filters and coloured lighting for special effects, see page 212.

Considerable variation in colour saturation can be observed at different intensity levels. The same colours will appear much more brilliant in full sunlight than they do at twilight and become almost 'colourless' under such low levels as moonlight. This is a characteristic of vision. However, photographs correctly exposed for the three levels of illumination would show roughly the same colour saturation. Thus, natural twilight and moonlight effects are impossible except by some kind of trickery, see page 53.

However, even at the same intensity level a colour surface lit by strongly directional light will appear more saturated than when lit with diffused light. This is explained by the fact that some of the diffused light is reflected back unchanged or as white light no matter what angle the surface is viewed thus 'diluting' the coloured light reflected by the pigment. With directional light the unchanged part will be reflected at an angle equal to the angle of incidence and at other angles the coloured reflected light will appear more saturated. This explains the more vivid colours obtained in sunlight as compared with those obtained with an overcast sky.

For a similar reason the colour of a polished, lacquered or wet surface will appear more saturated in colour than a matt or rough surface, see page 156.

The use of a polarizing filter over the camera lens may result in a substantial increase in colour saturation by the partial or complete elimination of surface reflections. It will often show a marked improvement in the greens of foliage by reducing bluish surface reflections of skylight. In a region of the sky at right-angles to a line between the camera and sun, light from the sky is strongly

polarized and can thus be rendered in various tones of blue according to the orientation of a polarizing filter placed in front of the lens. These and other effects such as the control of reflections from glass and water can be observed by holding the polarizing filter in front of one eye while at the same time revolving it between thumb and forefinger. Light reflected from surfaces of a non-metallic character is strongly polarized at an angle of about 34° with decreasing amounts at greater or lesser angles. At right-angles there is no polarization and a single polarizing filter serves no useful purpose in copying subjects such as oil paintings. However, if the subject is lit with polarized light by placing a polarizing screen in front of the light source, a polarizing filter in front of the lens can be orientared to a position where all surface refledtions are eliminated. This holds good also for metallic surfaces, see page 167, Fig. 11.12. Colour saturation may, indeed, be increased by an amount which becomes unnatural, see page 188.

Colour saturation and contrast may also be affected by the lens. Most lenses are now coated to reduce air-to-glass surface reflections. A non-coated lens having several air-to-glass surfaces used for landscapes may give somewhat bluish results due to the spread of skylight into the darker tones of the subject. At the same time there is loss of colour saturation and contrast. A similar effect could arise from the use of a dirty lens whether it is coated or not.

Choice of lighting

If the aim of the photographer is to obtain consistent results based on the best possible colour rendering, it is preferable to restrict exposures to illumination which is constant in colour quality such as that of clear sunlight (with the sun at least 40° above the horizon), flash, whether from bulbs or electronic discharge tubes, or voltage controlled high efficiency tungsten lamps. At the same time, it is worth noting that many pleasing and outstanding colour photographs are the results of non-standard lighting which has given false colour rendering which nevertheless 'happens' to suit the subject or enhance its pictorial value. This can be equally true of certain kinds of daylight—sunsets and sunrises are notable examples—as for various forms of artificial lighting. The 'creative' photographer may thus become more interested in avoiding 'ideal' lighting conditions with the intention of adding mood or atmosphere to his photographs.

However, while it is possible to make use of almost any form of lighting in black-and-white photography, since it is concerned only with tonal or brightness differences, the same freedom is far from being practical in colour photography in terms of achieving worthwhile results. For this reason it is worth considering the suitability of various kinds of light sources for colour photography.

Daylight

General characteristics of daylight have already been discussed in Chapter 3 and we need here only deal with aspects of special interest to the colour photographer.

On a clear day, daylight should be regarded as two sources of light consisting of strongly directional sunlight and highly diffused light from the sky. In an open

locality the sun is the main light source and determines the direction of shadows, though some light from the sky will also be combined with the sunlight. It is for this mixture of sunlight and sky light that daylight type colour films are sensitised to give their best colour rendering. Light from the sky may also be regarded as a supplementary source which illuminates the shadows. The intensity ratio between the two sources may be as high as 7:1 with noonday sun with a deep blue sky—a lighting ratio which is normally much in excess of that desirable for satisfactory colour rendering in both the highlights and shadows. The existence of strong haze gives a much reduced ratio and is often regarded as the ideal lighting for outdoor portraits. The ratio also becomes less as the sun approaches the horizon but at the same time sunlight becomes yellower, a change which is more apparent in a colour photograph than it is to the eye. In fact with the sun at from 10 to 15 degrees from the horizon 'normal' colour rendering can be obtained by using a film balanced for tungsten lighting or by using a blue filter, such as the Wratten 80B, with a daylight film.

Under a blue sky, shadows cast by the sun on light areas such as snow and white-washed walls may appear strongly blue in a photograph. One should, of course, expect them to appear blue since they are illuminated by bluish light, but in an actual scene we tend to see them as grey. Under certain atmospheric conditions, notably after a heavy fall of rain, and also at altitudes above 6,000 ft., a blue cast may be evident in tones which should appear neutral. This can be attributed to a higher than normal amount of ultra-violet radiation, which although invisible to the eye, will affect the blue-sensitive layer of a colour film. Subjects photographed in open shade under a strongly blue sky will also show a blue colour cast. This is less evident when the photograph is viewed under conditions which favour colour adaptation.

In all the above cases satisfactory 'correction' of excessive blue can usually be obtained by using a filter such as the Wratten 1A in front of the lens. This filter is also useful to give a somewhat 'warmer' colour rendering of scenes taken under a heavily overcast sky. Stronger 'blue' correction can be applied with the Wratten 81 series, see page 43.

The presence of a cloud layer acts as a strong diffusing medium to sunlight so that it becomes a single, multi-directional light source. There are no shadows, though, with only a very thin cloud layer, one part of the key will be brighter depending on the position of the sun. With diffused lighting the colour saturation will be reduced, but with some colour films, the effect can be very pleasing and is often regarded as ideal for outdoor portraits and fashion modelling.

Electronic flash

The general characteristics of this form of lighting are described in Chapter 8 page 121. As a light source for colour photography it offers a number of advantages. Firstly it provides a light of constant colour composition which closely matches that of daylight. It is therefore suitable as a fill-in for shadows cast by sunlight and equally suitable as the main light source for exposures with daylight type colour films. Thus if electronic flash is used for studio and other indoor work only daylight type colour film need be used, and both indoor and outdoor work can be combined on the same film.

A new electronic flash unit may be found to give slightly bluish colour rendering, but this is easily corrected by using a Wratten 1A or Wratten 81A filter over the lens.

Professional units with outputs for several lamps and provided with a pilot lighting system are extremely satisfactory for all forms of portraiture on account of the brief duration of the exposure (1/500 to 1/1,000 sec.) which avoids both camera and subject movement, and also on account of their low emission of heat and absence of dazzle up to the moment of exposure. The pilot lights are usually of low enough intensity to avoid dazzle yet provide sufficient intensity for positioning the lamps and to ensuring that the pupils of the eye are of normal dimensions. Flash exposures made in a dimly lit room suffer from the disadvantage that the pupils may be too widely open.

Electronic flash is particularly suitable for close-up photography of flowers and small animals and even a small portable unit will permit the small lens apertures which are needed to obtain sufficient depth of field.

Flashbulbs

Blue-tinted flashbulbs offer similar advantages to those of electronic flash though the effective exposure time, based on the burning characteristics of the bulb, is much longer being in the order of 1/40 sec. for small bulbs. Shorter exposures can be made with a synchronised shutter, see page 123. Clear flashbulbs may be used to expose colour films balanced for tungsten lamps using a filter such as the Wratten 81A.

High-efficiency tungsten lamps

Various types have been developed for colour photography the most recent being iodine vapour lamps, see page 53. These lamps fall into two groups: those intended to be run at a colour temperature of 3,400°K., such as the photoflood, Photolita and some iodine vapour lamps, and others, such as photopearl and colour-controlled projection lamps as well as iodine vapour lamps designed to give lighting of 3,200°K. However, both groups of lamps require accurate voltage control if they are to give their specified output and colour temperature.

For accurate work such as copying, duplicating and printing where the total wattage is not likely to be high, the most satisfactory method is to use an automatic voltage regulator. A less expensive alternative, if only occasional use is made of tungsten lamps, is to obtain lamps of lower voltage than that nominally available from the supply and to operate them via a rheostat using a voltmeter to check the voltage reaching the lamps. For less critical work it may be sufficient to restrict photography to periods when the mains voltage supply is not being subject to peak loads. A voltmeter can be used to check the voltage.

Photoflood lamps offer a further problem arising from their comparatively short life. After being used for about half their rated life they begin to blacken and this results in decreasing intensity and colour temperature. It is for this reason that iodine vapour lamps have been developed, the iodine acting as a kind of cleaning agent throughout the life of the lamp, see page 53.

Other disadvantages include the heat generated by tungsten lamps, which can

become excessive in a small studio. This may also prove excessive if a coloured celluloid filter or a polarizing screen is to be used in front of the lamp. Tungsten lighting of a sufficiently high level for portraiture tends to be dazzling to the eyes. If a number of different light sources are to be used, i.e., flood lamps and spotlights, it may be found that the latter differ in colour quality owing to the absorption characteristics of the fresnel lens.

Fluorescent lamps

These have been developed for visual illumination and have largely replaced tungsten filament lamps when large areas such as stores, factories and public buildings are involved. They are made in a variety of colour qualities ranging from pink to bluish 'daylight'. As they do not have a perfectly continuous spectrum their effect on colour films is not always predictable. Recommendations for the use of correction filters are published by some film manufacturers for use. on occasions when photography of interiors is made with this form of lighting. Because of their low emission of heat, fluorescent lamps of 'warm' daylight quality are very suitable for use in viewing panels designed for colour transparencies.

Reflected lighting

An occasional and usually unsuspected cause of non-standard colour rendering may arise from light reflected from non-neutral surfaces in the vicinity of the subject. The effect is often apparent in shadow areas which may rely chiefly on the ambient reflected light for illumination. The use of bounced flash in rooms having coloured walls may similarly give rise to colour distortions. Where the reflecting surface is partly seen in the photograph, the effect may well be acceptable even to the extent of adding interest to the picture. Usually the untrained eye does not notice the colour of shadows, but tends to accept them as a neutral grey.

CHAPTER 5
Assessment of Exposure

Much of the success of any lighting arrangement depends on the accuracy of the exposure. The same is also true of photography under existing or 'available' lighting conditions. Although a considerable latitude in exposure exists when exposing black-and-white materials and there is also some latitude with colour negative films, it is a grave mistake to adopt a technique which relies on the existence of exposure latitude to take care of approximations and guesses in assessing the exposure. In practice this becomes more apparent to a photographer who undertakes his own processing and printing, than to one who is concerned only with the exposure of negatives and leaves the printing to an expert.

In spite of the many aids and automatic devices for arriving at the best exposure, errors in exposure still account for a considerable waste of time and material and, in many cases, loss of quality in prints and transparencies. This is mainly because the conditions for obtaining a correctly exposed negative or transparency are either not properly understood or not taken seriously enough.

It is useful to return for a moment to the characteristic curve of a photographic material, p. 23, and to note that while a negative material may be capable of recording a very wide range of brightnesses, a printing material has a much more limited range, as also that of a reversal colour film. Both materials are, in fact, only capable of doing justice to a subject having little more than the brightness range of the average subject. Should the subject, therefore, contain highlights and shadows exceeding those of the average subject, there will be no exposure capable of producing an equivalent tone range in a print or transparency. Experienced photographers bear this limitation in mind and use all practical means of adjusting the brightness range to suit the particular photographic processing they are employing. Where this is not possible, it becomes a case of deciding what part of the subject brightness range is more important and then to adjust the exposure so as to obtain the best results of this part. In some cases, particularly when exposing reversal colour film, it becomes necessary to make three or more exposures at different levels, since the best photographic effect is not always predictable.

If 'difficult' lighting conditions can be anticipated, it is advantageous to make use of a film having a long exposure scale and uniform gradation, rather than one having a 'thin' emulsion and finer grain. If the maximum speed of a fast film is not needed when making exposures with strong lighting contrast, development to a lower gamma or contrast would be useful, giving somewhat fuller exposures

68

to allow for a reduction in the speed of the film. Occasionally the photographer must rely on his own or someone else's skill in printing a 'difficult' negative, and it must be admitted that a really skilled printer can often perform miracles with what many would discard as an impossible negative.

However, the assessment of exposure is not always dictated by the requirements of good tone reproduction. Photography is not exclusively a recording medium. In skilled hands it can become an art in the sense of interpreting and symbolising reality. Thus an exposure may be deliberately falsified in a technical sense with the object of eliminating certain tones or achieving some other effect. Indeed, it is not uncommon for an amateur photographer, even a novice, to produce a 'masterpiece' under interesting lighting conditions, resulting from an inspired guess or lucky miscalculation of the technically correct exposure.

Exposure of negative materials

It has already been pointed out, p. 24, that a printing paper will give the best tonal reproduction from a negative which makes use of part of the toe region of the characteristic curve. Such an exposure also represents very nearly the minimum acceptable exposure and thus exploits the maximum speed of the negative material. With photography employing small format cameras there are distinct advantages in working on the basis of the minimum satisfactory exposure. Thin negatives tend to be less grainy and also sharper since they suffer less from the scattering of light in the camera and irradiation of light in the emulsion. They are easier to print since the enlarged image is more brilliant than that from a denser negative and also requires less printing exposure time. By exploiting the maximum sensitivity of the film, it is often possible to make use of a slower film and thus obtain the advantage of finer grain. Alternatively, shorter exposure times can be used to minimise possible camera shake or movement of the subject, or smaller apertures to obtain greater depth of field.

At one time it was the practice of film manufacturers to include a safety factor in the speed numbers given for particular films. However, the widespread use of miniature format negatives, even among professionals, coupled with the advantages quoted above has led to the adoption of more realistic speed numbers much nearer the 'ideal minimum'.

The disadvantage of working to the maximum film speed is that it allows no latitude for under-exposure. That is to say, there is a risk of losing shadow detail. This is no problem when lighting conditions can be standardised or when an accurate assessment of the exposure can be made with a reliable exposure meter. When lighting conditions are abnormal, or the assessment of exposure involves some guesswork, it is always worth-while to make a series of three or more exposures at different levels, see p. 82.

At one time the golden rule for exposing a negative material was 'Expose for the shadows', the principle being, no doubt, that the highlights would find a place in the higher density range of the material. However, if the shadows happen to be very dark in relation to the highlights, the negative may present a density scale considerably in excess of the tonal capacity of the printing paper. In all probability such a negative would be printed with much more attention to the highlights than the shadows, unless it happens to be the case where local printing

exposure control can be applied, see p. 218. Thus in the normal way such a negative represents unnecessary over-exposure for the medium and lighter tones of the subject. But the rule is basically sound if we add 'Expose for the shadows *in which detail is required*', and in this case it is very often necessary to use some means such as a fill-in light or a reflector to increase the luminosity of the shadows in order to obtain a satisfactory negative, see Fig. 5.1. Present-day speed numbers for black-and-white materials allow for reasonably dense shadows when using an exposure meter for a normal reflected light reading, see page 75. However, when a particular film is used for the first time, it is useful to make a series of test exposures for a range of different subjects based on an already established technique for using an exposure meter. In this way it is possible to determine a 'speed number' which meets one's own requirements.

Exposure of colour negative films

Very much the same approach as for black-and-white films applies to colour negative films. However, it is important to bear in mind their more restricted exposure latitude, and even more so the need to control the lighting contrast, in view of the fact that colour printing papers are normally only available in one contrast grade. Although local exposure control is feasible in colour printing, it tends to be a far more complex operation.

Exposure of reversal films

The reversal process yields a direct positive image from the film exposed in the camera. The chemistry of the process has already been dealt with on page 33, and it is only necessary to note here that it is a highly standardised process which offers no control over the density, contrast and colour balance of the transparency. These are determined by the nature of the exposure given in the camera. It is true that certain colour reversal films can be given increased speed by increasing the time of the first development, but this is a characteristic which must be taken into account at the time of exposure. Unlike the negative/positive process, there is thus no possibility of adjusting the exposure of the 'reversal' positive image to correct over- or under-exposure. This means, in effect, that for subjects of average and more than average brightness range, there is virtually no exposure latitude.

In a transparency intended for viewing by projection or in front of an illuminated panel, it is normally desirable that the true highlights of the subject be reproduced as clear film which means the total absence of any dye image. That is to say, the criterion for exposure is the opposite of that for a negative film. Speed numbers for reversal films are therefore based on an exposure which will give acceptable tones and colours to the lighter brightnesses of the subject. This means that shadow detail will be recorded only in so far as it falls within the exposure scale of the film, otherwise it will be lost in the deepest density of which the film is capable. As we have seen, page 62, reversal films have a much more restricted exposure scale than that of the average negative film and can be more logically compared with a normal grade of printing paper.

The dense shadows which arise from contrasty lighting, as for example, strong sunlight, are rarely acceptable in a colour photograph. Exceptions include the

FIG. 5.1. Subjects in the shade against a sunlit background which usually require some degree of fill-in. This can be done with a reflector or with a small flash unit mounted on the camera.

deliberate use of foliage or an archway in deep shadow as a 'frame' silhouette to a distant view, the photography of sunrises and sunsets where some degree of under-exposure is necessary to obtain good colour saturation in the sky, thus rendering the foreground as little more than a silhouette, the shots taken against the light where the effect required is rather that of highlight and shadow than the rendering of colour. Thus for general photography, where good colour reproduction is required, lighting contrast must be far more limited than is generally permissible with black-and-white photography. For this reason manufacturers of colour films are wont to stress the advantages of frontal lighting. However, in practice some lighting contrast is desirable and can be extremely effective even at a ratio as low as $1\frac{1}{2}$:1, see page 62.

When the subject brightness range is below the average, as frequently happens with flat lighting as used for copying or diffused lighting such as bounced flash, the assessment of the correct exposure presents a somewhat different problem. It is now possible to give a series of exposures over a range of up to 3 stops on occasions which present increasing density and colour saturation. The exposure which renders the brightest areas of the subject as clear film is unlikely to give

the best transparency in terms of colour saturation. One of the problems in colour photography is that, while the vividness of colours to the eye increases with the intensity of the illumination, colour saturation in a colour photograph increases up to a certain limit with decreasing exposure. Thus if the intention of the photographer is to obtain the best colour saturation, a transparency which has received 1 or 2 stops less than that exposed for the highlights would probably be correct.

What is considered the best transparency in terms of overall density and colour saturation will also depend on the projection conditions. if it is intended for viewing in this way. If the screen brilliance is low, a thin transparency may be preferred, whereas the same transparency would appear 'washed' out or over-exposed with considerably higher screen brightness. The solution to this problem usually lies in making additional exposures, at say, 1 and 2 stops less than the normal highlight exposure. This procedure is still more important if transparencies of the same subject are required not only for projection, but also for photo-mechanical reproduction or for making reversal prints. Both the last two processes call for transparencies having good overall colour saturation to the extent of appearing somewhat under-exposed when viewed under ordinary projection conditions.

Visual and photographic sensitivity

The visual response to brightnesses covers a range exceeding a 1,000,000:1, that is to say, from brightnesses too dazzling to look at to those which can be perceived after full dark accommodation. This adjustment to different intensity levels is made unconsciously, chiefly by a process in which the sensitivity of the retina of the eye accommodates itself to the prevailing illumination, and to some extent by changes in the diameter of the pupil. For this reason the eye is not a reliable guide to brightness level. Thus two subjects, one observed outdoors in full daylight and the other indoors with normal artificial lighting, may seem to be equally well illuminated, though in fact, the former could be more than 200 times as bright, and thus require an exposure 200 times less.

The film, on the other hand, has a constant sensitivity range. If this is to be properly utilised, it must receive roughly the same amount of exposure or light action no matter how the brightness level of the subject varies. As we have seen, the exposure is the product of the intensity and time of exposure, see page 16, and differences in the brightness level of different subjects could therefore be equalised by appropriate differences in the time of the exposure. This, in fact, is one of the ways by which the photographer can control the exposure. However, the majority of cameras provide a second means of control, namely that of the lens diaphragm. By a series of 'stops' the intensity of the image transmitted by the lens may be varied by as much as 500:1 (f/2 to f/32). Yet another method of exposure control is that of placing a neutral density filter in front of the lens to reduce the intensity of the light before it reaches the lens. This method is useful when it is desired to use the lens at a large aperture to restrict the depth of field and a shorter exposure time is either undesirable or impossible with the shutter available.

The sensitivity of films intended for use in a camera is commonly indicated

by a speed number intended as a guide to exposures made with the aid of an exposure meter. However, film sensitivity may also be classified by such terms as slow, medium or high speed, and may also be considered in terms of the actual exposure needed for an average subject under given lighting conditions.

While speed numbers give a useful guide to the sensitivity of a film under certain conditions, they are by no means infallible. A great many factors may affect the results of a specific exposure. These include the spectral quality of the illumination, the age of the film, the composition of the developer and conditions of development, reciprocity failure, the method by which an exposure meter is used to measure the exposure, inaccuracies in the calibration of the shutter, etc., see page 74.

Exposure control by constant brightness level

One of the approaches to the problem of exposure is that of working to a constant brightness level. This can be achieved with artificial light sources used in a studio by lighting the set to a given brightness, based either on measurements of a standard brightness, such as a grey card, see page 77, or on an exposure guide number system which can be applied both to tungsten lamps and flash units. In this case the exposure can be regarded as a constant except for small variations to allow overall differences in the tone of the subject. That is to say, a subject of predominantly dark tones will require up to 1 stop more exposure, while one of light tones up to 1 stop less exposure. At the same time such a system allows control of the lighting contrast so as to keep the printing quality of the negative within the capacity of a given printing material.

The use of a constant brightness level is generally applied to copying and documentary photography, but can be applied advantageously to routine portraiture and catalogue photography. For any given studio, flashbulbs or electronic flash units used on the basis of indirect lighting, that is, bounced off walls and ceiling or large reflector boards, also represent a method of achieving constant brightness level which can be particularly valuable in colour portraiture and fashion photography.

Outdoor photography restricted to sunny conditions during the period two hours after sunrise and two hours before sunset with the sun behind the camera also provides a constant brightness level for the exposure of reversal colour film. This largely explains the enormous success of colour photography among novices and others who have few pretensions to the technicalities of exposure. Once the camera has been correctly set for a given film, all exposures made with the sun behind the camera will be satisfactorily exposed.

Exposure for different brightness levels

However, the photographer who wishes to operate under all kinds of lighting conditions will encounter widely different brightness levels. Daylight itself is a very variable light source, changing both with the altitude of the sun and the weather conditions. It becomes even more variable when it is partly obscured by adjacent buildings, trees, etc., or with interiors illuminated with daylight

coming through the windows. Artificial lighting can present equally great differences in brightness level depending on the nature of the light source, its distance from the subject, the nature of the lamp reflector, and whether used as direct or indirect lighting.

Various aids exist for determining the required exposure. These may take the form of tables or calculators based on various classifications of lighting, subject tone, distance and wattage of lamps, angle of lighting, etc., or of devices for measuring the illumination either in the form of exposure meters and photometers or light-sensitive cells incorporated in the camera which automatically set the exposure for any given film speed setting. Many experienced photographers are able to judge exposure requirements on the basis of previous results, especially if they make regular use of a particular film and processing technique. Finally, there is the possibility of relying on trial and error exposures, usually in the form of a series of exposures at different levels and based on a rough estimate of the most likely exposure.

Exposure tables and calculators

An exposure table for daylight photography in the open can be a remarkably reliable guide when used with reasonable care. Exposure guides of this kind are always included in the instructions packed with films intended for use in a camera. Daylight is usually classified under such headings as, 'Bright Sun', 'Hazy Sun', 'Cloudy Bright' and 'Cloudy Dull'. each successive heading calling for an increase of 1 stop or a doubling of the exposure time. Additional recommendations include allowances for light or dark subjects and for side- or back-lighting.

Exposure calculators based on a similar classification, usually include adjustments for film speed and filter factors.

Similar tables and calculators are available for exposures with photoflood lamps and give the lens aperture for different lamp-to-subject distances.

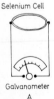
Selenium Cell

Galvanometer
A

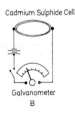
Cadmium Sulphide Cell

Galvanometer
B

FIG. 5.2. Circuit diagrams of photo-electric exposure meters. The selenium cell (A) produces electric current directly as the result of light action, while the cadmium sulphide cell (B) acts as a variable resistor under the action of light thus causing a variation in the flow of current from a small battery.

Measuring the illumination

Exposure guides of the kind mentioned above are for the most part limited to the more straightforward variations of illumination. A far more comprehensive aid to exposure is that provided by a light-sensitive meter incorporating either a selenium cell or a cadmium sulphide cell. The former produces a current of electricity under light action which can be measured with a microammeter, see Fig. 5.2-A, while the latter acts as a variable resistor under the action of light, the

FIG. 5.3. The Weston Master exposure meter provides two ranges of sensitivity covering a total brightness range of more than 1:32,000. An accessory 'invercone' enables the meter to be used for taking incident light readings.

changes in the flow of current from a small battery giving an indication of changes in the intensity of the light, see Fig. 5.2-B. Of the two systems, the selenium cell is still the more commonly used, but the Cd S cell offers greater sensitivity in measuring low intensities.

The exposure meter may take the form of a separate instrument in which the readings shown on a calibrated scale are converted into exposures by means of a calculator which also provides for adjustments for the speed of the film. In some cases the meter is built into the camera and provides an exposure value which can be applied to the lens-shutter unit, the meter itself still being independent of the shutter mechanism. An intermediate stage to the fully automatic control of the shutter by means of a light cell, consists in utilising the deflection of a pointer seen in the viewfinder as an aid to setting the shutter to the required exposure value. Semi- and fully-automatic exposure control is confined to miniature cameras and is chiefly valuable in action photography where the time required for taking measurements with an independent exposure meter may prove a serious disadvantage. However, for studio photography a separate exposure meter is far more satisfactory.

Measurement of reflected light

For average subjects, that is, scenes which give a brightness range in the camera of roughly 32:1, a measurement of the light reflected from the subject gives a

FIG. 5.4. A Weston exposure meter is shown being used to take a reflected light reading from the jumper of the model. Readings such as these, from various parts of the subject will give a guide to the brightness contrast.

close indication of the exposure provided the exposure meter is in good working order, and the speed setting used for the film is correct. It works on the basis that the light and dark areas of the subject are roughly complementary and hence the integrated reflected light under a given intensity of illumination is roughly the same for all average subjects. If the intensity of light falling on the subject is doubled, the reflected light is doubled, and so on.

However, this method of using an exposure meter tends to produce errors when the brightnesses of the subject are unevenly distributed, that is, present a much larger area of bright tones than dark tones or vice versa. This situation is often aggravated by the fact that the exposure meter accepts or takes in a much wider angle of reflected light than the lens of the camera. In outdoor photography such an error commonly arises from the fact that the exposure meter is unduly influenced by the light coming from the sky and thus gives a reading considerably higher than that which would be obtained by an average subject under the same lighting conditions but which includes no sky area. The error will be greater with an overcast sky or if the direction of photography is towards the brightest part of the sky. It is for this reason that reflected light readings of scenes which include the sky should be made with the meter tilted downwards so as to exclude most of the sky area. Errors will also arise if the object being photographed is taken against a dark background which presents a much larger

area than that of the object. In this case the reading will be unduly low and will indicate a much bigger exposure than is necessary. If the background were changed to one of very light tones, a much higher reading would be obtained and the exposure indicated much less.

Errors of this sort commonly arise in working with a camera having a built-in meter of the semi- or fully-automatic kind, as the response of the meter will be determined by the direction in which the lens is pointed. This could well include too much sky. However, recent developments in automatic exposure control, to be found in the more costly cameras, have done much to eliminate the possibility of such errors by employing two or more photo cells which take into account both the reflected and the incident light.

Returning to the use of an independent reflected light meter, the problem of obtaining a representative reading of subjects set against a very dark or light background or which are too small to allow for a satisfactory reading, can usually be solved by directing the meter towards an area having a similar brightness range, or which corresponds to an 'average' subject.

Grey card readings

Probably the most satisfactory method of using a reflected light exposure meter is that of measuring the light reflected from a grey card having a reflectance of

Fig. 5.5. The reading is being taken off a white card. This represents a highlight reading and must be reduced by just over 2 stops for a subject of average tone range. If a grey card having a reflectance of 18 per cent is used, the exposure indicated by the meter can then be taken as suitable for an average subject.

18 per cent of the incident light. Such a reflectance represents the integrated reflected light from an average subject. A grey card designed for this purpose is marketed by Kodak under the name Neutral Test Card and is particularly recommended for exposing colour film. It measures 8 × 10 in. and has a matt grey surface on one side with a reflectance of 18 per cent and a matt white surface on the other with a reflectance of 90 per cent.

When making a measurement with the grey card it is placed immediately in front of the subject with the surface facing half-way between the main light and the lens of the camera. The reading should be made from a distance of about 6 in. taking care to avoid shadows, which may be cast by the meter or hand, from falling on the card and thus affecting the reading. When it is not possible to place the card immediately in front of the subject, it can be held at the required angle under identical lighting conditions when making the reading.

The readings made from a grey card are, in effect, incident light measurements, see below, and take no account of differences in the overall tones of a subject. Thus for a subject having predominantly light tones, the indicated exposure should be decreased from $\frac{1}{2}$ to 1 stop, while for one of predominantly dark tones an increase of $\frac{1}{2}$ to 1 stop should be given.

White card readings

In the absence of a grey card, or if the illumination is not sufficient to give a satisfactory deflection of the exposure meter needle when using a grey card, a white surface can be used. As this reflects roughly 5 times as much light as the grey surface, it is necessary to increase the exposure indicated by 5 times, or to set the exposure meter as an ASA exposure index of 1/5, that is, the recommended index is divided by 5. While the Kodak Neutral Test Card provides an accurate reflectance of 90 per cent on its white side, in practice almost any white surface will serve the purpose, so long as it has a matt surface. It should be noted that if a shiny surface is used there is a danger of including specular reflections in the light falling on the meter window and thus obtaining a false reading.

In the studio white card readings can be useful for checking the distribution of light over different areas of the subject, as well as for checking the lighting contrast. If uniform illumination is required, the lighting must be adjusted so that all readings with the white card are the same. To check the lighting contrast, a reading is first made with the white card held near the subject and facing the main light at an angle which gives the maximum reading. All lights should be on except those positioned so far to one side or behind the subject that they might influence the meter directly. To measure the fill-in light, the card should face the camera with the main light switched off.

Incident light readings

An alternative method of assessing the exposure is to measure the intensity of the principal light falling on the subject, that is to say, the incident light. Exposure meters designed for this purpose are provided with some kind of diffuser which is placed over the light-sensitive cell of the meter. In some cases the diffuser takes the form of a cone or hemisphere with the object of integrating

the incident light over a wide angle, see Fig. 5.6. The reading is made by pointing the meter towards the camera from the position of the subject, though when operating indoors it is sufficient to hold the meter in line with the subject and camera and facing in the opposite direction to the lens.

With an exposure meter fitted with a flat diffuser, readings made under conditions of side- or back-lighting may prove unreliable since they take little or no account of the main lighting. A more satisfactory result will be obtained by making two readings, one as described above and the second with the meter facing the main light. A mean position of the needle is then used to calculate the exposure.

As with the use of a grey or white card, an incident light reading is unaffected by any overall brightness difference in the subject, that is, for predominantly

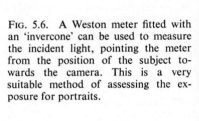

FIG. 5.6. A Weston meter fitted with an 'invercone' can be used to measure the incident light, pointing the meter from the position of the subject towards the camera. This is a very suitable method of assessing the exposure for portraits.

light- or dark-toned subjects. It is thus necessary to make allowance for this on the basis already suggested when using a reflected reading from a grey card, see page 78.

Checking an exposure meter

It should never be assumed that an exposure meter, even a new one, is an infallible instrument. As with all sensitive instruments it should be treated as fragile, care being taken to avoid severe jolts which may damage the needle suspension. Most meters are provided with a zero adjuster for the needle, and as a preliminary check, it should be ascertained that the needle is pointing at zero when the cell window is completely screened from light. A useful test with a new meter is to take a series of readings of a number of average outdoor subjects which

receive mainly frontal illumination from the sun when it is unobscured by haze and well above the horizon. The meter should be set to the speed number of a film which is commonly in use and the exposure recommendations of the meter compared with those given in the instruction leaflet supplied with the film for similar conditions of lighting. If there is a notable difference—1 stop or more— it can be assumed that the meter is at fault and it should be returned to the shop for adjustment.

Variations in shutter speeds

A further source of error, which may be mistakenly attributed to an exposure meter, is that the shutter of the camera may give considerable deviations from the time settings given on the scale. This is more likely to occur for the very short times—1/250 and 1/500 sec.—and the longer times, $\frac{1}{2}$ and 1 sec. Occasionally the performance of a shutter will change with big temperature changes, giving one set of speeds at high temperature and another at very low temperatures.

The accuracy of a shutter which is suspect can be checked by making a series of equivalent exposures at different combinations of f/number and shutter speed. For example a method of checking the slower speeds would be to give exposures of 1 sec. at f/22, $\frac{1}{2}$ sec. at f/16, $\frac{1}{4}$ sec. at f/11 and so on. Any noticeable difference between the resulting negatives or transparencies will indicate a deviation of the shutter. If it is not practical to have the shutter adjusted, allowance must be made when using the speed settings at fault.

Allowance for lens extensions

The value of the f/numbers engraved on the lens mount applies only when the lens is focused for objects at distance greater than about 10 times the focal length. When focused for objects at closer distances, the amount by which the lens must be extended causes a reduction in the intensity of the image for any given f/number. The f/numbers engraved on the lens mount represent transmission values based on the focal length of the lens and thus no longer apply when the lens-to-film distance is increased. In this circumstance, the effective f/number can be found with the following calculation:

$$\text{Effective f/number} = \frac{\text{focal length} + \text{extension}}{\text{focal length}} \times \text{nominal f/number}$$

For example a lens of 6 in. focal length is used at an extension of 3 in. at a nominal aperture of f/8. The effective f/number thus becomes,

$$\frac{6 + 3}{6} \times 8 = f/12$$

This does not apply to close-up photography done with the aid of a supplementary positive lens since the effect is that of shortening the focal length to avoid the need of a lens extension. However, if the supplementary lens is used

to shorten the focal length when photographing objects at normal distances, and this is only possible with a bellows camera, the effective f/number becomes greater than the nominal f/number. For example if a 2-diopter supplementary lens is used with an 8 in. lens, the combination results in a lens of approximately $5\frac{1}{2}$ in. The effective f/number then becomes

$$\frac{5\frac{1}{2}}{8} \times f/8 = f/5\cdot5$$

Filter factors

The use of correction and contrast filters in black-and-white photography, and of light-balancing filters in colour photography generally calls for some increase in the exposure. Such an increase is referred to as a filter factor, and for any given filter will vary according to the colour sensitivity of the film and the spectral quality of the illumination. Where exact data are not available, the filter factor for any given set of conditions can be found by making a series of exposures at $\frac{1}{2}$-stop intervals.

The use of a polarizing filter over the lens calls for a basic increase in exposure of 1 to $1\frac{1}{2}$ stops. However, in some cases the elimination of reflections is equivalent to reducing the intensity of the highlights and may require a further increase to obtain acceptable results. A typical example is the use of a polarizing filter to eliminate reflections from the surface of polished wood with the object of revealing grain. If the wood is of dark tone the additional increase would be in the region of $1-1\frac{1}{2}$ stops, thus making a total factor of 2-3 stops.

Reciprocity failure

The nature of reciprocity failure has already been dealt with in an earlier chapter (page 34). Its effect in black-and-white photography is usually that of a loss of speed, though in some cases it may involve some loss of contrast, With colour films the loss of speed is often accompanied with a change in colour balance, so that when exposing reversal colour film, it may be necessary to take into account the further increase of exposure required when using a particular light-balancing or colour compensating filter.

While some exposure data relating to reciprocity failure are issued by film manufacturers for particular films, it is frequently necessary for the photographer himself to establish the exposure increase needed for a particular set-up by making a series of exposures. These can be based on increases in the time of exposure on the basis of a factor of 2. A rough guide to the behaviour of black-and-white film can be taken from the following table.

Nominal exposure time	Factor to allow for reciprocity failure
1/1,000 to 1 sec.	no increase
2 to 5 ,,	$\times 1\frac{1}{2}$
6 to 15 ,,	$\times 2$
16 to 30 ,,	$\times 3$
30 to 60 ,,	$\times 4$

In practice it is frequently possible to avoid the problem of reciprocity failure by increasing the intensity of the illumination or by using a faster material or a combination of both. One of the advantages of using electronic flash is that the time of exposure is constant. As it produces no significant heat, very high intensities can be achieved for photomacrography by using the lamp at close distances, see page 198.

Film speed

The speed numbers issued with films are valid for a certain range of exposure times and specified development. We have already dealt with the former aspect under the heading of reciprocity failure (page 81), and reference to the standard development for assessing film speed has been made on page 21.

From a practical point of view, the developing instructions given by the manufacturer of a film can be assumed to correspond to standard development. However, many developers designed to give an image of finer grain cause a reduction in film speed which may vary from the equivalent of a $\frac{1}{2}$—2 stops increase of exposure. Some indication of any exposure increase needed is normally included in the instructions packed with special fine-grain developers.

With most standard developers some increase in the effective film speed will be obtained with increased development time and is usually accompanied with an increase in the gamma or contrast of the film. The amount of speed increase varies with the emulsion and composition of the developes and it is usually necessary for the photographer himself to determine the useful increase. Obviously, such an expedient would only be applied under poor lighting conditions, but in practice could amount to increasing the speed number by as much as 4 times.

A substantial increase in speed can be achieved with certain reversal colour films—notably Kodak Ektachrome-X and High Speed Ektachrome—by increasing the development time of the first developer. Thus in the case of the films quoted, an increase of 3 min. will double the speed and an increase of 6 min. quadruple the speed.

The use of any non-standard development which will affect the film speed must be taken into account at the time of assessing the exposure. For example, it would be most inadvisable to decide to use a fine-grain developer for a film which has been exposed on the basis of the published speed number since it may well result in under-exposed negatives.

Finally, it should be noted that the film speed published for a given film assumes that it has been reasonably well stored and is exposed within the period limited by the expiry date printed on the film carton. It further assumes that the film is processed within a reasonably short period after exposure. This is particularly important with colour films.

Bracketed exposures

It occasionally happens that an accurate assessment of the exposure, even with the possession of a highly sensitive exposure meter, is impossible owing to the nature of the lighting or because some special effect is desired. In addition there

may be occasions when a particular exposure meter is not sensitive enough or has been inadvertently omitted from the gadget bag. On all such occasions it becomes desirable to make a series of exposures of the subject in question which are calculated to cover the correct or best exposure as the case may be. An exposure series of this kind is often referred to as bracketed exposures.

The range of the exposures will depend on the circumstances. Where the correct exposure is reasonably certain, two additional exposures at ½-stop greater and ½-stop less than the assessed exposure are usually sufficient. Where there is greater uncertainty, the difference in the exposures can be based on 1 stop or if the effect sought depends on a very small difference in exposure, at ½-stop intervals, making five exposures in all. Where considerable uncertainty exists, five bracketed exposures at 1 stop intervals will usually be sufficient.

The method of applying the bracketed exposures can be based either on differences in time, differences in lens diaphragm or a combination of the two, depending on the particular circumstances. If the range of time exposures comes within the effects of reciprocity failure, it will be necessary to make allowances either by using greater time intervals or by extending the range of exposures.

Bracketed exposures are particularly useful when exposing reversal colour film under abnormal lighting conditions or when particular effects are sought in terms of colour saturation. The results often provide variations which may all be acceptable in terms of projection and thus involve no waste of film.

An exposure log book

The possession of an exposure meter may make the keeping of an exposure log seem superfluous. This is far from being true. As already indicated in the previous section, there are frequent occasions in general photography where the best result depends on an exact exposure under lighting conditions which may be unfavourable to the use of an exposure meter. In such cases details of the exposure found to give the best results from a series of exposures, will save both time and material on some future occasion.

If an exposure log is to be fully effective, the data must be recorded at the time of photography and not left as a mental record against the time that the actual results can be assessed.

A personal exposure log can be a valuable asset to the general purpose photographer: it can include exposure data for particular copying set-ups, for portraiture with bounced flash, and certain standard lighting arrangements in the studio. However, there is little point in recording details of every exposure. The majority of subjects can be satisfactorily tackled with a reliable exposure meter.

CHAPTER 6

Photography With Daylight

Daylight is a term which can be applied to an extremely variable range of lighting conditions originating from the sun. It can range from dazzling, overhead sunlight to the horizontal and yellowish rays of a rising or setting sun: it can vary in quality from strongly directional sunlight to the completely diffused light of an overcast sky: it can, in short, provide every nuance and trick of lighting imaginable and for this reason has long been the delight of the painter and photographer in search of interesting and dramatic effects. However, this gamut of lighting is far from being universal and is often of a fortuitous nature. It is a compound of geographic latitude, season, time of day, plus the effects of local weather and topography. Thus in some parts of the world, daylight is the passage of the sun across a clear blue sky and offers little by way of variety other than the change in altitude and direction of the sun's rays. In other places it may be represented mainly by the flat lighting coming from an almost continuously overcast sky. The most fortunate countries, in terms of variety, are those which experience a great deal of 'weather' in terms of haze, mist and variety of cloud. These can be ideal conditions for the photographer in search of pictorial landscapes or whose job is to produce scenic photographs (assuming he is not in too much of a hurry!).

But while daylight in some form or other is the only light source for landscape and scenic photography, it may be regarded as an alternative light source when the subject matter comes within the scope of artificial lighting. In this case it is usually regarded by the professional as a 'makeshift' light source or at best a 'natural' light source which requires some skill to imitate in the studio with artificial sources. In other words, if the required quality of daylight is available in the right place at the right time. it is obviously preferable to make use of it rather than create similar lighting in the studio. In some cases it is possible to modify existing daylight by the use of reflectors or diffusers and there are photographers who still prefer to work in a daylight studio in which a large area of window lighting can be modified according to taste by means of shutters, diffusing materials and so on. On the same count any room provided with one or more windows forms a potential daylight studio. In the field of photo-reporting, there has recently been a steady trend to make use of available lighting (which is usually some form of daylight) rather than to make use of flash. This is partly explained by the existence of faster emulsions and the increased availability of very wide aperture lenses, but it has also become fashionable to present people

Clear sky,

Strong haze,
midday.

Overcast sky,
mid morning.

Fig. 6.1. Three versions of
the same scene photo-
graphed under different
lighting conditions, but from
the same viewpoint.

85

Fig. 6.2. The same scene in a narrow street photographed with oblique sunlight and on a later occasion when the street was in total shade. The upper version gives a more interesting pictorial effect, and the lower version a more satisfactory record of the scene.

and situations in natural lighting even if the result is little more than a kind of photographic impressionism.

But there is another aspect of daylight to be considered, whether we make use of it or not as a photographic light source. As the predominant source of light for most of our waking hours, it establishes a number of conventions in the way we expect things to be illuminated. Thus the fact that there is only one sun in the sky means that we tend to accept as normal only one predominant light source and one set of shadows. Furthermore, as the sun is mostly well above the horizon, we are used to the main light coming from a point well above eye-level. To some extent similar standards apply to interiors lit with daylight coming through windows. This arises partly from the fact that it is an exterior light source and is thus of fixed direction in relation to the room which it illuminates. But there are other factors such as the softness and colour quality of northern window light and the kind of shadows or shadow areas it produces. However

we shall discuss these aspects more fully later in this chapter. In the meantime it is necessary to study the basic characteristics of daylight, beginning with the source itself, the sun.

Sunlight with a clear blue sky

Under these conditions daylight may be considered as two very different sources of light: the sun, a strongly directional light source that moves in an arc from one horizon to the other, and the blue sky, a diffused light source that reflects light from all directions of the hemisphere. From a visual point of view the two light sources may be considered as complementary, the sun being the directional source which gives modelling and depth, while the sky provides a general lighting for the shadow areas. The ratio of intensity between the two sources of light varies with changes in the atmosphere and also with the altitude of the sun. It is greatest when the atmosphere is very clear and the sun is at an altitude of 50° and more above the horizon. Under these conditions the intensity ratio may approach 8:1 and shadows will appear very dense. In a photograph taken under these conditions, the shadows may contain little or no detail. With increased amounts of haze in the atmosphere the sky, becomes more luminous (less blue), while the direct light from the sun becomes somewhat diffused. The intensity ratio becomes less and under conditions of strong haze may approach an intensity ratio of only 2 : 1. An average ratio can be taken as 4 : 1, this being represented by a moderately blue sky such as is common in northern latitudes.

The intensity ratio in relation to the sun's altitude is far more variable. As the sun approaches the horizon, the direct rays must pass through greater depths of atmosphere. With a clear atmosphere the intensity of the sun just above the horizon is only about 1/50 of its intensity when overhead. At the same time the sky continues to reflect a considerable amount of light thus tending to become very nearly equal in intensity. However, as the sun increases its altitude from

FIG. 6.3. Typical of the high contrast resulting from overhead sunlight. In this case the pavement reflected some light into the shadows, but a more acceptable result would have been obtained with fill-in flash.

87

Fig. 6.4. Sunlight, softened by a strong haze, provides ideal lighting for outdoor portraits in colour.

zero to about 20°, there is a rapid increase in its brightness, and this, coupled with the fact that all vertical surfaces facing the sun receive its light at something approaching an angle of maximum intensity, see page 46, the lighting ratio may be very high. This effect falls off rapidly with the presence of haze since the sky then reflects a much higher proportion of sunlight.

In colour photography the situation is complicated by a strong difference in the colour composition of the two kinds of light. With a clear atmosphere the sky will be a strong blue whereas the sunlight will be more or less yellow. Since the two colours are complementary, the difference is the more apparent and we may encounter a situation where the vertical surfaces receiving sunlight are strongly yellow while horizontal surfaces and areas in shadow become strongly blue. This is, of course, apparent visually but tends to be exaggerated in a colour photograph for reasons already explained on page 65. When the subject being photographed includes people or is, in fact, actual portraiture, it is usually desir-

able to apply some correction to the sunlight by way of filters or the use of a film balanced for artificial light, the object being to render the flesh tones as one would expect to see them. Since the filter used with a daylight type film will be bluish while a film balanced for artificial light has increased sensitivity to blue, the areas lit by the sky or which reflect skylight as in the case of water, will appear even more blue. But such a distortion is more acceptable than flesh tones which ppear to be somewhat yellowish.

The lighting ratio acceptable in outdoor photography depends very much on the nature of the subject. In a distant landscape even a contrast of 8 : 1 becomes acceptable with overhead sunlight since the shadows are relatively small. This becomes less so with low altitude sunlight, since the shadows formed by trees and hills become much greater and may assume greater importance. On the same grounds, a strong lighting ratio is usually unacceptable in photographs of built-up areas, moderate close-ups of everyday activities, fashion photography and portraiture, since the shadows will be far too dense and harsh. Certainly, the imaginative photographer may be able to extract interesting impressions from such lighting, but the results in unskilled hands are mostly unacceptable.

Strong sunlight has the further disadvantage in portraiture of being too dazzling to the eyes in terms of the light reflected from light-toned surfaces such as walls. pavements and a sandy beach. This results in the eyes being partly closed or screwed up.

It frequently happens that the lighting ratio is reduced in local areas by sunlight falling on adjacent surfaces being reflected on to shadow areas. If the reflecting surfaces are of a light tone and are large enough, the lighting contrast may be sufficiently low as to produce acceptable results in the photograph. Experienced photographers are always on the look out for such natural reflectors. The alternative is to employ an artificial reflector or to use a supplementary light source such as a flashbulb, to augment the illumination falling on the shadows, see page 98.

Hazy sunlight

The presence of a strong haze alters the characteristics of sunlight in several ways, for the most part, advantageous to the photographer. Firstly, the lighting ratio between direct sunlight and light from the sky becomes far more manageable reaching levels of 2 : 1 and even $1\frac{1}{2}$: 1 which are ideal for outdoor portraits. Secondly, shadows are much less dense and less clearly defined since the haze acts as a diffuser to the direct light. This characteristic, coupled with the fact that the sky assumes an almost white appearance, is less favourable to landscape photography which includes large areas of the sky. In black-and-white photography the sky will present a uniform white tone and the use of filters to darken the sky will have little effect. As we have already noted, strong shadows in landscape photography help to increase the depth and their absence tends to 'flatten' perspective. This is compensated to some extent by the effect of atmospheric perspective. whereby contrast is reduced with distance, see page 93. Thirdly, there is far less difference in colour quality between sunlight and skylight since the sky takes on the nature of a non-selective reflector of sunlight

FIG. 6.5. Portraits in the open under an overcast sky receive light mainly from overhead causing the eyes and lower surfaces of the face to be poorly lit. This is seen in the lefthand portrait. More acceptable and interesting lighting effects are obtained in restricted lighting conditions, such as light from a window or a narrow street.

This offers the advantage in colour photography of more acceptable colour rendering in shadow areas or with subjects photographed in open shade.

The presence of a strong haze reduces the intensity of sunlight to about half that of clear sunlight. This does not necessarily call for an increase in exposure when exposing negative materials since the shadows will normally be more luminous than with clear sunlight. Exposure meter readings may occasionally indicate a reduction in exposure. The lower contrast of hazy sunlight makes it an ideal lighting for photography in built-up areas and for photo-reporting.

Sunlight with broken cloud

The presence of cloud formations in the sky is chiefly of interest to the landscape photographer since they frequently combine the advantage of clear sunlight plus a means of adding interest to sky area included in the photograph. Indeed, the cloud formations frequently become the motive for taking a photograph. However, large areas of cloud occupying a position roughly facing the sun act as strong reflectors so that shadows in local areas may be far more luminous, and, for colour photography, more neutral in colour.

Broken dispersed cloud covering a large proportion of the sky often presents the problem of cloud shadows in landscape photography. If the atmosphere is free from haze, the contrast between directly lit areas and those covered by cloud shadow is usually excessive. This is aggravated in colour photography by a tendency for the cloud shadow to appear excessively blue. For this reason it is usually desirable to cover the lens of the camera with a very pale yellow filter or one specially designed for the purpose such as the Wratten 1A.

With a sky almost completely covered with cloud, the occasional gaps which permit direct sunlight, may present excellent opportunities to the leisurely landscape photographer to capture dramatic 'spotlight' effects. These can be especially effective when the direct sunlight has the nature of a back-light. Finally, it may be noted that for the photographer commissioned or wishing to obtain spectacular sunrise or sunset effects, cloud formations are the most important ingredient. The best combination is often that of a small bank of low-level nimbus plus high altitude circus.

Overcast sky

When the sky is completely covered with a layer of cloud, daylight takes the form of a single source of diffused light arriving from all parts of the sky. In the open, surfaces occupying a horizontal plane receive more illumination than those in a vertical plane, an effect which is usually displeasing in portraiture since the cavities of the eyes and the lower parts of the face take on a darker tone. Generally speaking, landscapes take on a dull lifeless appearance unless they contain very strong colours. The colour rendering of greens, browns and greys in a typical landscape tend to be degraded with a bluishness. Colour, generally, is less saturated with diffused light.

However, when the layer of cloud is thin enough to disclose the position of the sun so that one part of the sky is markedly brighter, conditions are very favourable for fashion and portrait photography in colour, as well as street scenes and other subjects where shadows are difficult to control. The quality of

FIG. 6.6. A lightly overcast sky gives a shadowless lighting which is usually more satisfactory for colour photography than black-and-white.

lighting is, in fact, very similar to bounced flash in a small room with white walls and ceiling.

Blue sky—open shade

Subjects in open shadow and lit with a large area of deep blue sky require the use of a pale yellow filter or Wratten 1A filter to obtain acceptable colour rendering. In other respects the lighting differs little from that of an overcast sky. With a hazy sky, in appearance very pale blue or almost white, the colour rendering may differ little from the normal.

Mist and fog

These consist of minute droplets of water suspended in the air which act as a diffusing medium to light. Their presence at ground level offers certain pictorial effects both in black-and-white and colour photography. The principal effect is that of reducing contrast, the magnitude of the reduction depending on the density of the mist or fog and the distance of the various components of the scene from the camera. Indeed the photographic effect is similar to the visual effect. The most interesting pictorial results are those obtained at night when the street lamps take on halos and sometimes give shafts of light where the rays are partly interrupted by projecting objects such as figures, trees and walls.

A light mist, early or late in the day, provides its most spectacular effects in a wooded area with the sun as a back-light. However, landscapes generally take on a delicacy of tone and depth of perspective in the presence of a very light mist. With a heavy mist or fog, the subject distance is much more restricted and the most effective use of such a condition lies in the play of contrast between the immediate foreground and objects at greater distances. With colour film it is usually desirable to include touches of strong colours such as orange or red.

Ultra-violet radiation

Before it enters the earth's atmosphere, sunlight is rich in ultra-violet radiation. which, although invisible to the eye, is strongly active to a photographic emulsion. At ground level, most of the ultra-violet light has been absorbed or scattered by the atmosphere and much of what remains is asborbed by the average camera lens. Nevertheless, there are certain conditions when the presence of ultra-violet radiation becomes an important factor in the tone and colour rendering of a photograph. The effect in black-and-white photography is to render certain tones too light and since ultra-violet, in common with the shorter wave-lengths of the colour spectrum (violet and blue), is more readily scattered by haze, to intensify the effect of haze in landscapes containing distant scenery. With colour film, ultra-violet radiation affects only the outer, blue-sensitive layer, since, although the other two layers are sensitive to it, they are protected with a yellow filter which absorbs blue, violet and ultra-violet. The effect is therefore to reduce the density of the yellow image so that haze or surfaces reflecting considerable amounts of ultra-violet appear excessively blue.

Ultra-violet is present in varying degrees at altitudes above 6000 ft. and also in regions near large stretches of water. It may also occur on a clear day after a heavy rain. The remedy in all cases is to use an ultra-violet absorbing filter, such as the

Wratten 1A, when shooting in colour. For black-and-white film it is frequently desirable to use a filter which also absorbs some of the blue light and no special consideration need be given to the ultra-violet.

Atmospheric perspective

An important factor in our perception of distance is that of aerial or atmospheric perspective whereby objects at increasing distances from the viewpoint become increasingly veiled by the greater depths of atmosphere through which the light must pass. The effect is to diminish contrast so that receding planes in a landscape take on increasingly lighter tones. In terms of colour, the veiling takes on a bluish appearance. Atmospheric perspective varies according to the degree of haze and the impression of distance is much stronger on a hazy day than a clear one. The effect on a familiar landscape may often be quite startling: on one day the hills may appear to be almost on top of us and the next day with a strong haze, to have receded many miles away. The effect of haze also varies with the direction of sunlight and is much stronger when the viewpoint is towards the light, see Fig. 6.7.

FIG. 6.7. Two photographs made from the same position, the first with the sun behind the camera and the second facing about towards the direction of light. The effect of haze is greater when facing the light.

The proper effect of atmospheric haze is obtained in a photograph only when it contains some features in the foreground of normal contrast to serve as a comparison to the diminished contrast of more distant planes. For this reason the results obtained when using a long-focus or telephoto lens may merely present a flat, low-contrast appearance rather than one of distance. In this case, it is usually preferable to discount the possible value of haze and either shoot on a very clear day or use a haze-cutting filter. When shooting with colour, the overall blue veiling can be reduced with a Wratten 1A filter and eliminated altogether by using a pale amber filter.

In black-and-white photography, atmospheric haze may be controlled by means of filters. Small reductions can be made with an ultra-violet absorbing filter and generally speaking such a filter is all that is needed to preserve the visual effect. Greater reductions are obtained with yellow, orange and red filters and the maximum reduction is obtained by using an infra-red sensitive film in combination with a deep-red filter. The effect of haze may be intensified by using a pale blue filter. However, the effectiveness of filters in the control of haze will be much less when the atmosphere contains industrial dust and smoke since these tend to absorb light of all wave-lengths.

FIG. 6.8. The upper version was made with a normal panchromatic film and the lower version, which reveals detail shrouded in mist, with an infra-red sensitive material using a deep red filter.

No filter.

Orange filter.

Fig. 6.9. The effect of a filter on the sky tones depends on the nature of the atmosphere. A clear, deep blue sky may record sufficiently without a filter, whereas one containing thin, vapoury cloud, as shown in the example, shows little effect even with an orange filter.

Tone control of blue sky

Closely associated with the control of haze is that of increasing the contrast between the tone of the sky and white surfaces of clouds, buildings, and other objects. Most modern black-and-white films are balanced to give 'natural' tone rendering, though in the presence of excessive ultra-violet radiation, blues tend to be rendered in lighter tones than that of their visual appearance. However, in practice a more acceptable contrast between an average blue sky and broken white clouds, etc., is obtained by using a medium yellow filter such as the Wratten No. 8. If there is considerable haze, giving the sky a whitish blue appearance, much stronger absorption of the blue will be required and a deep yellow or orange filter, such as the Wratten No. 15, will be needed to obtain the same contrast. The same filter

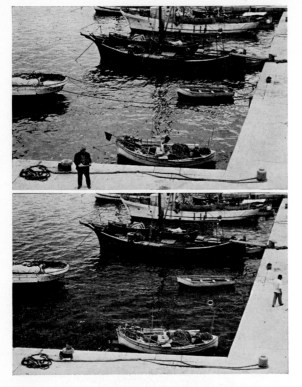

Fig. 6.10. Sky reflections from water are strongly polarized at an angle of about 34° with its surface and can be reduced by using a polarizing filter over the lens. This is often an advantage with colour photography as it can give more interesting colour to the water.

used with a very blue sky will give a very strong contrast. Still further contrast will be obtained with a red filter such as the Wratten No. 25 but, before using strong contrast filters, it is necessary to consider their effect on the tone rendering of other colours present in the subject. For example, a red contrast filter will render reds in lighter than normal tones, a tone-rendering which is usually unacceptable if people form the principal subject of the photograph. This is, perhaps, more important in portraits of women and children whose pink cheeks and red lips will tend to appear excessively light through a red filter. In this case, the darkening of a blue sky, which forms part of the background, may often be achieved by the use of a polarizing filter. Light from a blue sky is strongly polarized in the region at right-angles to a line between the sun and the camera, but in practice there is no need to calculate angles since the effectiveness of the polarizing filter on any part of the sky can be observed by holding the filter in front of one eye while at the same time rotating it backwards and forwards between thumb and forefinger. When the best effect has been located, it is usually possible to arrange the subject accordingly.

A polarizing filter offers the only means of darkening the tone of a blue sky

in colour photography. Its best effect can be judged visually as described above. Since it also reduces specular or surface reflections, see page 48, the darkening of the sky is usually accompanied by increased colour saturation in certain areas of the subject thereby increasing the overall colour contrast.

The effect of a polarizing filter varies with the amount of haze present in the atmosphere: the greatest effect is obtained with a very clear sky. Night effects in black-and-white photography can be obtained with a combination of a polarizing filter and a red filter. In this case a clear blue sky can be rendered as a black tone, see Fig. 6.11.

A polarizing filter is limited to conditions in which the sun gives either a top or side lighting and is completely non-effective when the sun assumes the position of a back-light. To some extent this applies also to the use of contrast filters in black-and-white photography since the scattering effect of haze is greatly increased.

With the exception of an ultra-violet absorbing filter, the use of filters demands some increase in exposure. This increase is usually indicated in the data supplied with the film and in many cases is engraved on the filter mount. However, the effectiveness of a filter may be partly lost through over-exposure and in some cases it may be preferable to give less increase than the amount recommended. Probably the best procedure is to give two additional exposures, one at $\frac{1}{2}$-stop less than the increase recommended and the second at 1 stop less. When no data is available, the series of test exposures should be extended in the manner indicated on page 82.

Local control of daylight

As we have already seen, daylight may present a number of problems to the photographer to do with lighting contrast, colour rendering, and direction of lighting. When the subject matter occupies a large area, the situation is either that

Fig. 6.11. The righthand part of the picture shows the combined effect of a red filter plus a polarizing filter. Under favourable conditions the sky can be recorded as black as at night.

97

of making the best of unsuitable conditions or of waiting for the most favourable lighting. However, when the subject matter involves a relatively small area, it is frequently possible to modify the existing lighting by the use of reflectors and/or supplementary lighting. With very small areas it is not only possible to change the direction of sunlight by use of a mirror, but to disregard the existence of daylight by using a light source which is effectively far more powerful than daylight, namely, electronic flash. However, we may begin by considering the use of reflectors.

Control of lighting contrast with reflectors

Reflectors, both natural and artificial, form a most valuable means of controlling the depth of shadows. All surfaces reflect some light, though for the purpose of lighting control only those having a high reflectance are of practical use. With colour photography, it is important to realise that reflected light will take on something of the colour of the reflecting surface. This can give rise to some rather unexpected results in the colour of shadow areas in a colour photograph, which will probably not have been observed at the time of photography and, if the reflecting surface is not included in the picture area, will appear unnatural. It is, perhaps interesting to note that the school of impressionistic painters presented some of the greatest innovations by their treatment of shadows. The 'classic' conception of shadows, based on the normal visual conception, is that they represent greyness or neutrality of colour. The impressionists either 'saw' or deduced that these areas are far more liable to colour change than those receiving strong lighting, and therefore depicted them in a colourful manner.

Among the most efficient of natural reflectors we may list the following. Areas of snow and white-washed walls: sand and rock faces of sandstone or chalk: concrete walls and paving stones. These are all fairly neutral in tone. Other strongly reflecting surfaces include colour-washed walls (common in the Mediterranean basin), awnings, and for small areas as in head-and-shoulder portraits, table-cloths, newspapers, books, and even light-coloured clothes. Where the reflecting surfaces are coloured, care must be taken to observe any effect they may have on the actual colours of the subject when shooting in colour.

The usefulness of natural reflectors depends very much on their location in relation to the subject. In outdoor portraiture, a location may be chosen because it provides ample reflected light: for figure and fashion work a courtyard with light walls, or a beach with high sand-dunes would be ideal locations. But with fixed subjects such as market stalls, partly in sunlight and partly in shadow, one adjacent to a white-washed wall which receives direct sunlight may be the only one worth photographing with colour film unless the photographer is equipped with a flash unit.

When the subject is relatively small, as in portraiture, flower studies, local craftwork and so on, an artificial reflector is far more satisfactory as it can be placed where it is most effective. A board of about 30 in. square will be sufficient and can be made to provide two different reflecting surfaces by painting one side a matt white and covering the other side with a sheet of matt or embossed aluminium foil. The white surface will reflect fully diffused light while the metaı

surface a blend of directional and diffused light, which will be effective at a much greater distance, see page 39. The board can be made more portable if it is hinged in the middle so that it can be folded.

The most convenient and effective use of a reflector is obtained when the photographer has an assistant who can hold and direct the reflector so as to obtain the best result. Generally speaking, the reflector should be positioned so that it throws light level with or slightly downwards on to the shadow region of the subject. If the photographer is working on his own, the reflector can be supported on a tripod by attaching a strong bull-dog clip to a ball-and-socket head. Alternatively, if the camera is to be supported on a tripod, a second tripod may be dispensed with by making the exposure by means of a long cable release, the photographer himself holding the reflector.

While the use of a reflector board is often dismissed on account of its bulkiness or because it limits the use of sunlight to certain angles, it offers the considerable advantage of preserving the effect of natural lighting more easily than with a supplementary light source such as flash. As a diffused light source it does not produce additional shadows and its effect can, of course, be seen, whereas it is always necessary to calculate the effect of flash.

FIG. 6.12. Two versions of a collection of shells photographed with late afternoon sunlight. The first shows the normal high contrast of the lighting and favours the shape and form of the shells rather than their colour. The second, using a small aluminium reflector as fill-in, gives a much lower contrast and makes a far better colour record of the shells.

Diffusing screens

Strong sunlight normally produces too high a lighting contrast and for this reason the ideal conditions for natural lighting occur when there is a strong haze which both diffuses direct sunlight and provides a much stronger fill-in from the sky. This effect can be obtained under conditions of strong sunlight by erecting a diffusing screen between the sun and the subject which is large enough to cover the area which will be included in the photograph. The screen can be of any diffusing material such as net, cheese cloth, translucent plastic, in one or more layers depending on the amount of diffusion required. If the subject area is fairly small, a frame-type diffuser of the kind described on page 116, will be light enough to be supported on a tripod provided with a strong clip. If a larger area is to be covered, the material may be stretched between two poles with sharpened points so that they can be easily stuck into soil or sand.

If only a small amount of diffusion is applied, it may still be necessary to employ a reflector for the shadows, but with strong diffusion the intensity of sunlight will be greatly reduced. A soft, only slightly directional lighting suitable for portraiture and still-life subjects can be readily created by constructing a muslim tent with bamboo supports—something after the style of a large fly protector but with one side open. This, of course, is only worth making if clear sunny weather is the normal rather than the exception. It can be used also for subjects which normally require a photographic tent in the studio, see page 163. On the same count, anyone having a sunny *terrazza* or balcony, will have the basis of a daylight studio by fitting it with a light canvas awning and some net curtains.

When introducing diffusion locally, as in portraiture, some account must be taken of the background contrast which may present something of an anomaly if it contains features in strong sunlight. This can be avoided by choosing a background in the shade or by throwing a strongly-lit background out of focus so that the highlights and shadows merge to give a much lower contrast.

Supplementary lighting

While there is something to be said for using a continuous source as a supplementary light to another continuous source on the grounds that the combined effect can be judged visually, the use of tungsten lamps with daylight presents certain problems. The first, of course, is the existence of a source of electricity of sufficient capacity for the lamp. The professional movie photographer on location will have the use of a powerful mobile generator capable of feeding a dozen or so high-wattage floods. Portable battery equipment using high-efficiency quartz-iodine lamps is available for the amateur movie photographer and can be put to equally good use by the still photographer as a fill-in lamp when used at fairly short distances. However, it is not suitable when shooting with colour unless covered with a correction filter (pale blue) so that it roughly matches the colour temperature of daylight. The second problem is that of achieving the required intensity of light with a lamp to be used even at a moderate distance from the subject. While a No. 2 photoflood lamp may appear to give a powerful intensity in a studio, owing to the fact that our vision is adapted to a much lower intensity, measurements made with a photo-electric exposure meter will reveal that the

illumination falling on a surface only 10 ft. away is only about 1/16 of that provided by strong sunlight.

However, the availability of small flashbulbs and electronic flash units, coupled with the fact that modern shutters are provided with flash synchronising contacts, makes the use of flash by far the better proposition, and few photographers would consider using anything else, whether by way of reflector boards, diffusing screens or tungsten lamps. Unfortunately, the ease by which a certain kind of fill-in can be obtained with the flash unit mounted on the camera, has led to a stereotyped style of portraiture in which the sun is used as a back-light and the flash provides the principal light source, see Fig. 6.13.

Flash as a fill-in light

The object of any fill-in light is to raise the level of illumination falling on the shadow areas of a subject so that they contain satisfactory detail and colour in a photograph. The amount of fill-in applied will depend on the effect desired and whether black-and-white or colour film is being used. If the latter, the amount of fill-in may be such as almost to equal the intensity of the main lighting. This presents no problems with continuous light sources, since the effect can either be judged visually or checked with an exposure meter. With flash it must be based on some kind of calculation or on the results of trial and error exposures. In the hands of the inexperienced and slap-dash worker, flash fill-in is something of a hit-and-miss operation and the results may vary from insufficient fill-in to excessive fill-in in which the flash becomes the main light. In the latter case it frequently gives rise to a second set of shadows suggesting, at times, that another sun has appeared in the heavens as a rival to the existing one!

The problem of predicting the effect of a particular flashbulb or electronic flash unit when its light is limited only to the shadow area of the subject is not a difficult one. It can be based on the guide number system in regard to the distance of the flash from the subject, but it is first necessary to establish a 'basic' outdoor guide number for the particular unit being used. This can be done by making a series of fill-in flash exposures of a typical subject on a clear sunny day so positioned that a substantial area of the subject is in the shadow. The flash unit, mounted on a tripod, is placed so that its light will fall on the shadow area. This, of course, requires the use of an adequate extension wire to permit the flash to be coupled with the camera shutter. Referring to the guide number known or recommended to be suitable for indoor photography in an average room, it can be assumed that the same guide number used outdoors would give about half of the effective illumination, since very little light arising from the flash will be reflected back from the surroundings, see page 127. If a flashbulb is being used, the guide number must be chosen according to the shutter speed, see page 124. The exposure set on the camera is based on a normal exposure meter reading or that known to be correct for sunlight. The nature of the subject will determine what combination of lens aperture and shutter speed are most appropriate, although the use of flash may require a different combination, as we shall see later. For the moment assume that the lens aperture has been set to f/4. and the guide number or flash factor is 40. It is now possible to predict that with the flash at a distance of 10 ft. from the

subject, the shadows will receive about half as much light as the sunlit areas or in other words we shall have established a lighting ratio of about 2 : 1. If we now make a series of exposures with the flash at distances of 5, 7, 10, 14 and 20 ft., we can be sure of covering the useful range of flash fill-in. The resulting photographs may well show excessive fill-in at 5 and 7 ft., with acceptable amounts at 10 and 14 ft. and little or no effect at 20 ft. Or it could be that a distance of 8 ft. gives the kind of fill-in required, but whatever the distance found to give the best result, this distance multiplied by the f/number being used for the test gives the basic guide number for fill-in purposes.

If it turns out that the basic number guide involves inconveniently long distances, the effectiveness of the flash can be reduced by placing a diffuser in front of the lamp. It has been found, for example, that a white handkerchief will reduce the light by about half. With some portable electronic flash units it is possible to set the power pack to 'half-flash' as well as setting the flash head to wide angle. Thus if set to half-flash and wide-angle the effective light is reduced to roughly a quarter of that given by full-flash and normal angle. When using a diaphragm shutter with electronic flash, the amount of fill-in can be controlled by the lens diaphragm if it is relatively unimportant what combination of aperture and exposure time is used. Since the duration of the flash is usually 1/500 sec. or less, the effect of the flash will be the same at all exposure times for a given aperture. Thus it is possible to adjust the exposure required for sunlight to a combination in which the aperture is chosen to suit the requirements of the fill-in flash, using either a longer or shorter exposure time as the case may require. This system can be used with advantage when the flash head is mounted on the camera and its distance from the subject is therefore determined by the subject area to be included in the photograph and the angle of the lens. For example with a basic guide number of 32, the aperture would be set to f/8 with a camera subject distance of 4 ft., and f/4 with a distance of 8 ft.

A rather similar method can be applied to flashbulbs on the basis of the exposure time. The full effect of a flashbulb is obtained at exposure times of 1/30 sec. or longer with the synchronisation set to 'X'. By using a shutter speed of 1/125 sec. and the lever set to 'M', the amount of light admitted by the shutter is only about half that of full flash, while at a shutter speed of 1/500 sec. it is only about a quarter.

However, neither method is likely to commend itself to a photographer who prefers to retain full control over the use of the lens diaphragm. If the flash must be mounted on the camera, as in photo-reporting, it is preferable and simpler to work within a zone of distances which will give acceptable fill-in.

The difficulty of calculating the effect of fill-in flash when certain areas of the subject receive both sunlight and an almost equivalent amount of light from the flash, induces many photographers to restrict its use to situations in which the sun becomes little more than a back-light and most of the subject is in shadow, this being illuminated by the flash used as a frontal light mounted on the camera. Anyone seriously interested in outdoor portraiture will have far greater control by the use of reflectors and diffusers.

The use of flash as the main light source for subjects outdoors is discussed in the chapter on flash, see page 198.

FIG. 6.13. The first example, made with the existing lighting, gives harsh shadows to the face. The second, with the correct amount of fill-in flash, preserves the effect of sunlight, while the third, with too much flash, gives an entirely false effect.

Restricted daylight outdoors

When large areas of the sky are obstructed by buildings, trees, cliffs, etc., daylight reaching the subject may create extremely high lighting contrasts and even light from an overcast sky, which in the open presents zero lighting contrast, may take on a directional nature in a narrow street of tall buildings or coming through an archway in cloisters or a roofed courtyard. Maximum contrast occurs when direct sunlight enters a narrow opening and falls on a subject which receives no direct light from other parts of the sky. While the eye is still able to accommodate itself to such a high contrast, it is well beyond the capacity of the photographic process.

There are two approaches to such lighting. One is the 'available' light approach and consists in making the best use of the existing lighting conditions, even if it results in a kind of silhouette interpretation of the subject. Occasionally such lighting may lend itself to a two-tone effect, any residual intermediate tones being eliminated in the printing process by using a high contrast printing paper. The second approach is to use a supplementary light source such as flash as a general fill-in light. Reflectors are rarely of any use, except for very small objects, owing to the restricted availability of sunlight.

The application of fill-in lighting needs some consideration. The most effective results are rarely the result of using a flash mounted on the camera. If there is an adjacent wall of light tone which, in less restricted conditions would act as a reflector to sunlight, it forms the ideal surface from which to use bounced flash. On other occasions it may be worth bouncing the flash off an artificial reflector which need consist of no more than a piece of white cloth held by an assistant. Or the flash may be concealed behind some part of the subject and used to light the background.

However, the increased contrast which can become an embarrassment when direct sunlight is involved, can be put to good advantage on an overcast day for outdoor portraits. The flat, predominantly overhead lighting on a dull day probably

represents the worst condition for portraiture, and since it can be all too common during the winter months, many photographers are inclined to consider outdoor portraiture as out of season. This is far from being the case as anyone who takes the trouble to study the work of 'available' light enthusiasts will realise. By making use of archways, overhanging roofs, passages and anything else that severely restricts the amount of direct skylight reaching the subject, a whole range of pleasing side- and back-lighting effects can be obtained.

The level of lighting will, of course, be considerably lower than that of open daylight, but this involves no more than using a fast film or even making use of a tripod. When using reversal colour film it is usually an advantage to place a Wratten 1A filter over the lens to offset the tendency towards a bluish colour rendering. The illustrations on pages 90 and 176 are typical of the results which can be obtained under restricted lighting conditions on a dull day.

Interiors lit with daylight

As with restricted daylight outdoors, the major problem of photographing interiors illuminated with daylight is that of excessive lighting contrast. This may reach very high ratios when a single window admits direct sunlight, but even when a single small window admits only diffused light from the sky, the contrast may still be excessive in terms of photography. When the object of photography is the interior itself—its walls, structure and the objects it contains—the problem is often more specifically that of excessively uneven illumination. It is under these conditions that visual adaptation and the characteristic known as brightness constancy are exercised most fully by the eye and very much to the disadvantage of the photographer who desires to produce a photograph having the same visual appearance. Even a room well provided with windows and which appears to be uniformly illuminated to the eye, proves far from being so in a 'straight' photograph, that is, a photograph that has received no local printing control by way of shading and dodging. Measurement with a sensitive photo-electric exposure meter taken from a white card will reveal to what extent the eye will minimise differences in the brightness of uniformly colour-washed walls in a room having a large window area along one wall. A brightness difference of 16 to 1 is not unusual if the room is fairly deep. In such circumstances the most satisfactory method of achieving the effect of uniform illumination in the photograph is to resort to artificial lighting applied in such a way as to simulate the soft almost shadowless light from a large area of window. This may often be achieved by 'bouncing' flash lighting from the ceiling and walls facing those which will be shown in the photograph. Alternatively, direct lighting, preferably well-diffused, may be applied by a number of lighting units until white-card measurements indicate that the overall illumination is uniform. Where very large areas are involved, the use of a single light source applied to successive areas during an appropriate time exposure can produce the desired effect, see page 132. If the area to be photographed includes actual windows, then the artificial lighting must be adjusted in brightness to match that of the window. In some cases the required effect can only be obtained by making two independent exposures on the same negative: that based on the artificial lighting, which is made during the hours of darkness, and a second exposure with daylight which is calculated to give the required tone rendering of the windows.

FIG. 6.14. Portrait exposed with light coming from a window. A large reflector was used to lighten the shadow area.

When the object of the photographer is to give a pictorial impression of an interior rather than a documentary record—and this is usually the case with churches and historical buildings—the exaggerated contrast obtained in a photograph is usually acceptable and often enhances the pictorial effect.

In black-and-white photography there are several ways of controlling contrast. Firstly, it is desirable to choose an emulsion of long gradation and to expose it on the basis of low contrast development using either a soft developer or reduced development time. If the negative still shows high overall contrast it may be possible to achieve the desired result by using a soft grade of printing paper. However, in many cases excessive contrast is of a local nature such as an area very near to a window which receives direct sunlight or a scene which includes a window or open doorway. In most cases these can be dealt with by local printing control. An excessively contrasty negative may also be made to yield an acceptable print by making a low contrast positive from it which is then used as a mask when making the print. The positive should be unsharp to avoid relief effects should the positive not be in exact register with the negative. As well as a means of controlling contrast, this technique will also increase the apparent sharpness of the print.

105

Daylight studio

Any room well provided with windows offers considerable scope for 'natural' portraits and still-life studies. If it happens to be an attic with a roof light, so much the better, as it can be used to provide top lighting. To be fully adaptable, the windows should have shutters or venetian blinds to enable them to be partly or fully closed. An ideal arrangement is to have a room with windows on three sides, all separately controlled with flaps that can be closed from the inside. The flaps should be painted matt white on the outer side as they then make valuable reflectors for collecting sunlight that happens to be entering obliquely and re-directing it as diffused light on to the subject. A window which normally receives direct sunlight can be converted into an excellent source of diffused light by covering it with one or more layers of net curtain. If the walls of the room are also painted white, any effect from strong directional light to total diffusion can be obtained. However, such a studio is more fitted to the 'artist' photographer who is not pressed for time and who prefers to avoid the technicalities of artificial light-ing. Among the subjects which lend themselves particularly to this kind of lighting are informal portraits, character studies of authors, painters, poets and children who can be made to feel more at ease in natural lighting, floral arrangements for calendars and Christmas cards, still-life compositions and artistic creations by way of sculptures whether of wood, stone or metal. Daylight which can be controlled in this way never gives the false effects which are all too common when using artificial light sources. It is capable of producing the finest gradations of brightness, a kind of modelling which blends with both the texture and colour of the subject.

However, it presents certain problems with reversal colourfilms since the colour rendering is determined by the colour quality of the illumination. If the light entering the windows is from a blue sky, a Wratten 1A filter over the lens may give all the correction needed. But it may happen that the light coming from one window is light reflected from an adjacent building and if this happened to be strongly coloured, then the reflected light will also be coloured, though perhaps not perceptibly to the eye. The same could apply to light which has partly filtered through the foliage of adjacent trees or which has been reflected upwards from a green lawn. On the other hand, sunlight, isolated from the surrounding blue sky, tends to give somewhat warmer colour rendering, an effect which increases at angles less than about 35° above the horizon. Thus the sunlight which penetrates a room has already reached a fairly low angle and will tend to give distinctly yellowish colour rendering in comparison from light coming from other windows. One remedy is to cover the 'sunny' window with a layer of very pale blue cello-phane, a material which is usually available at a stationer's. If net curtains are to be used for diffusion, a similar correction can be obtained by dyeing them a pale blue. Where the window sunlight forms the only source, a reflector being used to give any fill-in light required, the correction can be made with a pale blue filter over the lens.

The modern tendency in building to make large use of windows has greatly extended the possibility of making use of available daylight when it comes to photographing people at work. This, in turns, lends itself to more natural results and causes far less disturbance than when setting up artificial lighting.

CHAPTER 7

The Studio and its Lighting Equipment

While there has been a distinct trend in recent years among practising photographers to make use of 'natural' or 'available' lighting—a trend which is especially noticeable in the field of advertising—the photographic studio is still the ideal location for work requiring controlled lighting. Indeed it may be considered the photographer's special domain, a laboratory of lighting where any kind of lighting effect can be produced including 'natural' and 'available' lighting effects. Many such studios now exist since photography has come to play a vital rôle in modern society. Moreover, the photographer is no longer thought of as a seedy hack with his head covered by a black cloth as he peers at the focusing screen of some antiquated cabinet-made camera. He has become a kind of technical artist with cameras and lighting equipment costing thousands of pounds at his disposal.

However, the ideal studio remains a dream for a great many photographers and necessity often demands the use of restricted premises and makeshift lighting equipment. Such conditions do not preclude successful work, though they often make it more difficult and may also involve a compromise between what the photographer would like to achieve and what is practicable.

Dimensions of a studio

A studio may be thought of as an enclosed space from which all exterior lighting may be excluded. How large the space should be will depend on the kind of work to be carried out, but the photographer who is starting business will do well to consider future possibilities and obtain the largest space available or within his means. It can be a time-wasting and inconvenient operation to have to change to a larger studio at a later date.

A studio which is to be adequate for general photography, and under this heading we include fashion displays involving several figures, furniture arranged as in a normal room, kitchen equipment and catalogue work of large carpets, etc., should provide a clear floor space of about 50 × 30 ft. with a height of at least 15 ft. In considering the floor space, it is necessary to take into account not only the space occupied by the set and its background, but sufficient camera distance to avoid having to use wide-angle lenses, since in many cases these give exaggerated and unacceptable perspective. There must also be adequate working space behind the camera both for the positioning of lights and the comfort of the camera operator. A studio of half this floor space, i.e. 25 × 15 ft., would be adequate for portrait photography or the handling of small sets. For very small sets (of table top

dimensions) involving consumer products, close-up work generally, copying and documentary work, almost any normal-size room can serve as a studio. If back-projection is to be used, a long narrow room is preferable, though the projection distance may be reduced both by using a short focus lens and by inter-posing a mirror as indicated on page 203.

A studio should be a dry, well-ventilated room. Unless the photographer has a strong liking for daylight as a light source, windows are of importance only in respect of ventilation. Thus a dry basement which has sufficient height could be very suitable. Windows can either be fitted with light-proof curtains or permanently shuttered and fitted with air extractor fans. The walls and ceiling should be painted with white matt paint, since they will then serve as large reflecting surfaces either for indirect lighting effects as, for example, bounced flash, or a general fill-in by reflecting 'spill-light' from direct light sources. In addition, a large expanse of white wall may often serve as a background. The floor, whether of wood or concrete, is best covered with heavy linoleum or composite rubber material which can be easily cleaned and kept free of dust.

FIG. 7.1. A mirror used for make-up purposes should be surrounded with lamps so as to give the maximum light over all parts of the face.

Additional work rooms

The studio itself should be kept as unencumbered as possible and consideration should therefore be given to additional working space, as well as a storeroom for props and lighting equipment not in actual use. If the studio is to be used for portrait and fashion photography, a dressing and make-up room is essential. As well as the usual furniture, it should be provided with a large mirror for dressing and a make-up mirror provided with circular lighting as shown in Fig. 7.1. Washing and toilet facilities should lead off the dressing room.

A small loading room, which can also be used as a film and camera store, is indispensable. It must be completely light-proof and absolutely dry. Processing and printing, if undertaken by the photographer, will require two further rooms. Many photographers limit their activities in this respect to developing test negatives and making proof prints, the final finishing work being carried out by a commercial laboratory. This applies particularly to colour work which requires exacting control.

Electricity supply

Wherever electricity is used, either in the studio or elsewhere, good electrical practice cannot be ignored without risk of accident. There is a danger in loose

connections, frayed leads, over-loaded power lines, and risks should never be taken when the consequences can be serious.

There are two ways of bringing electricity to the studio. A series of extra power points may be installed at various intervals at near floor level along the walls. An end wall which may occasionally serve as a background should be left free. An alternative and perhaps more satisfactory arrangement is to have one or two main points sufficient to carry the total load of the maximum number of lamps to be used at any one time and to distribute the current by some form of mobile switchboard connected to one of the main points by a single cable which can be played out from a drum to the required length. The switchboard should contain enough sockets (each commanded by a separate switch) for the maximum number of lighting units which are likely to be needed for a particular set. It is an advantage to use fused plugs for each lighting unit so that if a particular lamp should burn out, causing a surge of current, only the one unit will be affected. When tungsten lamps are to be used for colour work, the switchboard should incorporate a voltage meter to indicate any drop in the voltage large enough to affect the colour temperature of the lamps.

The maximum load required on the main power line should be estimated on

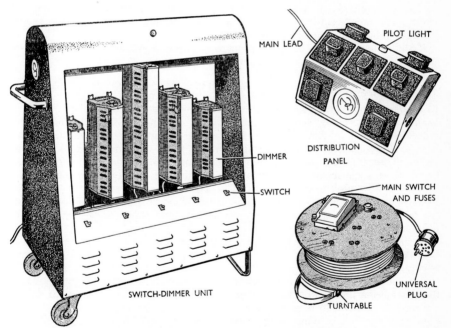

FIG. 7.2. The switch-dimmer unit will control five lights and bring each one to full brilliance. The distribution panel is for connecting floor lights as used in a small studio. The drum, which incorporates four sockets together with a main switch, fuses, pilot light and 30 ft. of cable, is intended for use on location.

FIG. 7.3. A small distribution panel for 500-watt lamps which enables two lamps to be operated in either series or parallel.

the basis of the total wattage likely to be used plus a 25 per cent addition as a margin of safety. Thus, assuming a total of 10,000 watts on a 240-volt line, the current consumed will be roughly 45 amperes. Adding 25 per cent, the supply line should be capable of delivering 60 amperes.

If studio lighting is to be based principally on electronic flash, the load will be much less even allowing for pilot lighting.

Studio furniture

In a large studio with a high ceiling it is convenient to have a number of gantry beams at near ceiling height as supports for lighting units, backgrounds and reflectors. Such a system leaves the floor space uncluttered with lampstands and cables. However, it is a costly installation and for a medium-size studio various pieces of furniture by way of stands and supports can be made up from wood or strips of angle metal of the type used for making up storeroom shelves, etc. This material is already drilled and can be assembled in the fashion of 'Meccano' to make supports for backgrounds, flat tops (of wood or glass), and the framework for tents and diffusing screens. Semi-permanent lamp supports can be made by using 'tube' scaffolding.

A simple stand for moderate size backgrounds can be made on the basis of two pedestal supports with a wooden crossbar, after the style of a high-jump apparatus. Such an arrangement offers the advantage that when not required it can be dismantled quickly and stacked in a corner. It should be robustly made, the posts being drilled to take carriage bolts so that the crossbar may be firmly clamped. It is useful to have a second, lower crossbar, see Fig. 7.4, as a means of pinning a cloth background tautly between the two bars. When not needed as a background support, it can serve as a lamp gantry, or individual posts as additional lamp stands.

The existence of 9 ft. wide display paper in rolls of various colours provides the studio photographer with an ideal means of obtaining a combined foreground and

background without the usual wall-floor angle. These rolls of paper can be supported on a stand of the type just described, but it is more convenient to have two brackets at near ceiling height on an end wall as a means of supporting the roll.

Flat tops for the support of subjects to be photographed may take the form of tables when dealing with small objects, but if a large area is required, it is more convenient to use sheets of heavy plywood supported on trestles. It is useful to have trestles which can be adjusted in height not only to permit the working height of the surface to be raised to the most convenient level, but also to obtain sloping surfaces. When not in use the plywood and trestles will occupy little space.

For very small objects it is useful to make up a square three-dimensional framework of the kind shown in Fig. 7.5. The four posts are drilled at intervals

FIG. 7.4. A stand for backgrounds, diffusing materials, reflectors, etc., which can be easily made up with 2 × 2 in. wood. The two grooved crossbars can be used to hold a sheet of glass in a vertical plane.

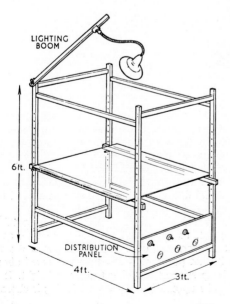

FIG. 7.5. A framework of this kind provides an excellent working base for the photography of small objects. The dimensions given may be scaled down as required.

to allow crosspieces to be fitted as supports for sheets of glass or plywood. Alternatively they may be slotted to allow the sheets to be slid in at the required heights. Such an arrangement makes it possible to combine different planes—and, if an illuminated panel is incorporated in the base, to eliminate shadows when photographing small objects or component parts, see page 118.

A back-projection screen, which may also be useful as a means of obtaining a shadowless background, can be made to any required dimensions by stretching material such as Kodatrace over a frame. It can be conveniently supported on two wooden stands with the frame bolted at the centre of each side. In this way the frame may also be used in a near horizontal plane to give a large area of diffused light when photographing objects such as jewellery, see Fig. 7.4, or placed in front of lamps at any desired angle to act as a diffuser.

Chairs and stools are essential furniture both in terms of comfort and as 'props' for fashion and portrait photography. Other furniture for sets is best hired or borrowed so that it can easily be disposed of after use. Only a very large studio can afford to maintain a 'props' department.

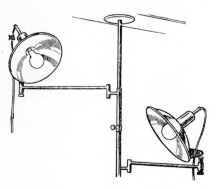

Fig. 7.6. An extendable lamp stand with end plates for contact with floor and ceiling.

Lighting stands and supports

A large variety of lamp stands are available commercially and it is rarely necessary for the photographer to consider making up his own. Light-weight lamp stands of the collapsible type are designed principally for work outside the studio and are not to be recommended for general studio use as they tend to be unstable and may easily be upset. Heavy lamp stands of tubular construction which provide a height adjustable up to 10 to 12 ft., and with the base fitted with smooth running castors make ideal standard equipment. Additional fittings include a boom and a head for mounting a spotlight.

An alternative to a movable lamp stand, consisting of two telescoping tubes fitted with end flanges and a locking nut, has appeared from time to time as a commercial product, see Fig. 7.6. It is expanded until the upper flange presses evenly against the ceiling and locked in that position. It can thus be moved about to any desired position and offers a lamp support reaching to ceiling height. It is a fairly simple piece of equipment to make up and if fairly robust tubing is chosen,

FIG. 7.7. A lighting unit designed to give a broad area of diffused illumination. It can be made for directional by removing the front reflectors.

DETACHABLE
REFLECTORS

FIG. 7.8. A bank of lamps designed to give general illumination for a large set and often used in combination with spotlights.

provides a very solid support. The lighting units can be attached with a clamping collar or, if reflector type photofloods are to be used, with spring clamps.

More elaborate lamp supports include tubular scaffolding and overhead gantries.

Lighting units

These fall roughly into two groups, flood lights and spotlights. The purpose of floods is to give a large area of lighting, whereas the spotlight is designed to give strongly directional lighting. There is no exact difference, since a single reflector type photoflood can be restricted by means of a funnel to give strongly directional lighting over a small area, while a spotlight can be set to broad beam and converted into a flood lamp by placing a diffuser in front of the lens.

The choice of lighting units depends very much on the kind of work that is

113

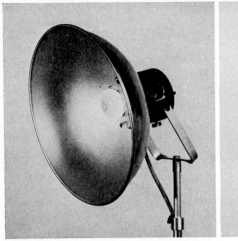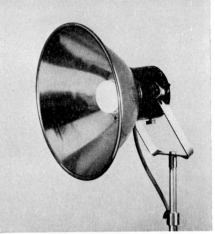

Fig. 7.9. Multilec Flash Heads fitted with a satin 'floodlite' reflector and a polished 'keylite' reflector. The satin finish gives a softer lighting.

to be undertaken. If large sets are to be illuminated, flood lighting may take the form of multiple lamp units, known as banks or broads. Spotlights will be of high wattage—2,000 to 10,000 watts. For small sets, single flood lamps mounted in fairly large diameter reflectors will be sufficient, while spotlights of from 250 to 1,000 watts will provide easily controlled direction lighting.

Flood-lighting units

These are normally based on 500 and 1,000 watt lamps and when used as single units should be provided with a reflector of at least 15 in. diameter. A more uniform spread of light is given by a double reflector system, see Fig. 7.7, or when two or more units are used together. When a large area of uniform illumination is required, a number of lamps can be mounted in a single reflector unit such as that shown in Fig. 7.8. A suitable reflector can be made up from sheet aluminium reinforced with angle strips. Wood can also be used and if lined inside with aluminium foil most of the heat generated by the lamps will be reflected away.

For black-and-white photography, the colour temperature of the lamps is not important and a large bank or broad can be based on 150 or 250 watt lamps having flashed opal bulbs. For colour work it is necessary to use colour-controlled lamps of either 250 or 500 watts. When 500 watt lamps are used, the spacing between the lamps should be doubled.

Banks and broads of flood lamps are necessary when it is desired to light a set to a level which will permit reasonably short exposure times.

Spotlights

The spotlight is by far the most serviceable and versatile photographic light. It can be adjusted to very fine limits and with suitable diffusion will serve the

114

purpose of a flood. Many types are commercially available ranging from small, simplified units for the amateur photographer to precision-made spotlights of lamp wattages up to 5,000 watts for large professional studios. The wattage of the spotlight depends very much on the kind of work being undertaken and for a small set miniature spots of 250-watt are entirely satisfactory.

In selecting a spotlight the following points are worthy of consideration:

(1) The lamphouse should be efficiently light-trapped, yet well ventilated so that the exterior does not become too hot to touch.

(2) The focusing adjustment should be accessible from both the front and back of the lamphouse.

(3) The illumination should be free from filament patterns and 'hot spots'.

(4) The fresnel condenser should be as 'white' as possible for colour work. Glass having a greenish colour may require the use of a colour compensating filter for critical colour rendering.

(5) Easy access should be possible for replacing the lamp.

(6) A lamp holder of the pre-focus type is preferable.

(7) The front of the lamphouse should be provided with runner guides for the insertion of filters, diffusing screens and attachments such as funnels, gates, etc.

With some spotlights the fresnel condenser is lightly frosted to add a slight

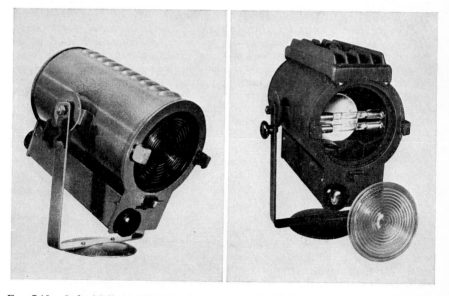

Fig. 7.10. *Left:* Malham 500 general purpose spotlight for 500 or 750 watt projector lamps. *Right:* Malham 1300 spotlight, based on two 650-watt 115-volt tungsten-halogen lamps wired in series.

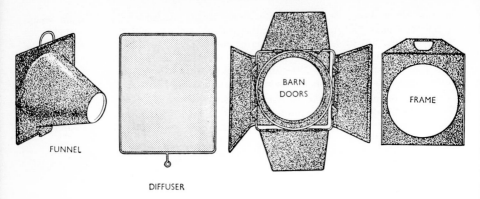

FIG. 7.11. Accessories for controlling the beam from a spotlight.

diffusion to the light. In others the rear mirror is dispensed with by using a lamp having a mirror incorporated in the glass bulb. This simplifies changing the lamp, but mirror bulbs cost considerably more.

A relatively inexpensive substitute for a condenser type spotlight, but by no means its equivalent, is the Reflectorspot, a form of reflector photoflood which gives a much narrower beam than the standard type.

Indispensable accessories for a spotlight are a 'funnel' or 'snoot' and a pair of 'gates' or 'barn-doors'. Both are devices for restricting the area covered by the beam of the spotlight while a funnel also serves to prevent any spill light reaching the lens when a spotlight is used as a back-light. Such devices, see Fig. 7.11, are available commercially as accessories to certain makes of lamp, but are not difficult to improvise.

It is worth noting that the modern slide projector employing a low voltage tungsten iodine lamp can often be pressed into service as the equivalent of a small spotlight. In addition to providing a source of strongly directional light, the beam can be accurately restricted by placing masks in the gate. It can also be used as a source of coloured light by mounting pieces of coloured celluloid in slide mounts.

Diffusing devices

Any direct light source may be partially or totally diffused by intercepting its light with some kind of translucent or light dispersing material. With materials such as bolting silk, nylon voile, diffusion may be added in amounts ranging from barely perceptible, using a single layer, to very strong diffusion using several layers. Plastic material such as Kodatrace and tracing paper will give strong diffusion and a sheet of flashed opal glass will give almost total diffusion.

The size of the diffusing screen depends on the amount of diffusion required and on the area to be covered. By using a large diffusing screen an effect similar to a large bank of lamps can be obtained with only a single light source. A large

diffusing screen could also be useful as a means of softening strong sunlight when undertaking outdoor portraits, see page 105.

Small diffusing screens can be made up by using embroidery hoops. These consist of two hoops of metal or wood, one having a slightly smaller diameter than the other, so that the material can be stretched between them. However, simple wooden frames, including light-weight picture frames, serve the purpose.

Photographic tent

This is, in effect, a diffusing device which covers all aspects of the subject for the camera viewpoint with the object of providing broad areas of reflected light from polished metal ware, ceramics and other objects having a mirror-like surface. In a large studio the tent may be large enough to include the camera, but it is usually sufficient to have a hole through which to poke the lens. The tent can be made up of light wooden frames covered with translucent or white polythene sheeting which can be assembled by means of clips to form a housing or tent around and over the subjects to be photographed. The flood lamps are placed at suitable positions around and above the tent to illuminate the polythene. Reflections can be controlled by attaching pieces of black paper to appropriate areas of the tent,

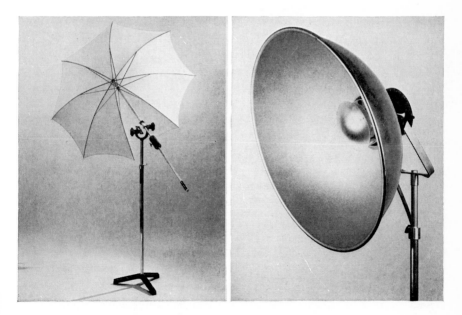

FIG. 7.12. *Left:* 'Paraflash' umbrella and standing for obtaining indirect lighting. *Right:* Multilec Electronic Flash Head fitted with a 'softlite' reflector.

see page 161. With colour photography, strips or other shapes of coloured celluloid can be used to introduce colour reflections.

Light box

The purpose of the light box is to provide a background or base which is 'whiter' than white and thus eliminates any shadows which objects placed against it or on it may cast. As it will normally only be used for small objects—with large objects it is usually possible to illuminate the background separately—it can be constructed as a movable device which can be used either horizontally or vertically. The illumination can be provided by a number of tungsten lamps mounted in the base, see Fig. 7.13, with a sheet of flashed opal glass mounted over the top. The box must be provided with ventilation holes and should be of sufficient depth to allow for a uniform distribution of light and to prevent the glass from becoming too hot. Daylight strip lights will overcome the problem of heat (where this is important) and as the background is to be reproduced as a tone whiter than white, there is no need to worry about the colour balance of the lamps since it will be recorded either as clear film in a transparency or white base in a print.

When used, the brightness level of the illumination applied to the object being photographed is adjusted to be somewhat below that of the illuminated panel.

Sheet of flashed
opal glass

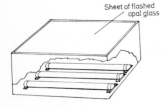

FIG. 7.13. A home-made light box based on fluorescent strip lamps and covered with a sheet of flashed opal glass.

Reflectors

Reflecting surfaces serve two purposes in photography: as a means of directing some of the main light on to the shadows and as sources of diffused light. In the latter case the surface should have a matt white finish and must be large enough to permit it to be used at a distance from the subject great enough for the placing of the light source or sources used to illuminate it. Thus the walls of a medium-sized studio painted white provide excellent reflectors of diffused light. White reflector boards may often take the place of a tent, particularly when the subject requires uniform frontal illumination. In this case a thin, flexible material which can be bent to form an arc, see Fig. 7.14, is the most suitable. Thin 'Masonite' sprayed with matt white paint is ideal for the purpose. Used frontally, it is necessary to make a hole just large enough for the camera lens.

When a reflector is to be used as an auxiliary light source, the surface will depend on the kind of lighting required. For example, a true mirror will reflect any light it receives unaltered and may be considered as an additional light source having the same characteristics as the source it reflects. A small mirror, concealed

Fig. 7.14. Arrangement of lamps and reflector for obtaining directly frontal diffused illumination for photographing metal plaques, jewellery and other polished surfaces which require uniform illumination.

by one element of a subject, may often take the place of an additional light source. Directional and semi-directional reflectors may be made with aluminium foil pasted to the surface of thin plywood or masonite. An almost mirror-like effect is obtained with smooth, polished foil, and various degrees of diffusion obtained by using foil which has a matt surface or has been crumpled or embossed. A white matt surface, as we have already pointed out, will give totally diffused light, but its efficiency is very much less when used at the same distance as a metallic reflector. For this reason matt white reflectors have to be much larger in area if they are to be effective, the width or height of the reflector being equal the distance at which it is to be placed from the subject.

Reflectors of the umbrella type have now become a standard accessory with electronic flash as a means of obtaining soft, semi-directional bounced lighting in portraits, see Fig. 7.12.

For colour work reflectors and diffusers should be of neutral tone unless some special colour effect is intended.

CHAPTER 8

Flash Illumination

The use of magnesium powder as a photographic light source goes back well into the last century and remained in use until the 30's of the present century when the flashbulb appeared as a more convenient alternative. Magnesium flash powder burns rapidly emitting light of great intensity. Used indoors or at night, its light is far more powerful than the existing lighting, and it was thus possible to make the exposure by opening the shutter immediately before igniting the flash powder and closing it immediately afterwards. The intensity of the flash could be roughly controlled by the amount of flash powder used. The use of flash powder was chiefly applied to portraiture which had hitherto required prolonged exposures, the effective time of exposure with flash powder being only a fraction of a second. Nevertheless, the operation must have smacked a little of magic since the sudden and intense emission of light was accompanied with a cloud of white smoke. But, of course, photography was a far more serious business than it is today.

The introduction of the flashbulb may be said to have tamed the rather unruly nature of flash powder and it has since become the most widely used artificial light source in photography. Modern flashbulbs consist of a quantity of shredded metal foil inside a glass envelope containing oxygen. The metal is ignited by an explosive primer which is itself fired by a small electric filament. Recently, zirconium has been used for very small bulbs as it gives a greater light output. The bulb is fired by the simple process of completing an electrical circuit and this has made it possible to construct camera shutters which incorporate contacts for firing the flash in synchronisation with the opening of the shutter, thus making it possible to use flash light with the same facility as a continuous light source.

The light output of a flashbulb depends on its size and nature, but is extremely high compared with continuous light sources. A small bulb may be compared with other light sources in terms of luminous flux as follows:

Standard candle	12·5	lumens
100-watt lamp	1,200	,,
275-watt photoflood	8,000	,,
Small flashbulb	1,000,000	,,

Flashbulbs available offer a range of light output which in lumen-seconds extends from 7,500 for small bulbs to nearly 100,000 for the largest. They also vary in

Fig. 8.1. Two examples of the use of a single flash unit. On the left, the flash was mounted on the camera and shows considerable differences in the intensity of the illumination, with over-exposure in the nearest plane and under-exposure in the background. More acceptable lighting is obtained by using the flash away from the camera as shown in the righthand photograph. All that is needed is a long extension lead for the flash. It also offers the advantage that the photographer is free to move to different viewpoints without affecting the exposure.

terms of their burning characteristics to allow for differences in the kind of shutter fitted to the camera. Originally there were three types, fast burning (Type F) intended for use with simple 'instantaneous' shutters, medium burning (Type M) for cameras with variable speed diaphragm shutters, and Type S (slow burning) for cameras with focal plane shutters. A fourth type—FP—having similar characteristics to the Type S, is available for miniature cameras fitted with focal plane shutters. The type F bulb has now disappeared since the Type M can be used for the same purpose.

Flashbulbs filled with shredded aluminium foil emit a light of 3,800°K, while those filled with zirconium a somewhat 'whiter' light of 4,200°K. Blue-tinted flashbulbs intended for exposure with colour films balanced for daylight give a light of about 6,000°K. Clear flashbulbs are obsolete, except for the very large sizes.

Electronic flash

The use of an electric spark as a powerful light source of extremely brief duration also dates back to the last century when, among other subjects, it was applied to

FIG. 8.2. In the first version the exposure was 1/25 sec. using a continuous light source. The second version was exposed with electronic flash which gave an exposure duration of 1/1000 sec.

the study of fire-arm projectiles. It provides a means of obtaining exposure times in the order of one-millionth of a second. The use of an electric discharge tube was originally developed to the same end, namely of obtaining exposures of very brief duration and is of more recent invention. The first commercially available unit, the Kodatron speedlamp, emitted a powerful flash having a duration of 1/10,000 sec. and thereby started a craze for frozen motion photography. This developed into units capable of emitting flashes at various time frequencies, known as stroboscopic lamps, which enabled a succession of photographs to be made of a particular movement, for example the swing of a golf club, and also made it possible to observe and photograph mechanical parts in motion as if they were stationary by adjusting the frequency of the flashes with that of the cycle of movement.

While these applications of the electric discharge tube are still utilised, it has since been adapted as an alternative light source to the flashbulb, and with the name 'electronic flash' has become enormously popular as a photographic light source in the form of the xenon flash tube. As the extremely short exposure times of the early units proved a disadvantage in terms of reciprocity failure, see page 34, the modern general purpose unit is normally designed to give flash duration times ranging between 1/500 sec. and 1/1,000 sec. which produce only minimal reciprocity effects when used with most black-and-white films and colour films balanced for daylight. However, a recent exception is the introduction of an 'automatic' unit with built-in photo-electric control which determines the light output of the tube according to the distance of the subject by reducing the duration of the flash. Thus, while the flash duration is in the order of 1/1,000 sec. for average distances, it is reduced to as little as 1/50,000 sec. for very close distances.

The electrical energy for supplying the flash tube is of high voltage and for this reason any attempt to play about with the 'innards' of a live electronic flash unit

is most inadvisable. It may be derived from small dry cells and storage batteries of low voltage and is first converted into alternating current and then transformed to high voltage, rectified and stored in a condenser from which it is discharged through the tube by a triggering circuit which ionises the gas thereby rendering it conductive. In many cases the power pack may be supplied directly from an A.C. mains. The recycling time of the power pack varies with particular units and ranges from about 4 to 10 seconds. An indication that the condenser is sufficiently recharged to produce a full flash usually takes the form of a neon lamp, but in many cases is supplemented with an audible 'bleeping' sound. However, in many portable units the neon lamp is unreliable and may glow when the condenser is only about 75 per cent charged. Professional units are more reliable in this respect and are often fitted with a meter which indicates the exact charge of the condensers. Thus with small units it is usually desirable to delay triggering the flash for a few seconds after the neon indicator begins to glow.

The output of a flash in watt-seconds or joules depends principally on the voltage and the capacity of the condenser, but its efficiency as a light source will also depend on the design of the reflector. A large range of units is available from those small enough to be carried in the pocket with an output of about 25 watt-seconds and a battery capacity of up to 50 flashes, to studio units having a total output exceeding 1,000 watt-seconds and designed to feed a number of separate flash heads. The latter usually incorporate a pilot lighting system, that is, tungsten lamps incorporated in the flash head as a guide to placing the lighting. Flash heads may take the form of floods or spots. Small circular flash tubes which may be mounted so that they surround the lens provide perfectly flat illumination in the close-up photography of cavities. Flash tubes are also used as the exposing light in enlargers designed for colour printing since their colour temperature is unaffected by voltage fluctuations. The colour temperature of a xenon flash tube corresponds very closely to 6,000°K. and closely matches bright sunshine plus light from a blue sky. It normally gives excellent colour rendering with a daylight type colour reversal film.

Synchronisation of flash

The requirements of synchronisation depend on the kind of shutter being used, the time of exposure and whether the flash is produced by the combustion of a flashbulb or by a discharge tube. Reference has already been made to the different types of flashbulb which differ in terms of their burning characteristics. Class M bulbs, which may be taken to include all small flashbulbs, produce their effective light output in about 15 millisecs. which is roughly 1/60 sec. Taking into account a delay of about 15 millisecs. after the firing circuit has been closed before the combustion reaches the half-peak stage, the total time between the instant of firing and the emission of light is about 30 millisecs. or about 1/30 sec. Thus any exposure time of 1/30 sec. or longer, whereby the opening of the shutter coincides with the firing of the flashbulb and the whole of the image formed at the focal plane is uncovered at the same time will satisfy the requirements of synchronisation and also make full use of the flash. This requirement is met by all simple shutters, all diaphragm shutters with the synchronising lever set to 'X' and the vast majority of focal-plane shutters to be found on miniature cameras where the slow speeds

are obtained with the whole of the shutter blind open for the pre-set time. However, many of the larger format technical and press cameras are fitted with a focal-plane shutter which is only full open when making a time exposure. In this case synchronisation can only be obtained by using a Type S bulb whose period of combustion is long enough and sufficiently uniform to illuminate the subject during the time that the slit of the shutter takes to travel across the focal plane, normally in the region of about 1/15 sec. The situation is somewhat similar for miniature cameras having a focal plane shutter when exposure times less than 1/30 sec. are used, since the shorter times are obtained by means of a slit which travels across the focal plane, although the total time to expose the whole area still remains at 1/30 sec. In some cameras this has been reduced to as little as 1/120 sec. Thus to ensure a uniform flash exposure at settings which involve the use of a slit, the flash must produce a uniform output for 1/30 sec. Such a requirement is met by the FP flashbulb.

When exposure times shorter than 1/30 sec. are to be used with a diaphragm shutter it is possible to make use of Type M bulbs by utilising the 'M' setting. This has the effect of advancing the closing of the flash circuit by about 15 millisecs. so that the effective light output coincides with the opening of the shutter. It is now possible to make exposures of from 1/60 to 1/500 sec. which will synchronise with the effective burning period of the flashbulb. The full light output of a flashbulb is only used when the shutter is open during the whole of the burning time: at 1/120 sec. only about half the light output is used, while at 1/500 sec. only about a quarter.

The position is different with electronic flash since the duration of the flash is very much shorter and occurs instantly the triggering circuit is closed. With a diaphragm shutter synchronisation is obtained with the 'X' setting at all speed settings. It should be noted that the 'M' setting which causes the flash to be triggered 15 millisecs. before the shutter opens is fatal to electronic flash since it will already have finished before the shutter is open! When using electronic flash care should always be taken to check the position of the synchronising lever. This is particularly important when using a camera not provided with a safety catch for the lever, since in handling the camera the lever may easily be accidentally moved from 'X' to 'M'. If all flash exposures are made with an electronic unit, it is worth blocking the lever in the 'X' position by some means.

With a focal-plane shutter electronic flash can only be synchronised for exposure times in which the whole of the focal plane is open at the same time. For most cameras this normally limits its use to exposure times of 1/30 sec. or longer.

Synchronisation of two or more flash sources

When using flashbulbs it is sufficient to feed the extension leads from the various flash-holders to a common lead which is connected to the shutter. The leads should be in parallel. If a single source of electricity is to be used to fire a number of flashbulbs, it must be of sufficient capacity. Small flash units are based on the use of a miniature dry-cell battery which charges a condenser. When the circuit is closed the discharge of the condenser supplies a surge of electricity to the filament of the bulb. However, with use or prolonged storage, the battery reaches a stage of exhaustion where it can no longer charge the condenser with enough

Fig. 8.3. Electronic flash used as an indirect light source to photograph soda water being poured into a tumbler. The flash was directed towards the white background from below the table.

electricity to fire the bulb. The larger flashbulbs, such as the PF 60 and PF 100, are fitted with screw caps to enable them to be fitted into standard lamp reflectors when they can be fired by switching on the mains supply. However, if they are to be fired synchronously it is necessary to employ a low voltage relay switch. The low voltage circuit of the relay is connected via the camera shutter to a dry-cell battery, while the mains circuit is connected in series with the high voltage circuit of the relay. A multiple flashbulb circuit is shown in Fig. 8.4.

Electronic flash units for studio use provide a number of outlets for separate flash heads. These will all be triggered simultaneously when the camera shutter is released. Separate units, each supplied with their own power pack, can be fired simultaneously by means of 'slave' units which operate by the light emitted by a 'master' unit connected with the shutter. The slave units employ a photo cell which permits the flow of electricity when it receives a strong dose of light from the master flash.

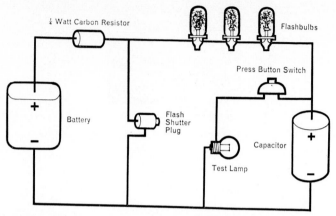

FIG. 8.4. Multiple Flash Circuit with test lamp. The flashbulbs are connected in series so that any sockets not in use must be shorted out. As the number of flashbulbs increases, so must the value of the components.

No. of Flashbulbs	Capacitor	Working Voltage of capacitor (min.)	Battery	Resistor (min.)	Test Lamp
1–6	250 mfd	25-V	22.5-V	3,000 ohm	6-V, 0.04-A
7–12	500	45-V	45-V	5,000 ohm	12-V, 0.2-A
13–18	750 mfd	70-V	67.5-V	10,000 ohm	12-V, 0.1-A

As the capacitor is charged through the flashbulbs, discharging the capacitor through the test lamp via the press button switch, proves continuity in the flash circuit.

(Courtesy of Philips Electrical Ltd.)

Pilot lighting system

The major disadvantage of any flash lighting is that its effect on the subject cannot be observed at the time of photography. While it is possible to predict the effect of a flash used as fill-in light, see page 101, or to utilise flash as an indirect light source by bouncing it off walls or ceiling, no intelligent use of flash can be made in terms of a multi-lighting system for general studio work without employing a pilot lighting system. Most of the large capacity electronic units designed for studio use already incorporate pilot lighting and it can be used both for arranging the lamps and also for estimating the exposure by means of a conventional exposure meter. With units not supplied with pilot lighting, it is necessary to employ tungsten lamps to achieve the required lighting effect. The tungsten lamps are then replaced by the flash heads for making the exposure. Such a system can be made more convenient by using reflector type tungsten lamps of, say, 250-watt, which are mounted in holders fitted with a standard camera accessory shoe. A similar shoe is usually fitted to electronic flash heads to enable them to be mounted on the camera. The lamp stands are fitted with a bracket which embodies a robust ball-and-socket head on which is mounted the slot for receiving the shoe of the

lamp holder or flash head. The change-over of lamps can thus be done in a very short time and with reasonable certainty of obtaining the same lighting arrangement. If a flash head is to be used as a back-light, it should be hooded in the same way as the pilot lamp.

With experience in the use of multiple flash units, it is possible to establish a number of 'standard' lighting set-ups suitable for portraiture or routine photography for catalogues and technical purposes. For copying originals such as oil paintings where specular reflections may be troublesome, pilot lighting is essential unless use is to be made of polarizing filters over the lamps, see page 186.

Assessment of exposure

There are three methods of establishing the correct exposure when using flash lighting. The one most commonly used is known as the guide number system and is based on the inverse square law of light emitted by a point source. The second is that based on measurements with a photo-electric exposure meter of pilot lighting and the third by using a flash exposure meter. There are, in addition, electronic flash units embodying exposure control devices.

The guide number system works reasonably well if due account is taken of a number of variable factors. The guide number or 'flash factor', as it is frequently called, when applied to an electronic flash unit, is usually based on certain average conditions. Thus it usually assumes that the flash will be placed at least 5 ft. from the subject: at closer distances the flash is usually less effective than is indicated by the guide number. This varies with different units since its depends partly on the nature of the reflector and it is therefore necessary to make tests with the unit being used. Secondly, it is usually assumed that the subject will be photographed in a room of average size having a white ceiling and walls of fairly light tone and thus takes into account the considerable amount of reflected light reaching the subject from its surroundings. When the surrounding surfaces are of dark tone or are at a considerable distance, as in a large hall or in the open, the absence of

Fig. 8.5. Multilec Quartz 1000 Flash Head showing the pilot lamp inside the ring flash tube. Normal domestic neta-bulbs in wattages from 25-150 may be used.

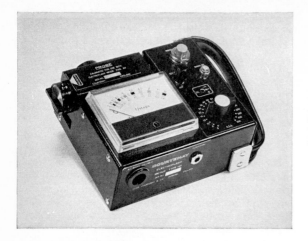

Fig. 8.6. Courtney Electro-Flash Meter which is designed for assessing the exposure with electronic flash sources.

reflected light may require up to 1 stop more exposure than that indicated by the guide number. The reverse is true when flash photographs are made in a small, white-walled room such as a bathroom: in this case the exposure based on the guide number may require up to 1 stop less. Thirdly, when using flashbulbs, the guide number assumes the use of an efficient reflector appropriate to the size of the bulb. The use of a midget reflector or none at all will cause considerable loss of light reaching the subject. Thus with a midget reflector it is usually necessary to increase the exposure by 1 stop. Also applying to flashbulbs, the guide number will either apply to 'open' flash or a synchronised shutter speed which makes use of the total output of the bulb, or to a specific shutter speed using 'M' synchronisation.

When applying the guide number system to a lighting arrangement employing two or more flash units, the exposure is calculated only for the unit which provides the main light. However, the effect of a flash unit used as fill-in or for background illumination can be predicted on the basis of the guide number. In fact, the guide number system can be applied to tungsten lamps, but with the increasing availability of exposure meters the practice has now almost vanished.

The second method of assessing the exposure is to establish the relative illumination given by a particular flashbulb or electronic flash unit with a tungsten lamp used as a pilot light. This can be done by making a series of test exposures, first using the tungsten lighting and then the flash lighting. The exposure for the tungsten lamps is based on an exposure meter reading from a white card, see page 78, and that for the flash on the guide number system. In both cases at least three exposures should be made, one at the indicated exposure and the other two with 1 stop more and 1 stop less. The difference in exposure between two matching negatives will give the conversion factor necessary to convert a tungsten light exposure meter reading to that required for flash. This method works well if the tungsten lamps have a light distribution similar to that of the flash units and it saves the bother of measuring lamp distances.

The third method, that of using a flash exposure meter, dispenses with the need of a conversion factor between pilot lighting and flash since it is capable of measuring the actual intensity of the flash. Obviously it is more suitable for use with an electronic flash unit where the firing of a test flash involves no expense.

Summary

In comparing the two kinds of flash illumination the photographer should take into account an important psychological factor, namely that relating to cost. The initial cost of a reliable electronic flash unit may appear excessive in comparison with the cost of an efficient flashbulb holder and there is the temptation to limit the use of flash to the occasional use of flashbulbs or to compromise by buying a small electronic flashgun offered at a bargain price. The enterprising photographer, whether amateur or professional, will find many occasions when some form of flash lighting provides the most satisfactory means of producing successful photographs particularly when shooting with colour. But to gain proficiency in the use of flash requires a considerable amount of test photography. Unfortunately, there is a tendency to restrict tests, even to dispense with them, when using flashbulbs, since each exposure represents an appreciable expenditure of money. This is not the case when the photographer is already in possession of an electronic flash unit, partly because the cost of the flash is negligible in terms of the consumption of electricity and wear and tear on the power pack or flash tube and partly because every exposure he makes with the unit represents a justification of his initial expenditure. While this may appear an irrational attitude since even with proper testing it may turn out in the long run that the use of flashbulbs is less expensive than electronic flash, experience shows that human nature is basically irrational.

There are, of course, other considerations which may determine the purchase of an expensive electronic outfit. It offers a certain prestige value and this can be important in the field of professional photography. It offers an extremely short exposure time under all conditions of use and it provides an ideal and consistent source of light for colour photography.

CHAPTER 9

The Application of Light

The term photography is derived from Greek words meaning light and drawing and may thus be said to signify drawing with light. However, when the word was coined, photography was no more than a process for making a record of the view at which the camera was directed. This, of course, still applies to the majority of photographs today, the only difference being that the process has been greatly improved. The idea of actually controlling the light falling on the subject developed very gradually so long as daylight was the only practical source for exposing sensitive materials. Even so, a number of portrait photographers constructed 'daylight' studios with large window areas that could be partly covered so as to obtain some control over the direction and extent of illumination. However, with the development of artificial light sources, the photographer could, if he was so minded, apply the illumination at his disposal in any manner he wished, thus approaching more nearly to the idea of 'drawing with light'. Indeed, anyone who has seen the inside of a modern commercial studio, can have little doubt that nothing is left to chance when it comes to lighting the subject to be photographed.

The first step towards becoming a 'graduate' in photography is to accept that light is a controllable medium and not merely something that happens to be available. There are, of course, many occasions when photographs have to be made with the existing lighting. Even so, a good knowledge of lighting control may often help to obtain better than average results. Indeed, there are many successful photographers who rely solely on 'available' light and whose chief delight is to produce first-rate photographs under conditions where there is very little available light! However, while this approach could be the correct one for a photo-reporter, it would be completely out of place in a commercial studio.

A proper understanding of lighting control does not involve a highly-equipped studio. Many aspiring photographers who have acquired a number of professional lighting units have been greatly disappointed with their results, often deciding that artificial light is anything but 'controllable' in comparison with natural lighting. To understand lighting, it is necessary to start at the beginning by observing what happens when an object is lit from a single light source, which could be anything from a candle to a spotlight. One of the basic principles of lighting arises from the fact that daylight originates from a single light source—the sun. We are thus used to seeing objects and scenes lit with one main light source coming from a position above eye-level and casting only one set of shadows. As the position of

130

FIG. 9.1 The upper portrait was made with an ordinary 60-watt ceiling lamp and corresponds very closely to the effect of overhead sunlight. The lower version includes the actual light source—a candle—and thus has no need to conform to normal standards of lighting —but see Fig. 9.2.

the sun varies both in altitude and direction, and the position of the viewer (or camera) relative to the sun may vary through the 360 degrees of a circle, we can also accept that the main light may come from any point in a hemisphere above the subject. Thus we can accept anything from frontal to back-lighting combined with variations from level to overhead lighting as being 'natural'. On the other hand, light coming from below eye-level, or from more than one light source so as to create more than one set of shadows, is usually felt to be 'unnatural' unless it clearly corresponds to some familiar situation arising from artificial lighting. Thus, as a general rule, artificial light even when it may involve a dozen or more separate light sources, should be applied in a manner which retains the idea of a single predominant source of light.

131

FIG. 9.2. The light source was at floor level and the result, in terms of shadows, is completely unlike the accepted appearance of the face.

Establishing uniform light

A useful beginning in the control of light is to consider a situation in which every part of the subject, which will be recorded by the camera, receives the same level of illumination. We may describe such lighting as uniform or flat, that is, the lighting contrast is zero. Such lighting may be needed not only for a flat subject such as a painting, but also for an interior or group of objects at different distances from the camera. It can apply particularly to colour photography where the purpose is to document or present the tonal and colour differences of the subject. However, it may also be appropriate to a lighting scheme which includes a key or modelling light. In this case it represents the second stage in lighting, the first being to establish the position of the key light.

Let us consider first the problem of lighting a flat surface uniformly. If the area is relatively small, uniform lighting may be obtained with a single light source which gives parallel or near parallel light having an angle of incidence of about 30° to the surface. At this angle any specular reflections from a smooth surface will be outside the angle of view of a lens of normal focal length. If the surface is rough or matt, the angle of incidence may be considerably greater.

132

Sources of near-parallel light include direct sunlight, light from a spotlight adjusted to give a narrow beam and any light source coming from a distance of 10 or more times the larger dimension of the area to be photographed. When dealing with a fairly large area, the use of sunlight is normally only possible in the open and for photography indoors some form of artificial light is needed. While it may still be possible to cover the area with a spotlight, the distance of a single light source will normally be restricted by the space available and it thus becomes necessary to use more than one light source, or under certain conditions, to use a single light source in more than one position during the exposure. The usual method for copying a painting is to use two lamps, one on either side of the subject at an angle of about 30°, see Fig. 13.1, page 184. In this case the lamp distance can be much less, since the two sources are complementary. More uniform illumination could be obtained by using two lamps on each side, spaced vertically and each directed towards the quarter farthest from it. This would be desirable, for example, if one wall of a room hung with pictures or containing a large fresco were to be photographed using a wider than normal angle lens.

When it is possible to work at night or to darken the room with curtains, uniform light over a large area can be obtained using a single spotlight set to give a fairly broad beam and played with broad sweeps across the area. The lens aperture should be adjusted to allow for a slow steady movement of the spotlight, the shutter being opened immediately before and closed immediately after the illumination is complete. A similar procedure can be adopted with flash, the direction of each flash being calculated to illuminate a different area of the wall. The number of flashes required will depend on the working distance and the size of the area to be covered: with ample working distance, two flashes, one from each side, could be sufficient, while with a very large area a dozen or more flashes may be needed. The flash must be directed at an angle which will avoid any silhouettes of the flash holder or person holding it from being included in the picture area.

When there is no objection to using diffused light (see page 46 on loss of contrast and colour saturation), the problem is often much simpler. Light from the sky coming through a large window will provide uniform lighting for pictures of considerable size, while diffusers placed some distance in front of individual light sources will provide a much greater coverage of light. In a room having white walls and ceiling, a large area of indirect and diffused illumination will be obtained by directing the light sources towards the walls and ceiling.

When the subject involves both a foreground and a background, or a number of objects are at different distances, as when photographing an interior containing furniture, the establishment of uniform lighting will generally call for a number of lamps covering different planes. The problem is often one of avoiding unwanted shadows. Background lights may often be concealed behind objects at nearer distances. Otherwise lights must be kept to the sides and well shielded to avoid light reaching the camera lens. Here again, the simple answer may be to direct light source towards the ceiling so as to create a wide distribution of light.

The uniformity of the illumination at different planes when using direct light sources is best checked by making measurements with an exposure meter from a white card, see page 78.

Intensity level

The desirable intensity level of interior lighting depends on a number of factors. The eye tends to adapt itself to a prevailing intensity level and what may appear equivalent to outdoor lighting may well prove to be as little as 100 times less bright when measured with an exposure meter.

When the subject is of a static nature and the camera is to be used on a stand. the intensity level becomes important only if it involves exposure times which are likely to give rise to reciprocity failure serious enough to cause under-exposure or to affect the colour rendering of a colour film. This does not necessarily imply working to a very low intensity, since it may frequently be necessary to use very small lens apertures, to obtain adequate depth of field. When the subject is liable to movements, as in portraiture, or the camera is to be held in the hand, the level of illumination must be sufficient to permit exposure times as short as 1/50 sec. For even a moderately small set, this would involve the use of several high wattage tungsten lamps. It is for this reason that electronic flash lighting units are now commonly used for 'live' studio work. Large sets, commonly used for fashion photography and film work may require tungsten lighting equivalent to a hundred or more kilowatts. On the other hand a very small set can be adequately lit with no more than 1 kilowatt.

As a general rule, the intensity level should be such as to give an appreciable deflection on the scale of the exposure meter in use when it is used to measure the light from a white card illuminated only with the fill-in lighting, see page 78.

FIG. 9.3. The portrait on the extreme left was exposed with a ring flash tube mounted round the lens. The second version with a lamp placed at the side. Used together, the two light sources provide a well-balanced lighting ratio.

Lighting contrast

With any lighting arrangement having a main directional light so placed as to create shadow areas, different parts of the subject will receive different levels of illumination. This is commonly referred to as the lighting contrast. When it is possible to measure the maximum and minimum levels of illumination or calculate them on the basis of lamp wattage and lamp distance, the values so obtained can be expressed as the lighting ratio. For example, if two lamps of equal wattage are used, one as the main light to the right of the camera and placed at a distance of 8 ft. from the subject and the other placed to illuminate the shadows created by the main light, but placed at a distance of 12 ft., an approximate value for their light ratio can be based on the squares of the two distances, namely, 64 and 144. As the intensity is inversely proportional to the square of the distance, the lighting ratio is slightly more than 2:1. If the fill-in lamp also covers the area illuminated by the main light, the lighting ratio will be increased to 3:1. The same ratio could be obtained by using a lamp of half the wattage for the shadows at the same distance as that used for the main light. Alternatively a diffusing screen could be placed in front of the lamp directed on the shadows at such a distance as to halve its effective intensity. This offers the additional advantage of eliminating any shadows arising from the fill-in lamp.

However, the most satisfactory method of establishing a given lighting ratio is with an exposure meter, see page 76. Having fixed the position of the main light and measured its intensity at the subject plane, sufficient light is then applied to

135

a *b*

FIG. 9.4. (*a*) Completely frontal lighting from a spotlight. The absence of shadows tends to 'detach' the tin from the base. (*b*) Full back-lighting giving a strong specular reflection from the top of the tin.

the shadows until they are illuminated to the required ratio. A normal ratio for black-and-white photography is 4:1. This will give strong shadows. For portraits a lower ratio is preferable unless the subject is to be presented in strong contrast. With colour photography much lower ratios are desirable and one of 2:1 should be taken as the normal.

Direction of main light

The main light is often referred to as the key light or the modelling light since it determines the direction and shape of the shadows, and for objects having curved and rounded surfaces, the gradation of reflected light in relation to the angle of incidence, see page 46.

The main light may come from any point of a circle around the subject. If it consists of a ring flash tube surrounding the lens mount, it provides direct frontal lighting with no trace of shadows. When placed near the lens axis as, for example, with a flash unit mounted on the camera, it gives near frontal lighting accompanied with a narrow shadow area which appears either to one side of the subject if the flash is at the side of the camera, or reveals itself as a narrow shadow immediately below such features as the nose and chin. The area of the shadows increases as the light is moved in a circle away from the camera, becoming side-lighting at an angle of about 90°, and back-lighting when it passes beyond this point. With full back-lighting, that is, with the lamp immediately behind the subject, there remains only a silhouette outline of the subject which is otherwise in total shadow, see effect of depth, see Fig. 9.4*e*.

In combination with this circular location, the main light may also be varied in altitude above the subject. With the lamp in almost the same plane as the subject, the effect is one of lighting at sunrise and sunset or from a nearby window.

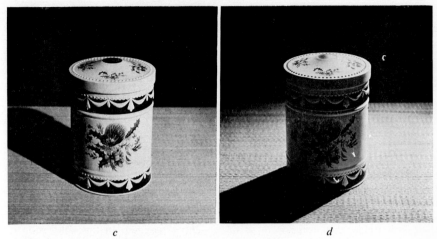

FIG. 9.4. (*c*) Light at 30° to the lens axis which emphasises the roundness of the tin. (*d*) Three-quarter back-light: the effect is to separate the tin from the background.

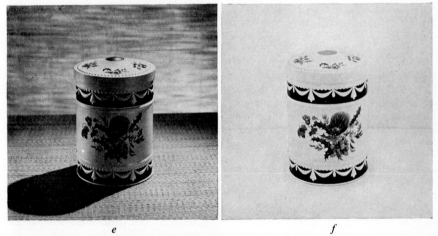

FIG. 9.4. (*e*) A combination of back-lighting and fill-in to give both separation from the background and modelling. (*f*) Photographed inside a photographic tent: the totally diffused lighting produces an abstract effect.

Normal angles are from 30° to 45°, the angle being based on the horizontal. When the main light occupies a back-lighting position, much greater angles are acceptable. Indeed, back-lighting at fairly high altitude is frequently used in the photography of commercial products for advertising purposes as it gives a strong effect of depth, see Fig. 12.10, page 180.

When dealing with three-dimensional subjects and particularly those having curved surfaces, the nature of the main light is very much that of a modelling light since the light reflected from the subject varies with the angle at which the light strikes the surface. This graduation of tone should not be confused with shadow effects which represent areas which receive none of the direct light coming from the main light, see Fig. 9.5.

Normally speaking, the position of the main light is the first step in lighting a subject. The need for and nature of any supplementary lighting is the second step.

Shadow or fill-in lighting

It may happen that none is needed, either because there are no shadows or because they fall outside the picture area. It may also happen that the existing ambient light (light from the sky or light reflected from the walls of a room) is sufficient for the purpose. However, if there are distinct shadow areas, then it is usually worth-while to check the lighting ratio with an exposure meter. If it is higher than is desirable, then some form of fill-in light is required. In this connection it is worth bearing in mind that the brightness adaptation of the eye usually leads to an under-valuation of the lighting ratio, see page 10.

The purpose of a fill-in light is to raise the luminosity of the shadow areas, not to create a second set of shadows. It is for this reason that many photographers prefer to make use of indirect lighting or diffusing screens. Sufficient indirect light can often be obtained without any additional light source by means of a large reflector board placed so as to receive light from the main source and re-direct it on to the shadows. Using a matt aluminium reflector a very high percentage of the light will reach the shadows usually making it possible to obtain a lighting ratio as low as $1\frac{1}{2}$:1. Considerably less light will be reflected from a matt white surface unless it is placed very near the subject. In outdoor photography it is often possible to make use of an existing source of reflected light such as a white wall or a sand-dune. The combination of a single main light source plus a reflecting surface for the shadows is restricted chiefly to side- and back-lighting positions of the light source. It becomes less effective as the main light approaches the direction of photography, that is, becomes increasingly a frontal light source. It then becomes necessary to use a separate lamp to illuminate the reflector if it is desired to use indirect lighting.

However, the use of reflector boards is not always convenient, not only because of their bulk and the difficulty of supporting them at the right angle without an assistant, but because they tend to restrict the choice of lighting direction and, with subjects such as china, glass and metal ware, will give rise to large-area reflections, see page 161. It is thus an advantage to the photographer to be able to apply an ordinary directional light source as a fill-in without creating unwanted shadows. One way is to use the fill-in light as closely as possible to the lens axis so as to give frontal and very nearly shadowless lighting. As the lamp cannot exactly coincide with the lens axis (except in the case of a ring flashtube), it should be placed a little higher than the camera and very slightly to the side opposite the position of the main light. In this way any shadows it may create will be illuminated by the main light. The main light can then be placed in any position from near

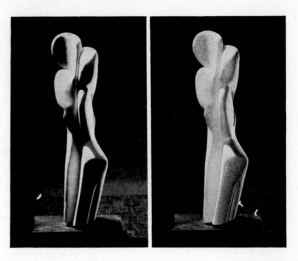

FIG. 9.5. A sculpture in white chalk showing a stronger, more solid appearance with contrasty lighting and a more 'plastic' effect with reduced contrast.

frontal lighting to full back-lighting. A somewhat stereotyped arrangement and one which makes the maximum use of two lamps of equal wattage—for example two photoflood lamps which can be used on the basis of series/parallel operation, see page 54—is to place the main light at an angle of about 45° to the lens axis with the fill-in lamp placed in the manner just described, see Fig. 9.6. This gives a lighting ratio of 2:1, based on the fact that one side of the subject receives the light from two lamps while the other from only one lamp.

When used in other positions, the fill-in lamp will tend to cast shadows on the background unless it is placed well to the side, and shadows on the foreground if it is placed above the level of the subject. Any shadows on the background will not be important if the background is to be illuminated separately, while those on the foreground can be avoided by keeping the lamp very slightly below the level of the subject. Shadows created by the fill-in light are more troublesome when the lighting ratio is low, and the background is light in tone (see page 149, Fig. 10.4). Weak shadows easily pass unnoticed at the time of photography, but become more apparent in a photograph.

FIG. 9.6. Simple lighting arrangement for two lamps of equal wattage which gives a lighting ratio of 2:1 and also makes the fullest use of the light.

FIG. 9.7. The same white background is used in both versions but using different lighting techniques. The white, shadowless background was obtained with indirect lighting from a large reflector in front of the camera, while the second version was lit with a boom-light hooded to give a circular area of light and using a much smaller reflector to illuminate the metal surfaces of the subject. See also page 161, Fig. 11.7.

When the subject has predominantly matt surfaces, a diffusing screen some distance in front of the fill-in light will eliminate the outline of weak shadows.

Background illumination

When the subject is situated some distance in front of the background, it is frequently necessary to illuminate it independently to bring it to the same level of brightness as the foreground. It may also be necessary to employ a separate light to obtain some special effect, or to eliminate shadows created by either the main or fill-in light.

The need for separate lighting to obtain a uniform level of illumination between foreground and background depends very much on the ratio between the two distances, lamp-to-subject and lamp-to-background. In fact it brings us back to the inverse square law of light propagation. Let us suppose the lamp to subject distance is 8 ft. and the background is a further 4 ft. away, that is, a total distance of 12 ft. The inverse square of the two distances gives a ratio of roughly $2\frac{1}{2}$:1, and the background would thus be considerably under-lit. However, if the main light were at a distance of 16 ft., thus making that of the background 20 ft., the ratio becomes 400 : 256 or about $1\frac{1}{2}$:1, a difference which may well be acceptable. There is thus some advantage in using the main light as the maximum possible distance, see Fig. 3.2 on page 38. If a spotlight is used as the main light so that its light also falls on the background, the difference in intensity will be very much less since the light approaches that of parallel light—for example sunlight, which remains constant at all distances.

When a plain background is used, it becomes possible to introduce special effects ranging from circles and ellipses of light cast by the narrow beam of a spotlight to projected images and shadows using a projector, see page 178.

The level of background illumination may also be varied to change the tone of a plain background. For example, a medium blue can be made to record in tones ranging from very light blue to very dark blue by varying the ratio of lighting between the subject and the background. Generally speaking, the colour temperature of lamps used for the background is less critical in colour photography than lamps used for the main lighting and it is thus possible to make use of photoflood lamps which begin to show signs of blackening.

Back-lighting effects

While the main lighting is usually placed in some position on the front half of a circle surrounding the subject, it may also occupy a position on the rear half of the circle and may therefore be described as back-lighting. However, a backlight may serve the function of an auxiliary light intended to add sparkle to a photograph by way of highlights and catchlights. It is commonly used in the more sophisticated type of portraiture such as that used in publicity portraits of film stars, pop singers and TV personalities. It is more applicable to black-and-white photography than colour photography where anything but the slightest degree of over-exposure produces an unacceptable, burnt-out effect. In black-and-white photography, back-lighting effects may range from a strong 'halo' effect to the barest touches of catchlight in the hair. Its application is largely a matter of taste, though in skilled hands it can be very effective and will often differentiate between a mediocre photographer and a 'maestro'.

As far as technicalities are concerned, it is of primary importance to prevent any light directed towards the camera from striking the surface of the lens. This may involve not only an efficient lens hood, but a funnel attached to the spotlight. The danger of obtaining a 'burnt-out' effect due to using too strong a spotlight can be recognised by examining the subject through a monochromatic viewing filter with all the lights switched on. Alternatively, measurement can be made with an exposure meter using a white card. The reading for the back-light should not be more than twice that of the main light and for colour work a ratio of $1\frac{1}{2}$:1 is recommended. However, a series of tests will serve to indicate the lighting ratios suitable for both black-and-white and colour work.

While a small spotlight is the most suitable light source for back-lighting effects, a well-hooded reflector spot-lamp of the type used for window displays, or any lamp which has been well-hooded may serve the purpose.

Normally a back-light will occupy a position behind and above the subject, but to obtain an outline effect the back-light can be placed immediately behind the subject or at a lower level so that the subject itself obstructs any direct rays of light from entering the lens, see page 178.

CHAPTER 10

The Formation and Control of Shadows

The existence of the sun as an all-powerful and strongly directional light source has conditioned us from infancy to the visual concept of light and shade. This is further reinforced by the semi-directional light from windows and the fact that many of the artificial light sources used during the hours of darkness consist of single lamps. Shadows are therefore an important part of our visual experience and may be described as important 'clues' towards the recognition and interpretation of what we see. For example, shadows can contribute to an estimate of depth and distance, and can provide clues to the shape and form of an object, see Fig. 3.6, will reveal surface texture, see Fig. 10.1, will indicate the nature and position of the source or sources of illumination and by providing contrast, aid considerably in our perception of detail, see Fig. 3.9. In normal visual perception, shadows are often complementary clues to binocular vision, but in photography they may assume greater importance as clues to depth and solidity, whereas in stereo-photography shadows are less important.

We might conclude this introduction by speculating on living on a world which is perpetually encircled by a cloudy atmosphere. There would be no distinct shadows arising from natural lighting and shadows would therefore be directly associated with artificial light sources. Their existence would probably be as strange and bizarre, no matter in what direction they fell, as the shadows cast by a light source coming from below the subject, see Fig. 9.2.

The perspective of shadows

Shadows may be thought of as projections of the outline of objects which become more or less distorted by the surfaces on which they fall. We may obtain a very nearly perfect projection of the outline of an object by placing it in front of a point light source (one having a small size filament and a clear glass bulb) and intercepting the shadow with a translucent screen placed immediately in front of the object. This, in fact, is one method employed for obtaining silhouette portraits. If the screen is tilted in respect of the axis between the point source and the centre of the object, the projected outline will be distorted in the direction of the tilt, while if the distance of the screen from the object is increased, the projected shadow becomes magnified. The degree of magnification for any given screen distance will depend on the distance of the light source from the object. Thus if the lamp-to-object and object-to-screen distance are equal, the projected shadow represents the outline magnified by two times.

Fig. 10.1. Light from a slide projector skimming the surface of a sheet from a writing pad which had received an impression of a message written on the preceding sheet. The image has been reversed in printing.

In the normal way we observe shadows in terms of reflected light, the area of the shadow reflecting less light than its surroundings. The outline of the shadow will bear a strong similarity to the object which creates it only when the surface on which it falls is fairly flat and is at right-angles to a line between the light source and the centre of the object. Thus the effect of a shadow on a background may be that of repeating the subject outline, see Fig. 10.2. Such a condition normally only arises with low altitude sunlight or when the subject is lit with a spotlight which is very nearly level with the object and in both cases there is a vertical background at a short distance behind the object and roughly at right-angle to the direction of the light source. However, for the most part, shadows bear only a vague resemblance to the outline of the object from which they are cast. The position on the light source (its angle and altitude relative to the viewpoint at which the object is observed) and the nature of the surface on which the shadow falls both contribute to its apparent shape from any given viewpoint. To this must be added the fact that shadows which are observed in depth are subject to the normal rules of perspective and therefore tend to diminish with distance and increase in size if projected at distances nearer than the object, i.e. when the light is behind.

These factors are of far more importance to an artist or draughtsman than to a photographer. The artist, unless he is working directly from an actual subject seen under stable lighting conditions, must calculate the outline of shadows

143

FIG. 10.2. A piece of sculpture in iron photographed with a single spotlight to create a repetition of its form on the background. In the original colour transparency the bright red of the subject is clearly distinguishable from the shadow image.

according to the position of the main light and the surfaces on which shadows fall. The photographer has merely to adjust the position of the main light relative to the object and the nature and position of the surface on which the shadow falls to obtain the kind of shape he wants in the shadow.

Sharpness of outline

The shadows arising from a strongly directional light source, such as clear sunlight or any other source of parallel light, will have clear-cut edges. The same applies when a point source is used or a small-area lamp at a considerable distance from the object. However, it should be noted that a shadow which is projected on a background some distance behind the object may be recorded as unsharp in a photograph owing to a very shallow depth of field. When the light source is relatively large in area in proportion to the distance at which it is placed from the object, the shadows have a softer outline or what is known as a penumbra, see Fig. 10.3. The larger the area of the light source, the larger becomes the penumbra until the dark core of the shadow proper may disappear altogether.

The outlines of shadows may also be softened in varying degrees by using varying amounts of diffusion in front of a strongly directional source. In small amounts the diffusion has the effect of a small amount of fill-in light rather than of forming a penumbra so that the shape and outline of the shadows remain unchanged. With strong diffusion the effect is that of using a large area light source.

Distance of the light source

With a source of parallel or near parallel light, such as that given by a spotlight, a change in the distance of the lamp will have little effect on the size of the shadows. With a point source shadows will increase in size as the lamp is brought nearer the subject. This effect is often suggestive of candle light which, as a weak light source is used at very close distances. The size of the shadows also increase as the distance of the background increases.

It should be noted also, that less area of a curved or spherical subject will be

illuminated with a point source at close distances. This is one reason for keeping the main light in portraiture as far away as possible from the subject.

Direction of light

The direction in which shadows fall is the same as that of the light source and it is thus possible to deduce the position of a light source by drawing a line between some characteristic point on the subject and its shadow counterpart. This fact makes it possible for the student of lighting to work out the lighting plan for any particular photograph and thus obtain similar lighting effects in his own studio.

It will be seen that if we move a lamp at roughly the same plane as an object in a circle round it, the shadow will fall on the side opposite the lamp. When the position of the lamp is the same (or almost the same) as that of the viewer or camera, the shadow will be totally concealed by the object (or very nearly so). With the lamp behind the subject but facing the camera, the whole of the subject will be in shadow except for a bright outline. At other positions between these two points, the shadow area of the subject will increase as the lamp is moved from the frontal to the back-light position. At the same time, the shadow projected by the subject will only be seen or recorded by a camera when the lamp occupies a position within an angle of about 35° of the lens axis. Thus shadows may often be avoided on the background merely by increasing the angle of the lamp.

When the position of the lamp is changed to either a higher or lower level the shadows move in the reverse directions. As we have already noted we are accustomed to shadows cast by a light source from some position above the subject.

The effect of increasing the height of a lamp is to foreshorten the shadows falling on the plane or base on which the object is placed. With the light overhead, the shadow takes the form of the greatest horizontal section of the object so that if the base is smaller than the top it will be surrounded by a shadow. On the other hand shadows become elongated as the light source approaches the horizontal plane, an effect which is particularly noticeable when the sun is near the horizon.

Shadows projected upwards from a light source which is considerably below eye-level are acceptable if it can be seen or easily deduced that the source of light is a fire or a candle which is being held at waist-level. Even so thay may suggest something sinister as if the light were coming from a subterranean inferno.

The direction of the light and hence the position of the shadow areas on a surface having depressions and bumps can produce reverse effects in a photograph which is viewed so that the light appears to be coming from the lower edge of the photograph, see Fig. 3.9. This is because we assume the light is coming from the upper edge.

Density of shadows

Shadows are formed when directional light has been intercepted by some opaque object and assuming no other light were to reach the area of the shadows they would appear as areas of complete blackness. Shadows of this sort could occur on the moon where there is no atmosphere and they could also be created by projecting a beam of strongly directional light through a hole in a room having

Fig. 10.3. (*a*) In the absence of shadows there is no clue to the distance of a plain background so that it could be anything from a few inches to an infinite distance (e.g. the sky).

the walls, floor and ceiling covered with matt black paint. In the normal way, even if no supplementary lighting is used, some light is reflected from surrounding surfaces.

However, there is seldom any problem in obtaining sufficiently dark shadows in a photograph. In fact the reverse situation is usually true, namely that shadows appear too dark in a photograph compared with their density in the original scene. This arises chiefly from the difference by which the eye observes and interprets shadows in an actual scene and their appearance in a photograph, see page 10.

There is often a real loss of brightness in the shadows recorded in a photograph arising from the restricted tone range of a printed paper. Thus shadows which may appear quite luminous to the eye in an actual scene may well have to be recorded in a photograph by the deepest black of the printing paper in order to obtain satisfactory detail in the highlights of the scene. It is for these reasons that some form of fill-in light for the shadows is needed when employing a strongly directional main light source.

The rôle of shadows in photography

A photograph, unless it is a copy of another photograph or a picture painted or printed on to a flat surface, represents objects of three dimensions in a two-dimensional form. The third dimension, that of depth, will usually be appreciated by anyone viewing the photograph from the fact that the image is presented in perspective and that any parallel lines will converge towards some distant point. However, geometrical perspective is not always apparent: the objects depicted may have curved or irregular shapes, and it is here that shadows play their most important rôle. Both by the extent and nature of the shadow areas on the objects themselves and by the shape and position of the shadows they project, the viewer is provided with valuable clues as to the form and relative position of the various objects depicted. Examples are given in Figs. 3.6, 3.9, 9.4, and 12.4.

Shadows may also increase the perception of outline and detail by providing greater contrast. This explains why side- and back-lighting are often so effective in revealing the detail of subjects such as flowers, insects and other finely constructed objects. The same applies to the use of strongly directional lighting as a means of revealing surface texture, see Fig. 10.1.

Shadows may be used to add to the contents of a photograph, either by revealing some aspect of the subject not seen from the camera viewpoint, or revealing the

Lighting unit at 4 yards.

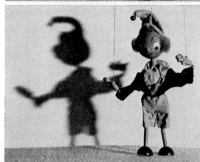

Lighting unit at 2 yards.

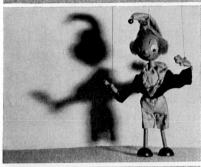

Lighting unit at 1 yard.

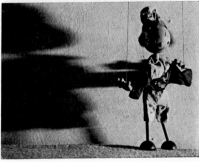

FIG. 10.3. (*b*) The size of a light source such as a flood lamp or flash head, can be related to the distance at which it is used. It can be seen that at 4 yards it more closely approaches a point source in giving a sharp outline to the shadows. At closer distances, the penumbra becomes increasingly evident. The bottom version gives an example of shadow distortion with oblique lighting.

147

existence of something outside the field of view as when a shadow of foliage is projected on to a background to suggest the presence of a tree or bush, see Fig. 12.11.

Shadows form an indispensable ingredient in pictorial photography. The play between shadow and highlight—*chiaroscuro*—has been the delight of the black-and-white photographer almost since the invention of photography. In addition to the balance of tones, shadows may be used to give mood and atmosphere to the subject matter and may in fact, represent the motive for making a photograph. Thus a low-key presentation of a subject, namely one in which the shadows mainly in shadow, may suggest sadness or age. The patterns of slanting shadows on a white wall, or those of a wrought-iron gate projected on the foreground by the back-lighting of low altitude sunlight rarely go unrecorded by the amateur pictorialist and are frequently used by professionals in the studio to suggest an outdoor setting.

Shadow effects may also be imposed on the subject itself either to create a pattern or to suggest a particular location. The trick of projecting the shadow of a venetian blind over nude figures never fails to appeal to the photographer in search of special effects. The shadow of a grill used in portraiture can suggest that the owner of the face is in prison.

False effects in shadows

Mention has already been made of the reverse relief effect which can arise when a photograph of a surface containing relief or *intaglio* designs is viewed so that shadows fall towards the upper edge. Since we are accustomed to shadows falling downwards we tend to interpret the shadows as if they were the result of a light source being directed towards the upper edge of the photograph. Thus depressions are interpreted as hills and vice versa, see Fig. 3.9.

Another false effect occurs commonly in portraits taken against a plain background on which shadows are formed. It may happen that the shadow cast by the main light falls outside the field of view whereas a second shadow arising from a fill-in light is recorded in the background, see Fig. 10.4. If the background is to include a shadow, it should clearly be that formed by the main light and not by any subsidiary lamp. Although not a false effect, the inclusion of more than one shadow of the subject is seldom desirable unless there is some special reason for indicating that it has been illuminated by more than one light source. Normally speaking there should only be one main light and it is from this that any shadow included should arise. Any other shadows should be avoided. How this is done depends on the arrangement of the subject and its background, the kind of lighting effect required and the nature of the lighting units. It is to avoid double shadow effects that many photographers prefer to work with a single main light using a matt reflector to provide fill-in for the shadows.

The direction of shadows should always be carefully studied in composite photographs where objects in the foreground are photographed against a 'picture' background which may either consist of an enlarged print or a back-projected transparency. Whatever the position of the main light in the background, the same position must be adopted to light the three-dimensional objects in the foreground. On the other hand if a particular lighting position is required for the main subject, the background must be selected to agree with this position.

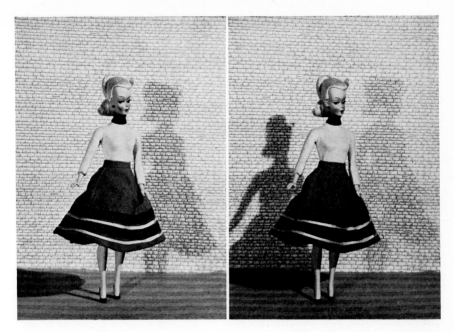

FIG. 10.4. The lefthand version shows a false shadow effect created by a fill-in lamp. The second version is more acceptable, but it is preferable to restrict background shadows to those cast by the main light.

The elimination of shadows

It is often preferable and sometimes necessary to produce photographs of objects which are presented without shadows against a white background. Such photographs are often needed for reproductions used in catalogues, technical reports and advertisements. One method of obtaining a white background in the print is to 'block-out' the background in the negative using an opaque ink. However, this is not practicable with small negatives and in any case is a time-consuming operation requiring some skill. In photomechanical reproduction the blocking-out can be done on the blocks, but this is also an expensive operation. By far the most satisfactory approach to the problem is to light the subject and background in such a way as to avoid shadows. There are a number of methods of avoiding or eliminating shadows depending on the nature of the subject and the kind of lighting effect required.

Background spacing and illumination

In many cases the required effect can be obtained by using a large enough white background to enable it to be placed some distance behind the object and illuminated separately so that it produces as a uniform white tone in the print. Large-area backgrounds can be obtained by having a wall of the studio painted a matt

white or by using 9-ft. wide display paper. Objects can be supported on a white base as near the rear edge as possible so as to reduce any shadow falling on the base to the minimum. When photographing small, relatively light objects, they can be attached to a vertical sheet of glass by modelling clay so that they are, for practical purposes, suspended in mid-air, see Fig. 10.9. Care must be taken to avoid strong reflections from the glass (of lamps), but other reflections against a white background will not be noticeable. If there are objections to using modelling clay, the glass may be used in a horizontal plane, at a sufficient height from the background which can be at floor level. The camera is directed downwards and the lighting so placed that it appears natural when the photograph is viewed in the normal way.

Illuminated panel

For small objects such as commercial products (kitchen gadgets, china, packed food, tools, etc.), mechanical parts presented as a collection of components for use in instruction manuals, natural history specimens and so on, the most satisfactory method is to place them over an illuminated panel. This can take the form of a deep box fitted with lamps or strip lighting and covered with a sheet of flashed opal glass, see Fig. 7.13, page 118.

Exposures when using the light box can be made either on the basis of a single exposure for which the intensity of the light falling on the objects is adjusted to a level such that no trace of shadow is apparent on the illuminated panel, or it can be based on the two exposure system in which a normal exposure is first given to the subject matter with the light box switched off, and a second exposure, adjusted

FIG. 10.5. The elimination of background shadows by means of a light box. The upper version was taken with the light box switched off.

FIG. 10.6. An abstract design created by an arrangement of vitamin pills placed on a sheet of glass over a light box. The exposure was made in two stages: firstly, the pills with black paper over the light box and secondly, with only the light box switched on.

to the intensity of the illuminated panel, made with all the other lighting units switched off, see Fig. 10.5.

The light box can be used in either a horizontal or vertical plane depending on the nature of the subject. The pills in Fig. 10.6 were photographed on a horizontal plane, whereas the grass in Fig. 10.7 was taken against a vertical plane.

For large objects a frame holding a sheet of white plastic sheeting can be illuminated behind with flood lamps. By using a sheet of opal 'Perspex' it is possible to attach small brackets to it as supports for objects such as shoes, gloves and other objects which may need to be placed vertically. The brackets can be made of stout copper wire to any shape required. With a slightly elevated camera viewpoint the brackets will not be visible.

Diffuse and multi-directional lighting

Total elimination of any shadows both in the object and the background can be achieved with diffuse illumination such as that obtained with a photographic tent, see Fig. 9.4f page 137. Similar lighting can be obtained in a white-walled studio by

FIG. 10.7. Only the background has been changed in these two photographs of a head of wild oats.

directing the lamps towards the walls and ceiling. The characteristics of totally diffused lighting in relation to different surfaces, tones and colours are discussed on page 155.

A ring flash-tube mounted round the lens provides completely shadowless lighting when it is required to photograph inside cavities at close distances. This commonly arises in medical photography and when photographing the 'insides' of mechanical and electrical equipment.

The effect of multi-directional lighting can be obtained by using a single flood lamp mounted on a rod and used as a moving light source. The exposure is made with the lens open and at such an aperture as to allow a convenient time for the operator to move the lamp round in a large circle so that all areas of the subject seen by the camera receive the same amount of light. Care must be taken not to bring the lamp within the field of view. The assessment of exposure is a matter of trial and error, but with experience and using an emulsion having a good exposure latitude, it is not difficult to obtain satisfactory negatives.

High contrast mask

There are occasions when the use of a strongly illuminated white background or illuminated panel is undesirable on the grounds that it creates unwanted reflections on the subject and may, if excessively bright, produce halation effects. In this case

152

Fɪɢ. 10.8. Wild oats photographed over an illuminated panel and without any frontal lighting.

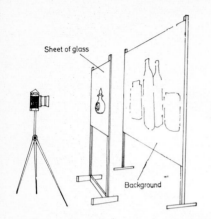

Sheet of glass

Background

FIG. 10.9. Method of photographing a small object to obtain either a shadowless background or one of an abstract nature. The object is attached to the glass with modelling clay and thus appears to float in mid air.

the two-negative method offers the most satisfactory solution. The first negative is made using a normal emulsion and consists of the subject which has been lit in the most advantageous manner possible and without attention to the background. The second exposure is made with a high contrast emulsion of the type used in process work with an illuminated background at some distance behind the subject and with no light falling on the subject. This second negative produces a sharp, high contrast silhouette of the subject which is then used as a mask when printing the 'normal' negative. In fact the two negatives can be bound together in exact register and filed as a single negative. It is, of course, necessary to have the camera rock-steady so as to ensure that there is no displacement of the camera in changing the dark sides. The focus and diaphragm of the lens should be the same for both exposures.

CHAPTER 11

Formation and Control of Reflections

Just as shadows play an important rôle in visual perception, as we have seen in the previous chapter, the presence or absence of specular reflections, their size, shape, colour, brightness, etc., provides us with valuable information about the nature of a surface, whether it is rough, smooth or polished; about its shape, whether flat, curved or irregular; and about the nature of the illumination, whether directional or diffuse, and if directional, something about the location and number of light sources. Certain objects such as polished metalware, glass, porcelain, enamel, etc., are characterised by specular reflections and if seen or photographed under conditions which prevent their formation, may well lose their character and be taken for something else. Transparent materials such as colourless glass, 'Perspex', Cellophane, etc., exist visually solely by reason of specular reflections. Thus we are normally not visually aware of the sheet of glass in a window unless it happens to be dirty or reflects light which approaches or exceeds the brightness of the light reflected from objects or scenes which it transmits, unchanged, to our eyes. From the inside, glass is usually invisible, but from the outside as when viewing a shop window, the reflections are often equal to or stronger than the transmitted light and thus interfere with a sheet of curved or concave glass with the object of eliminating reflections. In fact, the absence of reflections can be so complete as to give the impression that the goods are on open display and could easily be touched.

On the other hand there are many objects and materials which are partly identified by their absence of specular reflection: objects made of natural stone, clay (terracotta), unpolished wood are typical. There are objects which come somewhere between the completely matt and the highly polished, a characteristic which is found in the majority of manufactured goods and in such natural things as foliage, fruit and the skins of animals. The control and rendering of specular reflections, whether they be the sparkle of sunlit water, the sheen of silks and satins or the catch-lights in glass and metal-ware, are important aspects of the photographer's art and often distinguish the work of the 'maestro' from the mediocre worker.

Reflection

A ray of light falling on a flat polished surface is reflected so that the angle of incidence is the same as the angle of reflection, and the reflected light is in the same plane as the incident light, see Fig. 3.7. This reflection is termed specular reflection after the Latin word *specere* (mirror). Thus a perfectly flat mirror reflects the rays of light falling on it in exactly the same relationship, though reversed from left to

FIG. 11.1. A perfect mirror exists only in terms of what it reflects. In the first example it is indistinguishable from the wall and the frame could be empty. It is clearly seen as a mirror in the second version.

right, thereby producing a duplicate image of the object it reflects. If the surface of a mirror is convex or concave it takes on the characteristics of a lens.

A matt or rough surface, such as that of a slab of chalk, is characterised by micro-irregularities. Different parts of a parallel beam of light therefore meet the surface at different angles and may be reflected at almost any angle to the main plane of the slab of chalk. Such reflection is termed diffuse or scattered and were it not that most surfaces have something of this characteristic, we should have great difficulty in identifying the objects which surround us.

Another phenomenon of reflection is that nearly all surfaces whether coloured or not, reflect a certain amount of the light falling on them unchanged in terms of spectral composition. This is by nature a specular reflection from the 'outer' skin of the surface, the surface proper determining the selective reflected light which gives the object its tone and colour. As we have seen, if the surface is flat and highly polished, the specular reflection will be limited to a certain angle, namely, that of the incident light striking the surface, the reflection being in the opposite direction. This explains why reflections are far more characteristic of back-lighting or against-the-light viewpoints since we are at the 'receiving' end. However, with a matt surface,

these outer skin reflections tend to be seen in all directions along with the light reflected by the surface proper. The effect is to dilute colours and tones with a small proportion of white light so that they appear less saturated. Thus by glazing pottery, varnishing wood, or merely wetting a matt surface, the colours become more vivid and the tones darker.

Nature of illumination

Specular reflections are a characteristic of both the surface and the light falling on the surface. If the light itself is strongly directional such as that coming from the sun, a spotlight or a point source, the reflected light will itself be strongly directional. This applies to some extent even with a matt surface and explains why colours and tones appear more saturated under strongly directional illumination than when illuminated with diffuse and multi-directional lighting. In fact a highly glossy object such as a glazed vase may appear to have a matt surface when viewed

FIG. 11.2. The specular reflections from the surface of the darker vase reveal that it is glazed. When these are removed as in the lower version, the two vases appear to have the same finish. See also Fig. 11.11.

FIG. 11.3. Silverware photo-graphed with existing room light-ing and inside a photographic tent.

or photographed in totally diffused light coming equally from all directions. A similar effect, see Fig. 11.2, can be obtained in a photograph merely by retouching it so as to eliminate all specular reflections, and it can also be achieved by means of polarized light, see page 164. Under diffuse light, specular reflections themselves become diffuse and mirror-like surfaces such as those of polished silverware can be modified in appearance according to the lighting they receive. Under a strongly directional light source they are seen as a complex of extremely light and dark re-flections, whereas under uniform diffused lighting, such as that given by a photo-graphic tent, they take on the appearance of white plastic, see Fig. 11.3. Thus it is possible to modify the appearance of objects having a mirror-like surface by mak-ing changes in surfaces which surround them and whose reflected light they re-reflect, see Fig. 11.4.

It is, of course, also possible to modify a surface for the purposes of photo-graphy. Undesirable specular reflections from a polished surface can be reduced or eliminated by dusting the surface with powder or spraying it with a colourless matt varnish. This is frequently necessary when it is desired to use directional

light—usually when the subject matter consists of a collection of objects of different nature, such as a dining table set for a meal with silver and glassware, a bowl of fruit, a basket of rolls and a vase of flowers. The last three items would benefit from directional lighting, whereas the silverware and possibly the glassware, would benefit from highly diffused lighting.

Lighting for glassware

Because of the difficulty of controlling reflections from objects made of clear glass, they are usually photographed against an illuminated background, the background being a sheet of white paper for black-and-white photography, with the possible choice of a coloured material when shooting in colour. To avoid possible spill light from lamps used to illuminate the background, a sheet of flashed opal glass, illuminated behind, can be used. Glassware is often placed on a sheet of glass and, in addition to the background lighting, diffused lighting directed upwards from ground level, see Fig. 11.6. If it is desired to add highlights to the glass by way of reflections, these must be applied very sparingly and can best be done by using a small fluorescent strip-light fairly close to the camera and a little above eye-level.

Another method of photographing glassware is to use a black-background and direct a beam of light from a spotlight either from below (this can be done via a mirror) or from one side and slightly in the rear. This can be particularly effective with cut glass as the light shows up the various facets.

With colour film, various colour effects can be obtained by using an illuminated background, coloured or of neutral tones, and directing coloured beams of light from the sides, above or below.

FIG. 11.4. The appearance of a vacuum flask in different surroundings. Only the plastic cap and the label remain relatively unchanged.

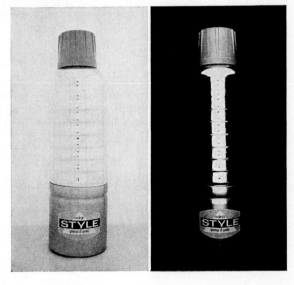

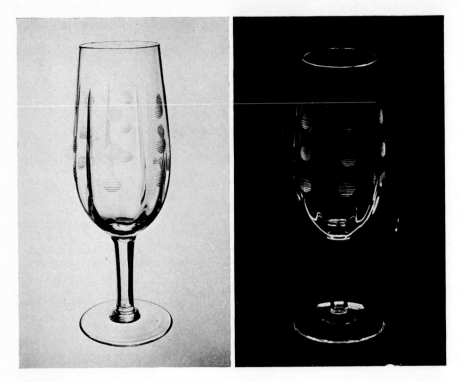

Fig. 11.5. Two versions of the same glass. That on the left is photographed by the lighting arrangement shown below in Fig. 11.6, while that on the right is illuminated only from a narrow slit under the base of the glass.

With glassware having an etched design, it is preferable to show the etching as a lighter tone against a darker background. In this case it is necessary to employ frontal lighting which can take the form of a small diffused spotlight.

There are of course many variations of the methods mentioned above and the

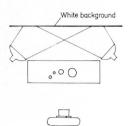

Fig. 11.6. Lighting arrangement commonly used for photographing glassware. The subject can be supported on a sheet of glass to enable diffused lighting to be directed upwards as well as behind.

student of lighting can obtain much practical information by exploring the variations for himself. The glass in Fig. 11.5 is an example: the only illumination was supplied from a ½ in. slit at the base.

Objects with shiny surfaces

Any perfectly smooth object will have mirror-like qualities in that it tends to reflect the images of its surroundings. If it has flat surfaces—for example, a chromium-plated toaster—the images will be clear and undistorted, while if the surfaces are curved or irregular, the images will be more or less distorted to the extent of becoming a mixture of highlights and darker tones. If the surface is made of metal, such as silver, chromium, aluminium, almost all the light will be reflected with very little change in spectral composition: with certain other metals, such as gold, copper and brass, the reflections take on the colour of the metal. With non-metallic surfaces the reflections are non-selective in terms of colour, though their appearance will be modified by the light reflected from the surface proper. We have already mentioned this double surface effect earlier in this chapter, page 156. For example, with white china or porcelain only 'highlight' reflections, those arising from actual light sources or very bright areas such as windows, are apparent since the reflected light from the white under-surface 'kills' the weaker, specular reflections. On the other hand, a glossy black surface becomes a kind of dark mirror from which reflections retain both tonal and colour differences. Between these two extremes we have objects of various tones and colours which give reflections more or less modified by the nature of the light reflected from the surface proper. For example, a shiny red surface will give a strong red cast to the reflections, though strong highlights, such as reflections of light sources, will still appear white.

The phenomenon of specular reflections poses certain problems to the photographer. For example, an ordinary mirror has no characteristic tone or colour and reflects only the tones and colours of the objects it reflects. A photograph of a framed mirror hanging on a wall could easily appear to be a photograph of

FIG. 11.7. The first photograph was lit from above in order to obtain the circular effect. It can be seen that the polished metal parts of the subject are not clearly defined. To achieve this, a small reflector was placed so as to render them uniformly white.

FIG. 11.8. A glazed coffee pot lit with a single light source. Reflections from the light background and base give it a false outline.

a picture unless it reflects something which could obviously not be the object of a picture, such as an area of a facing wall or window, or the objects it reflects are also included in the photograph, see Fig. 11.1. In fact, one method of taking one's own portrait is to use a mirror and then print the image in reverse. The same characteristic applies to an object of polished silver: we tend to think of silver as 'white' because it reflects a white surface as white and our surroundings usually contain large areas of white. But if a silver object is surrounded by dark surfaces and illuminated with a strongly directional light source (a point source or a beam of focused light), it will appear rather as a black object having certain highlights, see Fig. 11.3. It is for this reason that directional light sources are rarely used in photographing polished metalware except to add controlled highlights. To obtain the appearance of 'whiteness' it is therefore necessary to create large areas of uniform whiteness which will be reflected from the object as seen from the camera viewpoint. This is the function of the photographic tent, which provides uniform whiteness from all directions. Not that a tent is always necessary or desirable when tackling metalware: if the object is flat, as with an engraved plaque or a beaten panel, a single white surface will be sufficient if the subject matter contains both metal and non-metal surfaces, it may be desirable to use chiefly directional lighting and restrict the use of white reflecting surfaces to a limited area of the metallic components, see Fig. 11.7. In practice the most useful kind of reflector is one consisting of a sheet of curved material having a white matt finish which is situated immediately in front of the camera and is provided with a small hole in the centre

FIG. 11.9. These two versions of the coffee pot demonstrate how surface reflections can be controlled inside a photographic tent. The darker lines are obtained with strips of black paper draped over the outside of the tent. The diagram shows the tent open, but it can be completely closed leaving only a small hole for the camera lens.

large enough for the lens, see Fig. 7.14, page 119. The reflector can be made of thick card, sheet metal or, if a large area is required, of thin 'Masonite'. It can be illuminated by two or more lamps which are well-screened to prevent direct light reaching either the subject or the camera lens. With objects which can be photographed from above on a horizontal plane, a white ceiling may serve the purpose, the lighting being directed upwards. A white wall or large expanse of window fitted with white net curtains may serve the same function for objects photographed in a vertical plane. If necessary the ceiling or wall can be supplemented with side reflectors.

Generally speaking, jewellery consisting of brooches, necklaces and bracelets—

the latter when they can be opened flat—medals and coins, wrist watches, etc., require only a single curved reflector placed in front of the camera provided with a hole for the lens.

The need for a tent arises chiefly with articles having spherical or cylindrical forms which act as very wide-angle reflectors, see Fig. 11.9. However, even here it is usually necessary to introduce both shadows and highlights. The shadows are introduced by covering certain areas of the tent with pieces or strips of opaque material. Examples of this are given in the three photographs in Fig. 11.8 and 11.9. Highlights are introduced by means of a small diffused spotlight or, if the objects have a roughly cylindrical form, with a small fluorescent strip-light. However, not all subjects are suitable for 'tent' treatment and more acceptable effects are obtained with directional light, see Fig. 11.10.

Non-metallic shiny surfaces

The photographer is faced with a somewhat different problem in dealing with objects such as glazed pottery, varnished wood, enamelware, coloured glass, or with cellulose finish, etc. The effect of multi-direction diffuse illumination such as that given by a tent will limit reflections to a uniform addition of white light to that which is reflected by the surface proper. In other words tones and colours will appear considerably diluted by an overall veiling of white. This kind of lighting, plus carefully controlled highlights, can be suitable for subjects of strong tonal contrast or colours, but may prove unsatisfactory for objects or delicate tones and colours. It is necessary to introduce highlights with a small spotlight otherwise the effect can be that of non-glazed pottery, etc. On the other hand the use of strongly directional light with the purpose of obtaining full colour saturation may suffer from the effect of excessively bright highlights. In this case the best solution could be to use polarized light (lamps fitted with pola-screens) and to control the intensity of the highlight reflections with a pola-filter over the camera lens. This technique is discussed later in this chapter.

Objects of uniform dark tones offer considerable scope in the play of reflections when using tent illumination. Strips of black paper can be used to break up a uniform area of white as a means of emphasising curves and other shapes. Various effects are shown in the three examples of a coffee pot on pages 162 and 163.

Control of reflections with a polarizing filter

Specular reflections from non-metallic surfaces are strongly polarized when the angle of incident light is 34° with the surface. Polarization is less at smaller or greater angles, reaching zero at 0° and 90°. This phenomenon can frequently be put to good use as a means of reducing specular reflections which would otherwise interfere with the detail or colour of a surface. The effect of a polarizing filter from any given viewpoint can be judged visually since the photographic effect will be the same. It is chiefly of value when photography must be carried out with existing lighting conditions. For example, in photographing an interior from a viewpoint facing windows, reflections from the tops of polished furniture may be reduced or eliminated. Reflections from glass as in the case of shop windows, or of a subject below the surface of water may be entirely eliminated by choosing

FIG. 11.10. Two versions of a metal baking dish photographed with directional and diffused lighting. In this case the directional lighting gives a more acceptable effect.

a viewpoint of about 30° to the surface of the glass of water, see page 96, Fig. 6.10. In outdoor photography a great many surfaces reflect a portion of the skylight from their outer skin. Under a blue sky this reflected light tends to degrade colours with a bluish caste. By using a polarizing filter when exposing colour film the result will show cleaner, more saturated colours.

However, a single polarizing filter is of little use in the studio since it will only be effective with reflections reaching the lens at angles of from 20° to 45° from the reflecting surfaces. Thus it is of no use in controlling the reflections from irregular flat surfaces, such as those of oil paints, when these are at right-angles to the camera. Also it will have no effect on reflections from metallic surfaces which are non-polarized. To be effective it is necessary to illuminate the subject with polarized light by placing polarizing screens in front of the lamps. In this case the specular reflections will remain as polarized light at all angles, whereas the light reflected from the surface proper will have been de-polarized. It is thus possible to apply a polarizing filter to the camera lens to reduce or eliminate specular reflections from any surface, metallic or non-metallic and, at any angle. Full control is obtained when the two polarizing media, that in front of the lamp and that in front of the lens are 'crossed', that is, the planes of polarization are at right-angles to each other. If more than one light source is used, it is possible to orientate the screens covering the lamps either in the same plane so that all specular reflections are controlled equally by the polarizing filter over the camera lens, or to vary their planes for different lamps. For example, if it is desired to retain the highlight reflections arising from a particular light source, the screen in front of this lamp can be orientated to a position which corresponds more or less with the plane of the filter in front of the camera lens after this has been adjusted to eliminate reflections arising from other light sources. The total elimination of reflections is rarely desirable as it creates a false lighting effect. An example of

Fig. 11.11. The righthand version of a glazed object shows the complete control over specular reflections which is possible with polarized light. In the left hand version the polarizing filters are in the same plane of polarization.

this is shown in the photograph above Fig. 11.11, where a ceramic figure, has been photographed with fully crossed polarized light so as to eliminate all reflections. However, from the shadow which has been cast, it has obviously been lit with strongly directional light and in keeping with its glossy surface should obviously show specular reflections.

The control of reflections from glossy surfaces with polarizing filters applies only to those which arise from the polarized light sources themselves and not to those which are caused by light reflected from adjacent surfaces even though originating from a polarized light source, since it will normally have been de-polarized in the process of reflection. The only exceptions are when the reflected light is itself specular or when it happens to be falling within the range of 'natural' polarized light, that is, reflections from a surface at an angle of about 34°. Thus it is possible to use a metal reflector to re-direct polarized light since it remains polarized, whereas the light reflected from a matt white reflector will be de-polarized. This may seem rather complicated until it is put into practice when it is possible to see the effect of any particular set-up by viewing it through a polarizing filter.

The use of crossed polarized light may produce abnormal effects in certain circumstances. This occurs with transparent plastic objects which show 'rainbow' stress-patterns when viewed or photographed with transmitted polarized light

Diffused light.

Directional light.

Polarized light.

FIG. 11.12. The three versions of a gold and blue painted florentine tray are the result of different lighting. In the top version the blue paint appears darker than the gold, whereas the tones are almost reversed in the bottom version which was made with polarized light.

through a polarizing filter. Such effects also arise with crystal formations and polarized lighting is used on microscopy for the study of crystals and also by photographers with an artistic bent! Metallic surfaces, as we have already noted, rely on specular reflections for their 'visual' appearance and if photographed under conditions where they are illuminated solely by polarized light will appear dark in tone. For example, if an oil-painting is photographed in a 'gold' frame with crossed polarized light, the frame will take on a very dark tone. An example of this is shown on page 167, Fig. 11.12, where a gilt and painted florentine tray has been photographed under different lighting conditions. It can be seen that the tones between the gilt and the paint (light blue) have been reversed.

When used with high efficiency lamps, polarizing screens should be large enough to allow them to be mounted at least 6 in. from the lamp otherwise they may be damaged by the heat of the lamp. They should be mounted in a frame which can be rotated through 90°. Commercial units are available. When used with electronic flash, the polarizing screen can be mounted in the slot which is usually provided with professional units. Its effect can be judged by placing it in front of a pilot light. If the screens are marked with a small white spot of paint or adhesive plastic to indicate the plane of polarization, it becomes a simple matter to check that all the lamp filters are in the same plane in relation to that used on the camera when a fully crossed combination is required.

Considerable increase in exposure is needed when using polarizing filters owing to their absorption of light. A single filter used over the lens requires from 2 to 4 times increase over the normal depending on the particular filter used and to some extent on the nature of the subject. For example, when photographing an object having dark tones, such as stained and polished furniture, the elimination of specular reflections will reduce the total light reflected from a surface to that reflected by the surface proper, in this case to the very small amount reflected by the dark tone of the wood. The effect of the polarizing filter is to increase contrast in the direction of darker tones and to compensate for this, additional exposure is usually necessary.

When both the light source and the lens are covered with a polarizing filter, the increase is from 8 to 16 times the normal. The exact increase should be established with tests made under typical lighting arrangements of a subject offering a full range of tones. It is useful to include a grey scale in the photograph, as this will allow comparisons to be made between exposures made without polarized light, see page 189, Fig. 13.4. The increase in contrast can also be judged from such a test.

When polarizing filters are to be used with colour film, it is advisable to make a preliminary test for colour rendering. This will indicate any need for a correction filter when exposing reversal colour film.

Highlight reflections by retouching
It is worth mentioning in this chapter the possibility of adding highlights, where they are lacking, by retouching a negative or, if they are to be very small, as for example, catch-lights in the eyes and hair, by knifing the print. More extensive reflections can be added with a white retouching medium. Bearing in mind this possibility, it is often possible to use a lighting arrangement which avoids excessive highlight reflections without resorting to the use of polarized light.

CHAPTER 12

Lighting for Portraits

While it is possible to use almost any kind of lighting for making a portrait—even the light from a match is usable with a fast film—the purpose for which the portrait is made or requested will frequently determine the kind of lighting to be used, or at any rate suggest the most suitable kind of lighting, since this may not always be available. A portrait may be required—and most frequently is—for identity purposes, in which case the lighting is required to be predominantly frontal with the subject facing the camera. The object of the photograph is solely that of a physical likeness and it is not required to reveal anything of the character of the individual. In any other kind of portrait it is desirable to capture something other than a 'blank' expression (in practice it usually turns out to be an idiotic or guilty expression), and better still to suggest something of the character of the person. This may be regarded as pertaining to the psycholoty of portraiture and not that of the lighting, but, in fact, the kind of lighting and the way it is applied are important contributory factors in successful portraiture. Firstly, there is the subject's attitude to having a photograph taken. Most adults have a certain distrust. almost a fear, of posing for a portrait. Probably it boils down to a belief that the camera will not do them justice (whereas a painter would) and often greet the photographer with a remark such as 'I never make a good photograph'. This is very likely based on some casual snapshot made by a novice in whatever lighting happened to be available or with a flashbulb fired from the camera. And when confronted with someone they regard as a 'real' photographer, there is the frightening possibility that the result may confirm their belief. Probably few people are satisfied with what they can see of themselves in a mirror, but with repetition there is a tendency to accept the image, to become a little blind to its defects. And unless they are used to having their portrait taken, as in the case of models, actors and actresses and important public characters, even a well-executed portrait may come as something of a shock to their personal esteem. On the other hand, if the photographer has been sufficiently clever in his approach, they may be pleasantly surprised to discover that they are not, after all, such a dull-looking person. In many cases the success lies in the way the lighting has been applied. Children are not, as a rule, self-conscious until they reach adolescence, but they can easily be over-awed or even frightened with an aggressive display of lighting equipment. Lighting should therefore be kept as simple as possible for a 'first occasion'. Child models who are now available by the hundreds to meet the frequent demands of advertising, would probably be disappointed not to be greeted with a battery of lamps.

169

The level of illumination is important in portraiture and should be such that the eyes of the subject can accommodate themselves comfortably and without excessive use of the iris. If the level is too high the iris may become too small while at very low levels it may appear too large. A common fault in the use of flash lighting occurs when the existing lighting is low enough to require full use of the iris, whereas the photograph has obviously been made at a 'normal' level of illumination. In actual fact the flash represents an extremely high level, but with the exposure properly adjusted it appears to be normal in the photograph. Since the flash is too brief to record any reaction on the part of the eyes, they are recorded as eyes adjusted to a much lower level of illumination, see Fig. 12.1. To avoid this it is necessary to make the exposure wherever possible with a reasonably high level of ambient illumination.

When high efficiency studio lamps are to be used, it is desirable to allow the subject enough time to get used to the lighting. For this reason, the lamp-saving expedient of running photoflood lamps in series while setting up the lighting plan and then in parallel for making the exposure is not ideal as the subject tends to become dazzled by the sudden increase in illumination.

Strong sunlight is also too dazzling to the eyes and is suitable only when the portrait takes on the nature of an outdoor subject wearing sunglasses.

The level of illumination should normally be sufficient to permit the use of an exposure time short enough to allow for slight movements on the part of the subject. For adult subjects seated comfortably, satisfactory results can be obtained with exposure times ranging from a 1/15 to 1 sec. see Fig. 12·3, page 173. Still longer times can be used if the subject is leaning against a wall or some other support— indeed, in the early days of photography, exposures of several minutes were

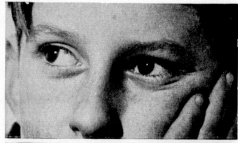
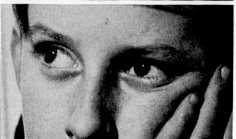

Fig. 12.1. The pupils of the eyes adjust themselves to the existing level of illumination and are unaffected by a flash exposure. In poor lighting, they thus tend to be too large, as can be seen in the lower version.

FIG. 12.2. A single electronic flash unit positioned to one side and well above eye-level can provide adequate illumination for a casual portrait. Note also the crispness of the definition obtained with electronic flash.

necessary and the subject was kept motionless by means of a head clamp. With young children it is desirable to be able to shoot at 1/60 sec. and better still at 1/120 sec. To this end it is preferable to use a fast film since the increase in graininess when using a small format negative is usually the lesser evil in terms of image sharpness. In fact loss of sharpness due to almost continuous slight movements of a subject which are rarely apparent to the eye can only be properly eliminated with exposure times of the order of 1/500 to 1/1000 sec. This becomes apparent when comparing photographs exposed with electronic flash with those exposed at 1/60 sec. There is a crispness of fine detail in the former which is nearly always lacking with longer exposure times. Of course, it can be maintained that such fineness of detail is rarely desirable in portraiture since it tends to reveal small defects by way of facial hair, pitted skin, etc. which are best unrecorded. This, however, rarely applies to children and young adults, and, in any case, 'excessive' definition in a negative can easily be reduced by applying some diffusion to the print image.

171

Choice of lighting

There are photographers who maintain that the only suitable lighting for por-
traiture is daylight, preferably daylight which is in some way restricted so that it
forms a directional light of soft, diffused characteristics, light, in fact, coming from
windows, through open doorways and other restricted localities. Fig. 6.5. They
claim that not only is it natural lighting from the subject's point of view and
therefore more evocative of natural reactions from the subject, but also in the
lighting effects produced which are always 'sincere' whereas artificial light always
induces a certain restraint, a certain unresponsiveness on the part of the subject
as well as a degree of 'falseness' in the lighting effects.

There are others who claim that any effect obtainable with daylight can be
duplicated in the studio with artificial light, while, at the same time, it is possible
to produce a whole range of lighting effects not possible with daylight, see Fig. 12.3.

It depends what one means by a portrait. If it is to be a sincere study of a
person's character, an aspect of his personality as other people see him, there is
much to be said for using daylight. But in fact a portrait might have an entirely
different purpose—that of 'glamorizing', or falsifying the natural appearance of
the individual for such purposes as advertising, the building up of a personality in
the vast field of entertainment, or as a means of satisfying a client in the normal
course of professional portraiture where a little flattery always pays off. Such a
scope calls for sophisticated lighting, such as that given by spotlights, which can
produce interesting catch-lights in the eyes, lips and hair as well as a range of
often exciting and startling back-lighting effects. Admittedly such effects are false:
rarely, if ever, is anyone seen under such lighting conditions. But this is not
important if the result is to glamorize, to render more interesting and exciting the
person whom the photograph portrays.

But, of course, there are other considerations. Whereas almost any source of
light can be used for black-and-white photography, colour films must be exposed
with light which closely matches the colour balance of the three-layer emulsion.
Some latitude is possible in the direction of 'warmer' colouring (slightly yellower
lighting) and in 'colder' colour rendering (slightly bluish lighting), but the amount
may be critical, depending on the complexion of the subject. For example a
'ruddy' complexion can easily become a 'boiled lobster' colouring with too much
yellow, whereas someone with a 'delicate' complexion may appear corpse-like
with too much blue. Other colour biases are usually only acceptable if the source
of the coloured light is apparent in the photograph. However, the somewhat bluish
effect obtained with overcast daylight, and lighting from windows in interior
portraits is now commonly accepted as being more natural than the same lighting
corrected by means of a Wratten 1A so as to give a warmer colour rendering more
in keeping with sunlight. This can undoubtedly be attributed to the frequent use
of 'sincere' or 'candid' portraits made with daylight and widely used in advertising.

In many cases, where the existing lighting is too weak to permit short enough
exposures even with a fast black-and-white film, some form of flash lighting may
be the only alternative. This commonly occurs in photo-reporting and results,
unfortunately, in the all-too-familiar flash portrait taken with the light source
mounted on the camera. A rather similar kind of portrait is now all too common
when flash is used as the principal light source in portraits taken under conditions

FIG. 12.3. An artificial light source used to suggest that the subject is near a window. A single spotlight was used.

FIG. 12.4. Two studies of the same subject which demonstrate how lighting can affect the character of a portrait. On the left, the harsh side-lighting emphasises the forcefulness of the attitude, while the softer, frontal lighting of the second study preserves the calm approach of the sculptor to his work.

of strong sunlight. Though the intention of the photographer may be to use flash (again mounted on the camera) as a fill-in light, the result, judging by what is published in magazines carrying a good deal of colour, is to relegate the sunlight to the role of an incidental background light. No doubt this is desirable from the point of view of photo-mechanical colour reproduction, but it has made portraits in colour terribly monotonous in terms of lighting.

Direction of light

When strongly directional light is to be used, there should only be one main light source and all other lights should be of a supplementary or auxiliary nature. The direction from which the main light comes in relation to the camera determines the direction and extent of any shadows that it makes. These will be very small with frontal lighting and increase as the direction increases in angle with the lens axis. With side-lighting half the head will be in shadow and with full back-lighting the whole head. While there are certain conventions in choosing the direction of the main light, the photographer is free to choose whatever direction he feels may best produce the effect he wants to achieve. Some of the best portraits of children

174

Fig. 12.5. A high key portrait using a single spotlight placed at a considerable distance from the subject.

and beautiful women are those made with very nearly frontal lighting, a single spotlight placed well away and high enough to make a vertical angle of about 30° with a horizontal level with the eyes. Many of the older 'schools' of photography favour a direction midway between a frontal and side-lighting so that a small patch of light, usually taking the form of a triangle, falls on the cheek which is in shadow. Another useful convention is that the head should be turned to face towards the main light. Thus a profile portrait would be lit from the side to which the head is facing.

In terms of height, the main light should preferably come from above the plane of the subject even if only a small angle of elevation is used. Horizontal light is acceptable in portraits which suggest a nearby window or table lamp and is also in keeping with lighting soon after sunrise or shortly before sunset. Lighting coming from below the plane of the eye is only acceptable if it is obviously coming from a fireplace, otherwise it produces a macabre effect, see Fig. 9.2.

The direction of light and hence of the shadows can often be chosen to minimise or conceal defects. Thus a scar on the cheek can be kept in the shadow or a double-chin minimised by raising the altitude of lamp. Oblique lighting should be avoided with a pitted or pimply skin since it tends to exaggerate the condition

Indeed, the best treatment is often to use highly diffused lighting when there are defects of the skin.

Lighting contrast

Rather more lighting contrast is acceptable in black-and-white than in colour photography in what might be described as straight portraiture, though in both cases extreme contrasts can be applied for dramatic effects. In terms of the lighting ratio between the main light and any supplementary or reflected light falling on the shadows, a ratio of 3 : 1 is very suitable for black-and-white portraits and a ratio of 2 : 1 for colour. This can be checked by taking meter readings using a white card in the manner described on page 77. However, the amount of lighting contrast depends to a large extent on the nature of the subject and the mode of presentation. Generally speaking a considerably lower contrast is desirable in portraits of children and young women than for men and older women and this applies even more so to colour work. This is because the natural colouring and perfection of skin is best preserved with lighting which is almost uniform and

FIG. 12.6. A low key portrait exposed with the rays of a setting sun which penetrated a deep archway. The archway excluded light from the sky.

Fig. 12.7. The lower lighting contrast of the left-hand portrait is very suitable for colour photography, while the higher contrast of the second version is more in keeping with the requirements of black-and-white photography. It can be observed that back-lighting gives much stronger modelling to the features. On the left, the fill-in was provided by a second lamp; on the right, with a white reflector.

gives little more than a suggestion of contrast. It is for this reason that bounced flash has proved so successful in child portraiture.

The use of strong lighting contrasts often helps to convey a sense of strength and ruggedness in men or to suggest great depth of character and a strong personality. Thus, whereas high-key lighting is chiefly suitable for children and beautiful young women, low-key lighting is generally more effective with older people whose faces reveal more of their character.

Back-lighting effects

The normal lighting contrast between the main light and shadow lighting may be further strengthened by introducing highlights in the hair or along the outline of the face and shoulder. Such effects are best obtained with a small spotlight situated somewhere in the semi-circle behind the subject. The height of the spotlight depends partly on the effect desired, but in practice only a spotlight well to one side or immediately behind the subject can be used in a horizontal or near horizontal plane otherwise it will come within the angle of the lens. For this

FIG. 12.8. Silhouette effect obtained by placing a small spotlight immediately behind the subject. The second version shows the effect of the back-light on its own.

reason, a back-lighting unit is usually situated well above the subject. In this position it more frequently serves to add highlights to the hair.

As with normal lighting contrast, considerably stronger back-lighting effects are acceptable in a black-and-white portrait than in a colour one. It is used chiefly to add glamour, since it is basically a false lighting effect. However, used with restraint and chiefly as a means of obtaining delicate reflections in the hair, it gives a certain finish and polish to a formal portrait.

Background Lighting

This may be required when a background is some distance behind the subject and is consequently not sufficiently illuminated by the main light, or when the main light takes the form of side- or back-lighting. If the background is to be rendered in normal tones then it must be illuminated to the same level as the subject. The placing of background lighting depends on the space available. If there is ample space it can be applied with two flood lamps placed as for copying, see page 184, unless it is necessary to retain the same effect of light and shadow

FIG. 12.9. Three lamps were used to light this study: one as main light, one as fill-in and one as a back-light for the hair.

179

Fɪɢ. 12.10. Left, silhouette obtained by lighting the background only. Right, an exposure made against the same background but lit normally.

applied to the subject in which case a single lamp must be used which occupies a similar position in relation to the background as the main light does to the subject. If the space is restricted, it is often possible to place a single background lamp immediately behind the subject.

When the background is of uniform tone or is to be rendered very much out of focus, the lighting level may be used to control the tone or colour of the background in relation to the subject. With less illumination it becomes darker in tone or colour and with more illumination lighter. For example, in colour portraiture a piece of blue material used as a background can be rendered in any shade from light to dark blue.

A plain background of light tone offers considerable scope for using projected shadow effects. These may take the form of abstract shapes such as a circular patch of light added to give contrast between the tones of the subject and the background, of recognisable patterns such as those of foliage, a lattice window or venetian blind, see Fig. 12.11.

The use of back-projection and coloured lighting offers further scope to the imaginative photographer, see page 201.

Summary

No attempt has been made to give specific lighting plans since they are rarely of any help in practice. Existing lighting conditions, often referred to as available lighting, offer many possibilities for portraiture. The art of the photographer lies in recognising favourable lighting in terms of the photographic process which as we have seen, tends to exaggerate visual contrasts. In this connection it is often helpful for the student to make use of an M.V. filter (M.V. stands for monochromatic vision) which has the effect, when held for a few seconds in front of one eye, of neutralising colours and emphasising the contrast of light and shade as it will tend to appear in a photograph. If the filter is used for a longer period, the eye will adapt itself and its effect will be reduced.

An important 'rule' in portraiture is to keep the lighting as simple as possible. There is no great virtue in making use of a multitude of light sources, even though it may reveal a great deal of skill in a technical sense. A surprising variety of effects can be obtained with a single light source, used either without or with a reflector board as fill-in. The student would do well to explore these before he tackles the complications which can arise from the use of additional sources.

An experienced photographer can tell merely by studying a photograph what kind of lighting plan was used and if he finds the photograph pleasing, he should have no difficulty in applying it to his own subjects.

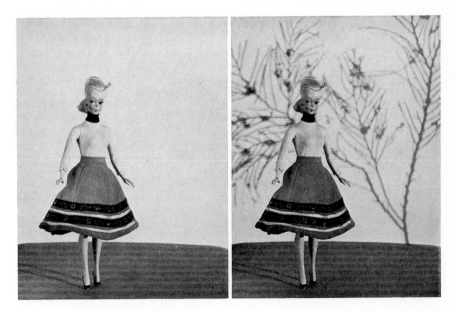

Fig. 12.11. The shadow background on the right was obtained by holding a sprig of foliage in the beam of a small spotlight.

CHAPTER 13

Copying

The copying of flat originals for the purpose of making photographic records in monochrome or colour occupies a rather specialised field in photography, though it frequently happens that the general photographer whether professional or amateur is called on to undertake such work. For example, many painters early in their career can ill afford the services of a specialised studio and often seek the help of some acquaintance who is equipped with a camera. Other artists, given some guidance, would prefer to make their own records, either in the form of small colour transparencies or as negatives in black-and-white or colour which can be sent to a professional laboratory for processing and printing. For this reason we shall consider both makeshift methods as well as specialised copying set-ups.

However, it is fitting to begin with a word of warning regarding the quality of colour reproduction using direct photographic methods such as reversal colour films and negative colour films intended for producing prints and transparencies. The pigments used by artists, the inks used in printing and the dyes used in fabrics, tapestries and carpets may give photographic results which differ considerably from their visual appearance. This is quite apart from deviations of colour rendering arising from errors in exposure or from the use of lighting which has not been properly balanced for the type of colour film being used. In addition, further differences in colour rendering, usually of a minor order, will be found to exist from the use of different types and brands of colour film and even the same type of film if it belongs to a different emulsion batch. Finally, differences in the age, storage and processing of a particular type of colour film may introduce yet further departures from its normal colour rendering. Methods of standardising conditions in direct colour copying will be discussed later in this chapter.

Standards of copying

In a strict sense the copying of an original implies producing a duplicate which is accurate in geometry, detail, tone and colour and in some cases preserving as nearly as possible the appearance of the surface texture. As far as the dimensions of the original are concerned, these can, of course, be recorded as actual measurements. Thus the scale of photography may not be important as long as it is sufficient to record the detail, unless some later process of reproduction based on the photographic copy calls for a transparency or negative of particular size.

For example, adequate detail may be recorded in a 36 mm. colour transparency which is intended to be viewed by projection in the classroom or lecture hall.

On the question of geometry it is necessary that the lens be free from such aberrations as distortion, astigmatism, and for colour work, transverse chromatic aberration. Lenses designed for copying flat originals and used on process cameras are often referred to as apochromats. They are costly and of relatively small aperture. However, the majority of high-grade general purpose lenses of normal focal length (as distinct from wide angle or telephoto lenses) give satisfactory results at an aperture 3 or 4 stops below the maximum. Distortion, if it is present, soon becomes obvious in copying rectangular pictures since the sides may show either a slight convexity (barrel distortion) or a slight concavity (pin cushion distortion). The lens must also give acceptable definition at the edges of the field and a suitable test for adequate coverage is to photograph a sheet of newspaper at different lens apertures.

Cameras for copying

Cameras intended specifically for copying form part of an assembly which includes a copying easel and a base or vertical column which keeps the focal-plane of the camera centred and parallel to the copying easel while permitting the distance between the two planes to be adjusted according to the size of the original or the scale of photography required. Some enlargers, such as the Durst series, may be converted to reproduction cameras with additional accessories and the base and column of almost any enlarger can be pressed into service as a copying stand for small originals. A number of camera systems provide copying accessories, and the handy photographer should have no difficulty in constructing a suitable copying stand if he is faced with a considerable volume of copying work.

For occasional work, a technical camera with a ground glass focusing screen offers the best possibility of setting the camera squarely with the original to be copied. It is an advantage to have the focusing screen ruled with squares as a means of checking rectangular shapes. For small format work a single lens reflex camera is ideal since it presents no problem with parallax. Cameras equipped only with a viewfinder are the least easy to use unless adapted for use on a copying stand.

Lens extension and exposure

The scale of copying frequently demands that the distance of the lens from the focal plane is considerably greater than the focal length of the lens. In this case the value of f/numbers is no longer valid for exposure calculations. The difference can safely be ignored if the extension is less than 1/10 of the focal length, otherwise the following formula can be used to find the effective f/number.

$$\text{Effective f/number} = \text{nominal f/number} \times \frac{\text{lens-to-image distance}}{\text{focal length}}$$

Uniformity of illumination

A basic requirement of copying flat surfaces is that the entire area to be photographed should be uniformly illuminated. This requirement can be achieved in a number of ways depending on the nature of the light source or sources being used. Where there is any doubt about the uniformity of the illumination, an exposure meter can be used to check the area concerned by measuring the reflected light from a sheet of matt white paper placed over the area to be photographed. Failing this, a photographic test can be made based on an exposure which will give a moderate density in the negative. A print from this negative made on a high contrast paper will reveal any unevenness in the illumination.

Methods of illumination

Depending on the volume or nature of the work to be undertaken, lighting can include sunlight, sky-light, or some form of artificial lighting. For a permanent copying set-up some form of artificial lighting is indispensable in the interests of standardising exposure, tone reproduction and colour rendering. The choice of lighting depends also on the nature of the surface to be photographed and the

Fig. 13.1. Lighting arrangement for copying.

effect desired. Lighting can also be of a highly directional nature, such as that from a spotlight, projector or direct sunlight, partly directional such as that of flood lighting, strip-lighting or daylight from a window, or wholly diffused such as open skylight or light reflected from matt walls, reflector boards, etc. In addition the lighting can be polarized by placing polarizing screens in front of the light sources. By using another polarizing screen in front of the camera lens almost complete control can be exercised over surface reflections.

Two lamp system

The usual method of lighting flat copy is with two lighting units situated one each side of the area to be illuminated so as to make an angle of lighting roughly 30° with the surface, Fig. 13.1. Each lamp is directed at the more distant half of the copying area. The distance of the lamps will depend on the area to be copied but should normally be at least twice the width of the copying area to ensure uniform illumination. If large originals are to be copied it is preferable to use two lamps on each side of the original in which case the lamp distances may be reduced. For copying black-and-white originals in black-and-white, the two light sources may be of any nature, including candles if the exposure time is not important. However, for copy up to 2 ft. in width two 150 watt pearl tungsten lamps in metal

reflectors permit reasonably short exposure times. For direct colour copying the lamps must be of the temperature-controlled type, balanced to suit the film being used, see page 42. A two-lamp system may also be based on two electronic flash units of equal light output and reflector characteristics or, if the occasion demands, two identical flashbulbs. Both types of flash lighting are suitable for colour work.

A two-lamp system provides satisfactory lighting for all subjects having a smooth surface. These include documents, printed copy, drawings, water paintings, smooth oil paintings, photographs and so on. It is also suitable for a subject having a textured surface where the purpose of the photographic copy is to record the colour and detail of the design or pattern it presents. With a subject having a shiny but irregular surface such as an oil painting, such lighting may be found to give specular reflections from peaks or ridges of the surface. It may sometimes be found that a change in the angle of illumination will overcome the problem, but in many cases satisfactory elimination of the reflections is only to be obtained by using polarized light plus a polarizing filter over the camera lens. An alternative is to use completely diffused illumination to equalise surface reflection, but this will give reduced contrast and colour saturation. Both methods are discussed later in this chapter.

Single light source

Uniform illumination may be obtained with a single light source placed to one side of the camera at an angle of about 30° from the lens axis. The lamp should be placed at least twice the camera distance with a lens of standard focal length so that the distance of the lamp from the near and far edge of the subject becomes negligible in terms of light intensity. However, if the light source is highly directional such as that of a 'beamed' spotlight or direct sunlight, the inverse square law of light propagation relating to a point source can be disregarded. With a spotlight it is necessary that the area covered is somewhat greater than the subject to be copied and that there are no irregularities due to the lamp filament. Some diffusion is usually necessary to avoid this.

A single source of directional light also provides the means of recording surface texture or for revealing raised or incised designs and lettering. Various effects can be obtained depending on the angle at which the light strikes the surface and on the amount of fill-in light applied, see page 186.

'Composite' lighting

Occasions may arise, as with wall paintings or exceptionally large pictures, when adequate simultaneous lighting is either impossible or offers the disadvantage of excessively long exposure times when using colour films which may suffer colour changes due to reciprocity effects, see page 81. Reasonably uniform illumination may be obtained by having the lens open and applying a spotlight in broad successive sweeps over the area to be recorded. The method requires some skill in avoiding 'overlaps' and in maintaining an even movement of the lamp. It is also necessary that the existing level of illumination should be insufficient to form an image and such photography is therefore best done in the hours of darkness. Flashbulbs or an electronic flash unit provide an alternative illumination and in

this case the area is successively illuminated with individual flashes. Care must be taken to avoid overlap and, if the flash is used at a distance closer than the camera, that the flash is directed at an angle which will avoid a silhouette either of the lampholder or the operator. The exposure is based on the effect of a single flashbulb and for this reason the distance of the flash to subject must be roughly the same throughout the series of flashes.

With a flash-synchronised shutter that can be re-set independently of the film winding lever (this excludes the majority of modern hand cameras which combine the shutter resetting with winding on the film) it is possible to operate in moderate interior lighting by using the flash at a level well above the existing illumination. Care must be taken not to move the camera when the shutter is reset.

Surface texture

Smooth matt surfaces present no particular problems and may be lit by any of the above methods found convenient. Smooth glossy surfaces which are perfectly flat offer no special problem so long as the lighting striking the surface avoids specular reflections in the camera. This may occur when using flash as the light source too near the lens axis, as the effect cannot be seen at the time of exposure except by using a pilot light in the same position. Originals covered with glass, such as framed paintings or plate glass used to keep unmounted copy flat, may show reflections of any bright metallic parts of the camera or other bright objects within the angle of reflection. Such reflection can be avoided by placing a sheet of thin board covered with black flock paper in front of the camera but with a hole large enough to leave the lens uncovered. If the board is light enough it may be conveniently fitted over the lens mount by making the hole a slight push fit.

Where it is desired to emphasise surface texture a single source of strongly directional lighting is placed at a more or less oblique angle to the surface, depending on the degree of emphasis desired. At extremely oblique angles—the light almost parallel to the surface, greatly exaggerated effects can be obtained—see Fig. 13.2. The light from a spotlight, a slide projector or rays of sunlight may be used for this purpose. Normally an increase of 1 to 2 stops is required compared with the exposure which is correct for lighting at 45°.

Excessive contrast can be reduced by allowing some light to fall on the surface at a normal copying angle. This can be applied when photographing subjects such as tapestries and certain paintings when it is desired to record both the design and colouring with some indication of the surface texture.

Oil Paintings and the use of polarized light

The irregular surface of oil paintings due to brush marks and pallette knife almost invariably present the problem of specular reflections with normal copying illumination. This problem can be overcome by placing polarizing screens in front of the

Fig. 13.2. Two versions of a carved surface: the upper version was made with the light source at about 30° to its surface, while the lower version was made with the light at about 5°. The maximum depth of the carving was less than $\frac{1}{4}$ in.

187

light sources so that the light reaching [the subject is plane polarized in one direction. Any specular reflections remain polarized while the light penetrating the surface and reflected back towards the lens will be depolarized. Thus by placing a second polarizing filter in front of the lens, the specular reflections (even from metal surfaces) can be almost eliminated with the polarization plane at right angles to that of the plane of polarization of the illumination. The effect can be seen visually and gives an unusual contrast and colour saturation to the image. In a black-and-white photograph the increased contrast is rarely objectionable though it frequently reveals tonal differences that are not readily apparent to the eye when viewing the original. Thus an unusual effect may be obtained from a black-and-white crayon drawing executed with grease crayons since specular reflections will depend on the direction of light and the direction of the strokes of the crayon—see Fig. 13.4.

Fig. 13.3. Complete elimination of specular reflections from an oil-painting can be achieved by placing polarizing filters over the light sources as well as one in front of the camera lens.

If two lamps are used, the polarizing screens should occupy the same plane. However, the use of polarized light makes it possible to position a light source much nearer the lens axis and a single light source such as a spotlight adjusted to give a broad beam may be sufficient. The screen should be large enough to allow some distance between it and the lamp if the latter gives off a considerable amount of heat. For this reason electronic flash may be considered ideal as the amount of heat emitted is negligible.

The use of 'crossed' polarizing screens results in a substantial reduction in the brilliance of the image reaching the lens and an increase in exposure of from 12 to 16 times will be necessary to compensate for the absorption of light. The exact amount will depend on the screens being used and is best determined by an initial series of test exposures.

When using colour film, some shift in colour balance may occur if the polarizing screens are not strictly 'neutral'. This can be corrected at the printing stage with colour negatives, but when making direct transparencies using a reversal film,

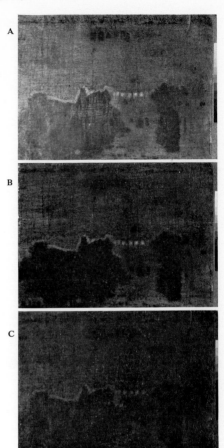

Fig. 13.4. Three versions of a crayon drawing. (*a*) Normal lighting based on the two lamp system in which some reflections from the surface were apparent at all angles of the illumination. (*b*) Using polarized light to eliminate all specular reflections, the correct tonal differences become apparent. (*c*) Additional exposure with normal lighting has merely increased the over-all density. The grey scale to the right of the photographs show that (*a*) and (*b*) are correctly matched in exposure but differ considerably in contrast because of the absence of reflections.

it will be necessary to determine a suitable correction filter for use over the camera lens. Another problem with colour is that of obtaining a false effect of colour saturation when all surface reflections are eliminated. This can be remedied where necessary by giving a second 'flash' exposure equal to 1/50th of the main exposure with a sheet of white paper placed over the painting.

Tone reproduction in black-and-white

In copying continuous tone black-and-white originals satisfactory tone reproduction can be obtained by including a grey scale such as that included with the Kodak Colour Separation Guides. The exposure and development of the negative should then be such that a reasonably accurate reproduction of this scale is obtained on a normal grade of printing paper. The presence of the grey scale is particularly

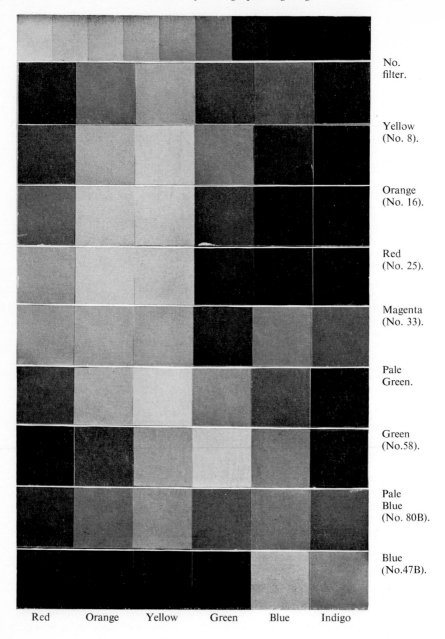

No.
filter.

Yellow
(No. 8).

Orange
(No. 16).

Red
(No. 25).

Magenta
(No. 33).

Pale
Green.

Green
(No.58).

Pale
Blue
(No. 80B).

Blue
(No.47B).

| Red | Orange | Yellow | Green | Blue | Indigo |

valuable when copying abstract paintings and other subjects which cannot be judged on their pictorial content. The use of a grey scale is indispensable when prints have to be made without the possibility of direct comparison with the original. The grey scale also serves as an ideal image on which to base test exposures for printing.

When copying colour originals in black-and-white the initial aim should be that of obtaining a tonal effect similar to the response of the eye to colour brightnesses under normal daylight illumination. Even with well-balanced panchromatic films some filtration will be needed depending on the kind of light source used for copying. Recommendations for filters are normally given in the manufacturer's instructions packed with sensitive materials. The grey scale is, of course, equally valuable in dealing with colour originals as a check on exposure and overall tone reproduction.

In practice it frequently happens that different colours having a strong colour contrast may have roughly the same brightness to a correctly balanced panchromatic film. We could, for example have an orange and green which will be recorded as identical tones of grey. This situation frequently presents a problem in abstract paintings, printed fabrics and so on. The answer is some degree of colour distortion and in this the artist or designer must usually be consulted. In the example given it would be possible to increase the brightness of either colour at the expense of the other. Thus, by using a filter which absorbs green light but transmits yellow, orange and red, the green part of the design will be reproduced with a much darker grey than the orange. The reverse effect could be obtained by using a filter which strongly absorbs yellow, orange and red, while freely transmitting blue and green. Small tonal differences can be achieved by using filters with weaker absorbing characteristics and in some cases even a change in the kind of lighting may produce sufficient difference.

In applying tonal changes of this kind it can be useful to make up a test card consisting of a range of colour patches of roughly the same visual brightness. These should give roughly the same tone of grey when photographed with a correctly balanced panchromatic film. Tonal changes with different lighting and different filters can then be observed. A series of such tests, see Fig. 13.5, can also be used to demonstrate the effect of filtration with an artist or designer who is not familiar with photographic practice. Generally speaking the visual effect of observing the subject through different filters for a few seconds will give some guide to the photographic effect. Thus a filter will lighten the tone of its own colour and darken those of complementary colours.

FIG. 13.5. A series of coloured patches corresponding roughly to the order of the spectrum colours is shown photographed with a panchromatic film, firstly without a filter and then with a range of Kodak Wratten filters to show the shift in tonal contrast. The grey scale at the top was used to obtain exposure and printing control. The chart can be used as a guide for copying line diagrams, etc., so as to obtain various contrast effects.

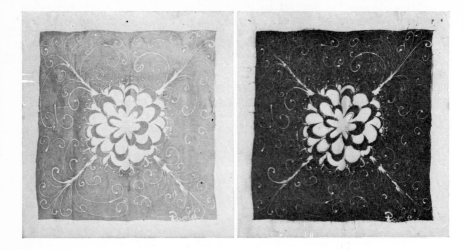

FIG. 13.6. Two versions of a hand-printed scarf in medium blue on a white background. The first is an unfiltered photograph and the second was taken through an orange filter.

Line originals in black-and-white

The copying of black-and-white originals such as printed matter, drawings and manuscripts in near black or dark blue ink presents no special problem save that of obtaining satisfactory contrast between the subject matter and the background. If a technical camera is being used permitting the use of sheet film or plates, a 'process' material of high contrast would be the best choice. If only black-and-white originals are to be dealt with, it can be of the non-colour sensitive type. Satisfactory contrast can be obtained when using 35 mm and roll film cameras with a fine grain panchromatic film developed in a hydroquinone developer (to produce a high gamma) and, if need be, subsequently printed on a contrasty grade of paper. However, even with normal development, should the film also contain continuous tone subjects, adequate contrast can be achieved with a high contrast printing paper.

If the original has a coloured background, it can be made to appear white in the copy by using a filter of the same colour over the lens. If some tonal suggestion of a coloured background is to be retained it can be treated as a continuous tone subject without special filtration. If coloured ink has been used on a white back-ground, contrast may be increased by using a filter of the complementary colour over the lens. If both ink and background are of different colours, the choice of filter will depend on which colour is to be dark. It may also happen that no filter is needed if there is already a marked difference in brightness.

When more than two colours are involved, as for example a chart or map, it may be preferable to make an initial test without a filter. If a particular colour is found to be too weak, moderate filtration may help to adjust the balance.

Copying in colour

No difference in treatment is possible between continuous tone and line originals when employing either reversal or negative colour films. The chief problem is that of colour balance and this depends on achieving lighting of a colour composition which matches the film to be used. This problem has already been discussed in Chapter 3. One aspect however, is of special interest to regular copying assignments, namely, that of standardising both the technique used and the type of film. It has earlier been mentioned that accurate colour rendering is still far from possible with materials at present available. This situation can be further aggravated by the use of different types of film or different sources of illumination.

Some thought must also be given to the purpose for which a colour transparency is made, as well as the conditions under which it will be viewed. If it is intended for projection a somewhat less dense image is usually preferable as compared with one which is likely to be used for photomechanical reproduction. In the normal way the copying of paintings solely for photomechanical reproduction is done by making direct separation negatives from the original. When making transparencies of small format there is much to be said for making two exposures, one adjusted to give a good projection quality and the other at $\frac{1}{2}$ to 1 stop less exposure, for possible use in photomechanical reproduction.

When copying with colour negative film which is to be printed commercially with automatic printers, the lighting should correspond to that recommended in the instruction packed with the film. Even so one should not expect anything more than a mediocre colour rendering. Individually printed colour negatives which have been exposed to include a grey scale and colour guide can be expected to reach a much higher standard, especially if reference can be made to the original at the time of printing.

CHAPTER 14

Lighting for Close-ups and Photomacrography

While the lighting for small objects does not differ essentially from that required for objects of 'normal' size, it presents certain problems which are not encountered in photography at normal scales. It is logical to regard close-up photography in terms of the scale of the image recorded by the camera and to limit it roughly to a range of scales from 1/10 to 1/1, and to regard photomacrography as applying to magnifications of the subject at the camera stage. For practical purposes these may be considered as extending up to 20 times, after which it is necessary to use a microscope and it becomes photomicrography.

One of the problems arises from the fact that depth of field diminishes rapidly with increasing scales of the camera image and it therefore becomes necessary to reduce the lens aperture to compensate for this. It is worth noting in this connection that depth of field is the same for lenses of all focal lengths for the same image scale. The commonly referred to advantage of miniature cameras in terms of depth of field for photography at normal distances arises from the fact that the scale of the negative image is smaller in proportion to the focal length of the lens. Taking a 2-in. lens as standard for a miniature camera and one of 6 in. as standard for a 5 × 4 in. technical camera, the scale of the smaller negative is only 1/3 of the larger, if the two cameras are used at the same viewpoint. The depth of field of the smaller negative is, therefore, considerably greater and remains so even when the two negatives are enlarged to give print images of the same scale. However, if both cameras are used to obtain, say, the same scale images of a small object, the 2-in. lens will require to be at a distance of 4 in. from the object, while the 6-in. lens will be at a distance of 12 in. and the depth of field will be the same. Bearing this in mind, it is usually an advantage when working with a small format camera to work to a smaller scale and to rely on the enlarger to produce the required print image scale. This is necessary in any case if the image at a particular scale exceeds the format of the negative. Thus in terms of close-up photography, the 5 × 4 in. camera can accommodate objects of three times the linear dimensions compared with those possible with a 36 × 24 mm. (1½ × 1 in.) camera. This could be an advantage if the photograph takes the form of a colour transparency, since the larger transparency could be viewed with the naked eye whereas the smaller one would need to be viewed with a magnifier or as a projected image. On the other hand, if the photograph is produced via a negative, the advantage could lie with the smaller format on the grounds of greater depth of field.

The need to use small lens apertures for close-ups makes it necessary to compensate by giving either longer exposure times or, if camera or subject movement

Fig. 14.1. Sunlight provides a useful lighting for moderate close-ups since being highly directional it gives good colour saturation. When only a shallow depth of field is involved, an aperture such as f/5.6 will allow a shutter speed of 1/125 sec. even with a slow film such as Kodachrome II.

precludes this, to increase the intensity of the illumination. The increase is not merely related to the f/number as in photography at normal distances, since at scales greater than 1/10 the distance from the focal plane at which a sharp image is formed becomes significantly greater than the focal length of the lens on which the f/number system is based. This is usually referred to as the lens extension and must be taken into account when calculating the exposure. Close-ups made with the aid of a supplementary lens do not suffer from the lens extension problem, since the effect of the supplementary lens is to shorten the focal length of the lens so that the existing distance between lens and film remains unchanged, and hence also the image brightness for any given f/number. Generally speaking the definition is impaired towards the edges of the field when using supplementary lenses of more than 3 dioptres unless they have been specially corrected. Even so the use of such lenses is limited to scales of up to 1/1. They are chiefly of use for cameras having a fixed lens which does not permit the use of a bellows extension.

The lens extension is related to the scale of photography. Thus at a scale of 1/4 the extension equals 1/4 of the focal length, at 1/1 it is equal to the focal length, while at a magnification of 3 times, it becomes three times the focal length.

Thus at any given lens aperture or f/number, the intensity of the image decreases as the distance of the lens extension becomes greater. The difference between the nominal f/number and the effective f/number can be calculated by the following formula:

$$\text{effective f/number} = \frac{\text{nominal f/number}}{\text{focal length}} \times \text{focal length} + \text{lens extension}$$

To save the bother of calculation the following table indicates both the effective aperture at different scales and the increase in exposure time necessary for a given nominal f/number at different scales of reproduction.

Scale	$\frac{1}{8}$	$\frac{1}{4}$	$\frac{1}{2}$	1	2	3	4	6	8	10	12	20
Exposure time at Infinity taken as 1 sec.	$1\frac{1}{4}$	$1\frac{1}{2}$	$2\frac{1}{2}$	4	10	16	25	45	80	120	160	250
Number of stops by which effective aperture is less than nominal	$\frac{1}{3}$	$\frac{1}{2}$	$1\frac{1}{3}$	2	$3\frac{1}{2}$	4	$4\frac{1}{2}$	$5\frac{1}{2}$	$6\frac{1}{2}$	7	$7\frac{1}{2}$	8

However, the increase may not end here if the exposure time to compensate for the reduction in effective f/number involves using a time longer than 5 sec. for black-and-white films or 1 sec. when using a colour film, since there may be loss of speed from reciprocity failure, see page 81. In fact this may involve substantial increases and it may turn out that the increase in exposure time for a camera magnification of, say, 10 times, involves increasing the exposure time, which would be sufficient for normal photography, by as much as 500 times.

One solution to this problem is to avoid reciprocity failure by increasing the intensity of the illumination so that lengthy exposure times are avoided. Since the object to be photographed is small, increased illumination can be achieved either by using light sources at shorter distances or using some kind of optical system to concentrate the light on a small area. On the basis of the inverse square law of light propagation, if the lamp distance is halved, the intensity increases four times. This, of course, applies to point sources. When the area of the light source becomes relatively large compared with the distance at which it is used, this ratio no longer holds good. Thus, while it is possible to apply this law to a normal lighting unit at distances greater than 5 or 6 ft., the increase in the intensity falls off steadily with shorter distances. In this connection it is necessary to consider a lighting unit not only in terms of the lamp, but also to take account of the reflector which may well more than double the effective illumination at normal distances, while having much less effect at very close distances. For this reason a small spotlight of, say 250 watt may prove more effective than a 1,000 watt flood lamp at a distance of less than 2 ft. from the object to be photographed. In photomacrography where

FIG. 14.2. Two stages of magnification in photomacrography. In the original trans-
parencies the scales are x3 and x10, the exposures being, made with electronic flash
placed only a few inches from the subject.

the area to be illuminated may be little more than a square centimetre, it is clearly
illogical to apply a lamp which illuminates an area several hundred times
greater. What is needed is a lamp having a small area filament of very high intensity
which is provided with an optical system designed to deliver the maximum amount
of light in a small area. Lighting units of this kind are used for photomicrography
in which the light from a low voltage, high intensity ribbon filament lamp of no
more than 36 watts will deliver a narrow beam of light many times the intensity
of strong sunlight.

It is also necessary to consider the problem of heat. A high wattage lamp
becomes extremely uncomfortable at close distances and may cause actual damage
to the camera, and although it is true that the heat from a low wattage lamp will
be concentrated, along with its light, on a small area, this will not affect the
camera or anyone in the proximity of the camera for the purpose of framing and
focusing the subject. If the heat from the small, concentrated beam of light is
likely to prove damaging to the specimen to be photographed, a small heat-
absorbing filter can be placed in the beam.

Light sources for close-ups

For the purpose of the present chapter we have already limited close-ups to a maximum scale of 1/1. If the lens is used normally, the maximum extension will not exceed an exposure increase of 4 times whereas for a scale of 1/8, the increase is only $1\frac{1}{3}$ times, an amount which can usually be absorbed in the exposure latitude of the film. The selection of an aperture to give sufficient depth of field will depend on the nature of the subject. Frequently it is limited to a shallow depth or can be so arranged that the area of interest lies in a shallow plane in respect to the lens. It is thus frequently possible to accommodate the subject with an aperture of f/8 or f/11 and at times even f/5.6. With a film of average speed (64 ASA), and strong sunlight an exposure of 1/100 sec. is normal at f/11, so that even with a scale of 1/1, adequate exposure would be obtained at 1/25 sec. By using a tripod, smaller apertures could be used without involving 'time' exposures.

For indoor work a slide projector will supply a very useful beam of light for close-ups. At a distance of 6 in. from the projector lens, the intensity of the illumination from a projector fitted with a 150-watt 24 volt tungsten iodine lamp is roughly equivalent to strong sunlight and is also quite cool. By means of a swivelling mirror it is possible to direct the light in any direction required without need of tilting the projector. The light usually gives acceptable results when using a colour film balanced for light of 3,200°K. but if required a light balancing filter can be placed in the gate of the projector.

Fig. 14.3. Construction of a simple field-frame for close-ups. The strip of wood forming the base for the camera is long enough to support a small electronic flash unit so as to give lighting at about 45° to the lens axis.

A small electronic flash unit is undoubtedly the ideal light source from the point of view of exposure. At a distance of 1 ft. it provides an intensity of illumination many times more powerful than sunlight with an exposure time in the region of 1/1000 sec., short enough to permit the photography of live specimens and overcome any camera shake when it is necessary or convenient to dispense with a tripod. It has the additional advantage of being of the right colour temperature for colour films and its emission of heat is of too short a duration to be appreciable. It can be used equally well indoors and outdoors and for outdoor photography it can be used either as the main light source without reference to any existing daylight or at such a level as to balance existing background lighting. In the former case it is only necessary to set the flash at a distance from the subject which permits an exposure of 4 to 8 times less than that which would be correct for the existing lighting. At this level hardly any trace of daylight would be visible

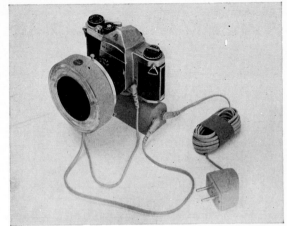

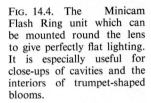

Fig. 14.4. The Minicam Flash Ring unit which can be mounted round the lens to give perfectly flat lighting. It is especially useful for close-ups of cavities and the interiors of trumpet-shaped blooms.

in the exposure. If it is required to record existing background lighting, the distance of the flash should be such that it equals the background lighting. With a diaphragm shutter it is possible to adjust the distance of the flash to suit the required lens aperture and to set the shutter for a time which will be correct for the background. The increase in exposure time will not affect the exposure given by the flash. However, if there is any movement of the subject, there is a danger of obtaining a 'double' image effect.

One of the disadvantages of using flash as the sole light source at close distances is that it falls off rapidly in intensity if the background is at a considerable distance beyond the subject. However, this can be an advantage if a dark background is required, but if the purpose is to use flash as if it were normal daylight, it is necessary either to make use of existing daylight, as indicated above, or to use an artificial background which is in keeping with the tones of the subject. There is a tendency for some photographers to work always at the minimum aperture for close-ups on the basis that the maximum depth of field is always desirable and occasionally with the belief that the lens gives better definition at its smallest aperture. In fact, it is frequently possible to use a larger aperture and hence to set the flash at a greater distance from the subject. In this case the fall-off of intensity will be less. This effect is illustrated on page 38. At the same time the use of a large aperture will have the effect of more selective focus on the plane of interest. As regards definition, most modern anastigmatic lenses give the best definition at 2 or 3 stops below the maximum aperture and with short focus lenses the effect of closing the aperture may introduce loss of definition through diffraction.

Small flashbulbs provide an even more powerful light source and may prove useful when working at scales greater than 1/1. It is, however, advisable to make tests when working at close distances as the exposure guide number system may indicate less exposure than is actually needed. Once the effectiveness of a small bulb used at a close distance has been established, it will serve as a guide for all future exposures made under the same conditions. This applies similarly to a

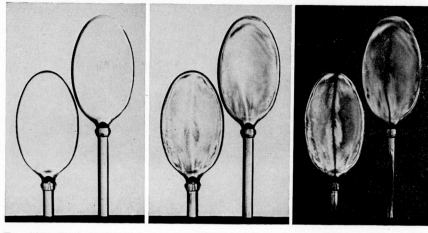

FIG. 14.5. Transparent polystyrene spoons photographed with transmitted light: (*a*) with unpolarized light, (*b*) polarized light with camera polarizing filter in the same plane as the transmission filter, (*c*) camera filter fully crossed. The colour pattern changes as the camera filter is rotated.

small electronic flash unit, but in this case the expenditure of a few test flashes costs little more than the film which has been exposed.

Direction of light

Strong side- or back-lighting often produces the most successful close-ups of flowers, insects, and similar subjects. One of the surprising aspects of living creatures is that the closer one looks, the greater becomes the detail particularly under high-contrast lighting. Strongly directional oblique lighting will reveal details of surfaces not apparent with frontal lighting, see Fig. 10.1. With subjects which are semi-transparent, the most effective lighting may be back-lighting either as directional lighting, as in the case of flowers, or as an illuminated sheet of flashed opal glass giving the effect of a detailed radiograph, see page 153, Fig. 10.8. Frontal lighting is useful in colour photography when the colours of the subject, for example, a butterfly, are more important than the texture, see Fig. 14.4.

Where needed, fill-in light can usually be provided with a small reflector arranged to collect some of the main light. A matt foil reflector will provide a strong fill-in, thus giving a very low lighting contrast more suited to colour work. A sheet of white paper will provide a much softer fill-in.

Polarized light

Certain transparent objects such as crystals and plastics reveal colour defects related to the structure or stresses of the object. The effects can be obtained by placing a polarizing filter between the light source and the object and a second polarizing filter over the camera lens. Various colour effects can be obtained by rotating one filter in relation to the other. Examples of such effects are given in Fig. 14.5.

CHAPTER 15

Special Lighting Effects

One of the aspects of photography not always appreciated by the still photographer is that three dimensional objects may be combined with a two-dimensional photograph (or its image projected on to a background) to give the same effect as a photograph based on an actual three-dimensional background. This technique has long been in practice with professional movie makers as the only satisfactory means of shooting action sequences which occur in situations which would make normal photography extremely difficult and at times impossible. A typical example is that of a small boat on a rough sea. Though it might be possible to locate the scene off the end of a long mole, using long focus lens for the close-up shots, it is far simpler to shoot these in the studio against a projected background of rough seas, with the rocking of the boat obtained by means of levers and the occasional showers of sea-water coming over the side of the boat by throwing a bucket of tepid water over the boat and its occupants. Occasional long distance shots of the boat rocking about on the open sea are enough to persuade the average film-goer that the whole sequence is taking place on the open sea.

Back-projection

The same sort of trick can be applied, even more easily, in the shooting of a still photograph which requires a background not easily accessible or not available because of unsuitable weather conditions. For example, let us assume that skiing equipment and clothes have to be photographed out of season for a catalogue. Of course they may be presented merely as objects in a studio and printed as 'cut-outs', but far more telling photographs could be made by the use of an Alpine background plus a little artificial snow in the foreground. The background could either be a very large photograph, and very often is, in a commercial studio where cost is not important, or it could be a projected background.

The use of a projected background instead of an actual photograph offers certain advantages and certain disadvantages. It is less expensive if regular use is to be made of projected backgrounds, since once a suitable set-up has been obtained the projected image can be supplied by a small transparency which is cheap to produce or readily available from a photographic agency. Also the size of the image can be varied within the limits of the screen or a particular portion of the transparency used. There is also the possibility of throwing the image out of focus when the effect of an unsharp background is required under conditions where normal differential focus is not possible or convenient. Finally, it is possible to distort the colour rendering of the background to obtain, say, a moonlight effect.

On the other side of the balance sheet, there is the possible disadvantage of the extra space that is needed behind the screen, whereas an actual photograph can be mounted against a wall. This does not apply to front projection but since its application is far more restricted, see page 206, it is seldom worth considering as an alternative to back-projection. From time to time special front projection systems are devised but these are usually very costly or involve special lighting equipment. Another disadvantage is the tendency of a back-projection screen image to be brighter towards the centre than the edges. However, the principal disadvantage is that of lighting the objects in the foreground so that no light falls on the screen, since this will be partly reflected from its surface and thus affect the uniformity and contrast of the back-projected image. This does not arise where a two-exposure system can be adopted, see page 204. Similarly there is the disadvantage of balancing the brightness of the screen image to that of the subject, but this can also be eliminated in the double exposure system. When shooting in colour, there is the problem of achieving a proper colour balance between the recorded image of the background and that of the objects in the foreground. However, this may also arise in using a colour photograph as the background since, even if it has been adjusted to 'normal' colour rendering, the colour rendering may differ in the re-photographing to that of the objects owing to the fact that the dyes of the colour print react differently to a colour film than they do to the eye, see page 182.

The back-projection image

The image from a slide projector can be presented either as a reflected image by placing the projector in front of a white screen or as a transmitted image by placing the projector behind a screen consisting of ground glass, or paper or plastic material providing a similar surface. Any slide projector will do, but if a single exposure system is required, as when using projected backgrounds with portraits, the brilliance of the screen image should be such that it can be conveniently matched with the lighting used on the subject. If colour film is to be used, then a projector fitted with a tungsten iodide lamp (giving a colour temperature of 3,200°K.) will probably require less by way of filter correction in obtaining a satisfactory colour rendering of the background.

The size of the screen image is relative to the distance of the projector from the screen, but the distance range for particular screen sizes is also related to the focal length of the projector lens for any given size transparency or slide. Generally speaking the lens fitted to a slide projector for normal front projection requires inconveniently long projection distances for back-projection and it is advantageous in terms of space to use a projection lens of much shorter focal length. However, the projection distance for lens of normal focal length can be reduced in terms of depth behind the background by utilising a mirror as a means of diverting the image through 90°, as shown in Fig. 15.1. To reduce the distance by about half, the mirror must be large enough to reflect a half-size image.

The screen can be made from a sheet of good quality tracing paper or a plastic material such as Kodatrace, which is stretched across a wooden or metal frame, the frame being supported on a stand which allows it to be adjusted in height. An

alternative is to clamp the frame to one end of a table which can be used as the support for the objects to be photographed. The size of the frame may be limited by the width of the paper available, since it is difficult to make a join between two sheets which will not be obvious. On the other hand a great many objects which lend themselves to back-projection treatment do not call for a very large screen. For general purposes one which is about 3 × 4 ft. will be sufficient. Moreover, if the two-exposure system is to be used, the screen may be placed almost immediately behind the objects to be photographed.

Fɪɢ. 15.1. Arrangement of mirror to reduce back-projection distance.

Screen brightness

This depends on the wattage of the projector and the magnification of the image. The brightness can be reduced by placing a neutral density filter over the projection lens, but there is no method of increasing it other than to use a projector of higher wattage.

A back-projected image is brightest at the centre of the screen, the effect being more noticeable when the axis of the projector lens coincides with the axis of the camera lens. It is less apparent, though may still be troublesome, when the camera is aimed from one side or above the centre of the screen. In many cases the objects in the foreground occupy a central position and the problem will not arise. The nature of the background subject may also be such that the non-uniform brightness of the screen illumination is not noticeable. Some photographers overcome any persisting hot-spot by applying the printing technique of using a disk attached to a length of stiff wire which is used to 'shade' the centre of the image. The extent of the shading is first found by trial and error but once established becomes a constant for a particular set-up. The disk can be quite small and is held at a distance from the projection lens so that it throws a silhouette of about half the area to be shaded. During the exposure it is moved in a circle in its own plane so that its coverage corresponds with the area of the hotspot. The projected image is, of course, clearly visible behind the screen as a reflected image. Correction by means of shading naturally involves adopting exposures of several seconds. Another method is to make up a correction filter which absorbs some of the light in the centre of the field. Such a filter can be made from a piece of fixed-out film to which a spot of neutral retouching dye is applied to the centre of the

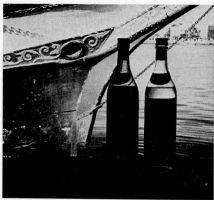

FIG. 15.2. Two stages in the exposure of a back-projection set-up. The first exposure was based on the screen brightness with the subject itself appearing as a silhouette The second exposure was made with the screen covered with black paper and was adjusted for the lighting of the subject. The exposures were made on successive frames of films in the initial test and then on a single frame of film to give a single colour transparency. The examples on the facing page show the screen image sharply in focus and somewhat out of focus to give the effect of reduced depth of field.

emulsion side. The emulsion should be well soaked and be free of any excess water and the dye should be very dilute. The spot of dye is then worked with a fine brush as uniformly as possible to form a disc of the required dimensions—about $\frac{1}{3}$ in. for a 35 mm. transparency. Successive and smaller spots of dye should be worked into small discs so as to finish up with a uniform increase in density towards the centre and without any distinct 'steps'. Alternatively a white card can be painted with a neutral grey disc of graduated density and then photographed to the required scale on colour film. Yet a third method is to photograph the screen with a normal black-and-white negative film without having a slide in the projector. The negative is then used to make a positive and this in turn to make an enlarged print which will appear as a greyish patch on a white field. If the contrast has been kept constant throughout, the greyness will be inversely proportional to the hot spot on the screen and if photographed with a colour film will make a suitable correction mask. Some trial and error is to be expected in making such a filter, but once a satisfactory specimen has been produced it will serve as a standard for all future work.

Exposure

There are two methods of making an exposure: as a single exposure in which both the foreground and background are illuminated at the same time or as two exposures, one of the foreground only with the screen covered with black paper, and the other of the screen only, all other lighting being turned off. The first method is essential when dealing with live subjects but can also be applied to still

Screen
image
sharp.

Screen
image
unsharp.

subjects: the second method can only be applied to still subjects but offers considerable advantages in lighting.

With the single exposure system it is necessary to obtain a proper balance between the foreground and background in terms of brightness. Since the background will be a fixed brightness for a given size screen image and transparency, it is necessary to adjust the intensity of the foreground lighting to this level. An exposure meter will give a useful guide to the balance, as a reading taken from a representative area of the screen will be roughly equivalent to a grey card reading of the main light falling on the foreground. With the help of a test exposure, it is then possible to make small adjustments to the foreground lighting by varying the distance of the main light.

With the two-exposure system there is no need to consider lighting balance. The first exposure is concerned only with the foreground lighting and can be based on a grey card reading. An initial test can then be made by exposing three frames of film in which the first exposure is kept constant and the second exposure (screen only) based on the exposure meter reading of the screen with two further exposures at 1 stop more and 1 stop less. Thus the three negatives will vary only in terms of the background density and prints made from each will indicate the correct exposure for the background.

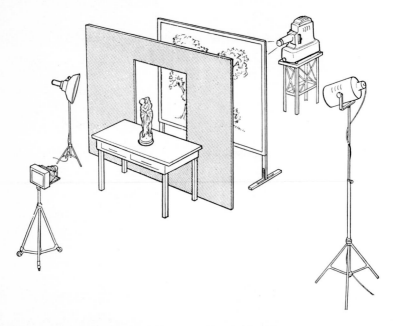

Fig. 15·3. Arrangement for back-projection based on a single exposure. The intermediate screen must be large enough to prevent any spill light from the lamps used to light the subject from falling on the screen.

Lighting precautions

With single-exposure back-projection it is necessary to prevent any of the foreground lighting from falling on the screen. This normally restricts lighting to well-hooded lighting units placed well to the side or above the subject with the back-projection screen itself a considerable distance away from the foreground. Greater flexibility in lighting is possible by the use of a screen of black paper or card having an aperture only slightly greater than is required for the angle of view of the lens which is placed immediately behind the subject plane as a means of intercepting light which would normally reach the projection screen, see Fig. 15.3.

The problem does not arise with the two-exposure system if the background for the first exposure is covered with a sheet of black flock paper and the second exposure made with no other light except that of the projected image.

In arranging the lighting for the foreground it is necessary to take into account the direction of lighting already existing in the projected background. Alternatively, if some particular lighting direction is to be used for the foreground, the transparency chosen for the background, in so far as it reveals a particular lighting direction, must be consistent.

Special effects

Mention has already been made of the possibility of introducing differential focus effects by varying the sharpness of the projected image, see also Fig. 15.2, and that of using filters both to balance and distort the colour rendering of the projected image in relation to the foreground. Back-projection also offers considerable possibilities by way of abstract background effects. Objects or cut-out shapes placed in the projector beam will throw shadows on the screen which can be varied in size and sharpness according to the distance from the projector lens or nearness to the screen. These can be combined with the use of coloured filters placed in the projector gate either of a single colour or a mosaic of different colours. Composite title slides can be made by mounting the letters on a sheet of glass which is photographed in front of any desired projected image, realistic or abstract.

Multi-exposure techniques

One of the possibilities of photography is that of combining two or more images in the same photograph. This, of course, can happen accidentally when we forget to chagne a sheet film holder or wind on a rollfilm to the next clear frame. It can at times produce amusing results but for the most part it is a waste of material and far worse, a waste of effort and opportunity. Hand cameras and miniature cameras have long provided safety devices to prevent double exposures and the chief victims of accidental double exposures are those using technical cameras with dark slides and rollfilm holders.

However, we are not concerned with accidental results. The combination of images on the same frame of film or the same print can be put to valuable use if it is done intentionally and with due regard to the rules of exposure. It offers, as we have already seen in the preceding section on back-projection, a convenient method of avoiding the difficulty of different intensity levels as well as unwanted

light from the foreground falling on the background. But in this case we are not concerned with combining two different images so much as exposing a subject (foreground plus background) in two stages. It can only be applied if the two elements remain constant in their spatial relationship. We could, in fact, make the two exposures on two frames of film and by combining them in exact register in the enlarger produce the same result, see Fig. 15.2. Multi-exposures can be used to record more than one aspect of an object by using a background such as black flock paper or velvet. Since the background reflects little or no light, only the object—or parts of it—which reflect light will record any image on the film. For practical purposes the whole of the background area represents unexposed film. Thus if we wish to add a second aspect of the object, it only remains to move it in respect of the camera so that its image falls on an as yet unexposed area. Not only can we repeat the operation several times, always assuming we keep track of the areas already exposed, but we may change the scale of the image, the direction of lighting, and if we are shooting in colour, the colour of the lighting. The important thing is to keep track of what we are doing and to maintain roughly the same level of illumination for each exposure, see Fig. 15.4. A succession of images of a cycle of movement can be made by using a stroboscope as the light source, the number of images depending on the frequency of the lamp and the total duration of the exposure. Here again a dark background is helpful.

When using negative materials, multi-exposures can be made either at the camera stage on a single frame of film or they can be made on the basis of separate camera exposures producing negatives which can be printed together in the enlarger. When using reversal colour film the images must be recorded at the camera stage when using a black background, but two and possibly three images exposed against a white background, as separate transparencies, can be mounted together and projected as a single transparency. For example, it is quite common to add a flight of ducks or geese shot against an overcast sky so they appear as silhouettes on otherwise clear film, to a colourful sunset shot taken on another occasion.

Overlapping images

When a second image is added to an existing one with no change in the position or lighting of the object, the effect is merely to increase the overall exposure. A series of intermittent exposures with, say, an electronic flash unit may be necessary to achieve adequate exposure in photomacrography where considerable lens extensions may reduce the effective lens aperture to something like f/90 or when photographing a large interior. This is equivalent to giving time exposures with a low output light source. Or again, a single electronic flash unit may be applied as a multiple lighting system under conditions where the existing lighting is sufficiently low and both camera and subject are stationary. This could be applied, for example, to copying a flat original, the flash being fired first one side at an angle of about 30° to the surface and then the other side at the same angle. It would similarly be possible to use the flash first as the main light, then as fill-in and finally as a back-light by working on a pre-set plan. By using a lens cap between exposures, the camera shutter can be left open throughout series, while the flash unit is being re-set in the next position.

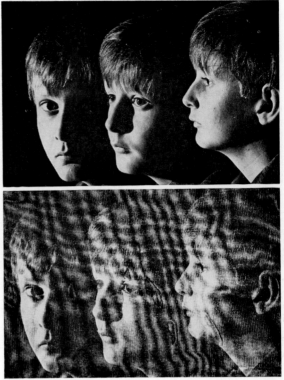

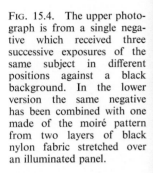

Fig. 15.4. The upper photograph is from a single negative which received three successive exposures of the same subject in different positions against a black background. In the lower version the same negative has been combined with one made of the moiré pattern from two layers of black nylon fabric stretched over an illuminated panel.

The situation is entirely different when two different images overlap. Two light areas combine to make a lighter area, two dark areas remain a dark area, and so on. Such a process is only useful when one image provides a sufficiently large dark area for a second image as in Fig. 15.5. The effect is most successful when one object is lit strongly from one side so as to leave a large area of shadow for the second image. In this case the exposure for each subject is based on the normal. However, when the images are to overlap, it is necessary to base the exposure for each image on the total effect of the two exposures. Thus if a second image is to overlap an area which has already received some exposure, the second exposure must be reduced. Generally speaking this involves some trial and error until experience has been gained in making such combinations.

With reversal colour film, overlapping areas may produce changes in colour as well as in density. For example if an area of green overlaps an area of red the result will be yellow or orange depending on the density. Green and blue mixtures produce more or less what one would expect, blue-green or cyan and this also holds good for blue and red which produce the colour known as magenta.

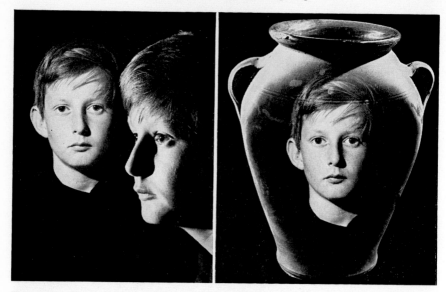

Fig. 15.5. Double image effects produced by combining negatives at the printing stage. The double portrait was obtained by sandwiching two negatives together. In the second example the negatives were printed separately so that the size of the vase could be increased to contain the head.

If all three primary colours overlap in roughly the same proportions the result is white which is recorded as clear film in a colour transparency.

Images of tracks

Closely associated with multiple exposures is the practice of leaving the camera shutter open for a certain length of time in order to record the movement of bright images such as the lights of moving cars, fireworks, and in some cases, objects and people in motion. The technique is also applied to time and motion study as an aid to simplifying manual operations, small lamps being attached to the hands of the operator.

Here again the most successful results are those made against a dark background or, in the case of fireworks and street scenes, at night. The length of the exposure will determine the amount of movement recorded as well as the number of tracks on one frame of film. When photographing fireworks, such as rockets, it is usual to have the shutter open so as to record three or four successive explosions. The exposure or brightness of the image is controlled by the lens diaphragm. To obtain a sharp image of any background detail it is necessary to have the camera on a firm tripod, but still further image patterns can be obtained by moving the camera during the exposure. Indeed, in this case it is not necessary that the lights be moving: strange effects can be obtained from neon signs and street lights by moving the camera during the exposure.

However, this method of making exposures is not so much a problem of lighting as one of exposure and is only mentioned as a matter of interest.

Coloured lighting effects

While the aim of normal colour photography is to obtain as accurate a colour rendering as possible, modern colour films lend themselves to considerable 'poetic licence' in the rendering and distortion of colour. Under certain viewing conditions, the eye itself will adapt and accept as normal considerable departures from the correct colour rendering. This applies particularly to projected colour transparencies so long as a series of slides does not contain sudden jumps from one colour bias to another. For example, it is possible to start a series with a transparency which has a distinct yellow bias to which the eye will rapidly adapt itself. This can be followed by transparencies which progressively improve towards the correct colour rendering and gradually become progressively bluish until a strong blue bias is reached. While the eye may be vaguely aware of the change ,it is quite incapable of appreciating the very marked difference in colour rendering between the first and last slide of the series. This can only be appreciated if the two are viewed side by side or immediately following each other. From this it will be seen that attempts to convey a certain mood in a projected transparency by employing a particular colour bias, require that the photograph be viewed immediately after a slide of normal colour rendering. This factor does not apply nearly so much to the viewing of colour prints since these are often viewed in isolation and under conditions of illumination which have pre-determined the adaptation of the eye.

Colour saturation and exposure

When a reversal film is exposed to a low-contrast but colourful subject, a series of exposures ranging from 2 stops under to 2 stops over-exposure may all give projectable transparencies. They will, of course, differ considerably in overall density and colour saturation. though different colours may show marked differences in relation to the exposure. Both density and colour saturation will increase as the exposure is reduced, but the effect is often more noticeable in the rendering of blues than in the rendering of yellow and orange. Thus the efect can be to change the relative colour brightnesses and hence give different versions of the same subject. As we have previously pointed out, the visual effect differs from the photographic effect: colours appear more saturated at higher levels of illumination whereas they show less saturation at greater amounts of exposure. For example, the effect of coloured spotlights on the lighter tones of a subject may appear very striking to the eye, but show little or no colour effect in a normally exposed transparency. This aspect will be discussed later in the chapter.

Mixed lighting effects

Normal colour rendering in a colour photograph requires that all the illumination falling on the subject should be of the same colour composition or colour temperature. If two different sources are used, the effect will be more noticeable in a photograph than to the eye when viewing the actual scene. The two most

common occurrences of mixed lighting are those of sunlight with a deep blue sky, the effect being to give light-toned areas in shadow a strong blue colouring, and window daylight with indoor tungsten lighting. In the latter case if the tungsten lamps give the higher intensity, and the film is balanced for artificial light, areas lit with daylight will appear excessively blue.

Strong colour biases can be obtained by using a film balanced for artificial light with daylight and if some reduction in exposure is given, the resulting bluish colour rendering is reminiscent of moonlight. The reverse yields a strong yellow bias which may occasionally be useful to suggest candle or firelight in a scene lit with daylight or electronic flash.

Filters over the lens

Filters in colour photography are normally used to balance or compensate for differences between the colour sensitivity of the film and the light source. The effect of a colour filter is to absorb certain parts of the colour spectrum to a greater extent than others. Their application to colour photography has little in common with their application in black-and-white photography where their purpose is to give tonal changes. Thus a strongly yellow filter, which is commonly used to darken the tone of a blue sky, would merely have the effect of giving a strongly yellow colour rendering. However, if an overall colour bias is required, be it violet, pink or amber, the effect can be achieved with ordinary white light plus a suitable colour filter over the lens. A useful application arises in making title slides since white letters can be made to yield any colour desired.

Filters over light sources

By far the most practical method of creating coloured effects is to change the colour of the illumination. By using more than one light source, the effect of the coloured lighting can be restricted to certain areas and can also be combined with white light. This method is particularly effective with glass objects and white porcelain. With glassware, coloured lighting coming from below will be contained within the inner surfaces of the glass, revealing itself only at the rims or in facets which have been cut into the glass. Additional effects will be obtained from surface reflections which will contrast strongly against a background of a different colour. On the other hand, white objects will take on the colour of the light they receive and may be taken for objects which are actually coloured. Solid white lettering for titles can be presented in two colours, one being applied frontally to colour the face of the lettering, and the second from the side to give a contrasting colour in depth.

The effect of coloured lighting will be most noticeable in the medium and darker tones of the subject, being least in areas which would normally be rendered as white. To obtain strong colouring in the lighter tones it is necessary to reduce the exposure and with a subject having a full range of tones this will result in underexposure in the darker areas.

It should always be borne in mind that coloured lighting means an absence or reduction of certain regions of the spectrum. Thus colours in the subject which strongly reflect such regions will tend to appear greyish or even black. For example,

if red is illuminated by a strongly green light, it will be recorded as nearly black. When two or more coloured light sources are used, their combined effect on areas where they overlap will produce different colour effects. Perhaps the most startling is the overlap of green and red light which results in a strong yellow. When two complementary colours overlap in roughly the same proportions, the colour rendering is roughly equivalent to the area being illuminated with white light.

The shadows cast with coloured lighting on a white background may also produce unusual effects. For example, if three projectors are directed at a subject to cast three sets of shadows, the shadow produced by each light will take on the combined colour of the other two lights. If the three filters used consisted of red, blue and green—the three primary colours—the shadows will become cyan, yellow and magenta—the three subtractive primaries, while the area of the background receiving light from all three projectors will appear white or greyish.

Coloured reflectors

The effect of a coloured light source can also be obtained by directing a white light source against a strongly coloured reflector. Minor effects of this sort occasionally occur in normal photography when light from an adjacent and strongly coloured surface falls on the shadow area of the subject. The result is frequently disturbing unless the source of the coloured reflection is seen in the photograph.

Coloured metallic foil will provide very efficient coloured reflectors and is frequently more convenient as a source of coloured lighting than a lamp covered with a filter. Mounted on paper it is rigid enough to be curved or bent so as to provide a restricted angle of illumination. Various effects of lighting can be obtained by crumpling the surface slightly. Multi-coloured effects are easily obtained by combining several pieces of differently coloured foil. Such effects can be useful in 'glamorizing' certain kinds of commercial products, in table-top photography and in making titles for slide presentation.

Smooth metallic foil offers an unusual medium as a background material in virtue of its ability to mix and reflect coloured lighting. If a plain, uncoloured foil is used for this purpose, it can be made to take on the colours of adjacent reflecting surfaces which can be changed at will by adjusting the position of the reflectors, and resulting in pleasing 'abstract' colour compositions. Colours of infinite variety and extremely high saturation can be obtained when using polished foil. Softer effects are obtained with foil having a satin finish. Specular (white reflections from light sources used to light the subject) may be controlled by using crossed polarized light as described on page 50.

The effects obtained through the inter-reflections between two or more coloured foils may be applied to both title making and table-top compositions. The effects are far easier to demonstrate than describe and anyone interested in exploring this field need expend no more than a shilling or two on some sheets of coloured foil.

Multiple exposures

Coloured lighting effects can be based on two or more exposures on the same frame of film and also by combining two transparencies. When using reversal

colour films it must be remembered that two successive exposures which partly overlap will combine to form an image of a different colour and lighter density, whereas two transparencies combined to form a single picture will produce increased density while strong overlapping colours will tend to produce neutral or dark colours. However, with combined transparencies it is usual to select two images which are complementary in terms of density and colour, so that a dark area of one coincides with a thin area of the other.

CHAPTER 16

Processing, Printing and Presentation

The success of planned lighting effects depends largely on standardising the processing and printing of the sensitive material used in the camera. This may appear too obvious to be repeated in this manual were it not that many photographers, having taken the greatest care in arranging the lighting and calculating the exposure, hurry on to develop the film without due regard to the chemistry of development and then proceed to print the negatives as quickly as possible, often without bothering about test prints. Such a procedure is unlikely to produce the best results and may even involve having to repeat the same job. Those who already carry out the finishing stage of photography with sensitometric precision need read no further: those in the process of acquiring photographic skill or who are inclined to rely on luck would do well to continue reading.

Developers

It is logical to choose the developer recommended by the maker of the film being used and, if more than one type is specified, to choose the one most suitable for the kind of work being done. There is usually a 'standard' developer designed to give maximum speed (shadow detail) and an alternative fine-grain developer which usually requires the film to be exposed on the basis of half the rated speed. Obviously this choice should be made before exposing the film. In addition to developers recommended by the maker of the film, there are a number of ready-to-mix or ready prepared developers marketed by photographic chemists which include such types as 'universal', fine-grain and extra fine-grain. Universal developers are intended for use in different concentrations for both negative and printing materials, and if the problem of graininess does not arise, offer the advantage of reducing the number of bottles in the darkroom. The choice of a particular make of fine-grain or super fine-grain developer is largely a personal one, but the practice of changing from one brand to another merely for the sake of being up-to-date is not recommended. Once a satisfactory film-developer combination has been found it should be adopted as the standard.

Variables in development

The action of a developer had already been discussed in Chapter 2, page 21, and can be shown in the form of a time-gamma curve. The gamma or contrast to which a film is developed will normally be determined by the method of printing and

215

possibly by the kind of printing paper used. If the latter is available in one grade only, as with colour printing paper, the negative contrast must be adjusted to suit this grade of paper. Even when a range of contrast grades are available, it is an advantage to produce negatives which are suitable for the normal grade. This simplifies the stock of printing paper since only a small quantity of other grades need be held for emergencies (severe under-exposure, contrasty lighting conditions, etc.).

The amount of action of a developer for any given time is subject to variation at different temperatures, at different degrees of agitation and also from the effects of partial exhaustion, namely, the development of successive films in the same solution. While it is possible to compensate for differences in temperature by reducing or prolonging development, it is preferable to work to a fixed temperature. This applies also to applying agitation during development: the same procedure should be adopted for all films. The problem of partial exhaustion can be dealt with in two ways. If a large volume is in use then a system of developer replenishment can be used provided it is done regularly. If only a small volume is used, then it is preferable to discard it after use. The small economy achieved by keeping, say, 600 cc. of developer for further use does not equal the advantage of starting each film or batch of films with fresh, unused developer. This advice refers to black-and-white development: when processing colour materials the much higher cost of the developers makes it expedient to work to the maximum safe capacity of the solutions.

Ideal negative quality

The most common fault to be found in black-and-white negatives made by the average amateur photographer is over-development usually coupled with over-exposure. We have already pointed out that the ideal negative from the point of view of tone reproduction is one which has been exposed so that the shadow tones fall on the upper region of the 'toe' of the characteristic curve, p. 24. Such a negative can be easily recognised from the fact that the shadow areas, or at least those in which detail is required, show only a thin deposit of silver. The deepest shadows—those which will be reproduced by the maximum black of the printing paper—will thus be clear film. At the same time, the lightest areas of the subject should still show a considerable 'transparency' when viewed by normal transmitted light. If they appear very dark, then either the film has been over-developed or the subject presented too high a lighting contrast.

To some extent the ideal contrast will be governed by the method of printing. If large negatives are involved and are to be printing either by contrast or with an enlarger employing diffused light, then a somewhat higher contrast is desirable than that suitable for small negatives which are to be printed with an enlarger employing a condenser lens in the lamphouse. Development times published by film manufacturers frequently indicate the difference in development time to allow for this factor. However, since enlargers differ somewhat in their illumination systems. it is recommended to make a preliminary test when using a new enlarger. These should be made on a normal grade of printing paper. Correctly exposed and developed, the print should show a full range of tones.

Printing paper

The maximum tone range will be obtained from a printing paper having a high gloss finish since the darkest tones will be less affected by surface scatter, see page 23. Such a paper is normally used for prints intended for technical reports or for photo-mechanical reproduction. A highly glossy surface gives strong specular reflections and unless mounted flat so that the entire surface can be viewed at a favourable angle, is not the ideal surface for general viewing. If the surface has been glazed, it is also unsuitable for pencil retouching though it can be spotted with a retouching dye which has preferably been mixed with a little gum so as to maintain the glossy surface. Matt and textured papers give a better viewing surface quite apart from any artistic effect they may have on the photograph. Thus a very rough surface may be used for certain types of portraits to give the appearance of a pencil drawing. Retouching is, of course, much simpler with a matt or textured surface.

While it is logical to standardise on a normal grade of contrast, some workers prefer the next softer grade on the grounds that it gives a tone reproduction more suited to a negative exposed on the straight-line portion of the characteristic curve. However, this factor may vary with different makes of printing paper and skilled workers have their special preferences. The advantages of producing negatives suitable for a normal grade of paper is that the softer grade can be used for subjects of higher contrast.

Print exposure and development

From the characteristic curves shown in Fig. 2.7, page 23, it can be seen how both the speed and the maximum black are affected with the degree of development. To obtain the maximum black demands a certain minimum development below which the paper may be said to be under-developed. While it is possible to utilise a certain development control to adjust minor errors in print exposure, the development of printing papers should normally be standardised. Unless this is done, test strips or previous exposure data will lose much of their value. The activity of a print developer is affected by temperature in much the same way as that of a negative developer and it is thus necessary to have some means of maintaining a fixed temperature throughout a printing session. The amount of agitation is also important, not only in respect of the rate of development, but also in the interests of uniform development. It is normally applied by rocking the dish in alternate directions, but maximum uniformity, especially with large prints, is best obtained with brush development.

Even assuming that a negative is properly matched for a particular grade of printing paper, the best print will only be obtained when the exact exposure for full normal development has been given. Over-exposure will mean that the print must receive less development to achieve an acceptable result, while under-exposure will require prolonged development. The correct exposure can best be found by making a series of test exposures, but to be really valid, these must be separate exposures of an important area of the negative which also contains the full range of densities. The method of exposing a strip for a range of increasing

217

exposures is valid if the entire area covered is representative of the density range, but almost useless if it has to include areas of totally different density. Test exposures should be given full normal development and be properly fixed so that they can be examined in white light.

In the absorption of a printing session, often accompanied with the desire to get as many negatives as possible printed, it may not be realised that the developer becomes steadily more exhausted after each print has been developed. One way of checking this is to expose a number of small prints at the beginning of a session using a subject such as a grey scale. One of these is developed at the same time as the first print and the others at later stages in the session. When the grey scale shows a noticeable loss of density at normal development times, the developer should be renewed.

Local print control

This technique which goes by such names as 'shading' and 'dodging' forms a valuable means of controlling excessive contrast which usually occurs when a subject contains both indoor and outdoor lighting or has received uneven illumination. The latter condition often passes unnoticed at the time of photography (unless an exposure meter has been used to check illumination) but becomes very evident in print. Very often nothing more than a little hand shading is required, a procedure that is rapidly acquired with experience. Somewhat more difficult in terms of exposure differences is the subject of an interior which includes a door or window looking out on an externally lit scene. An example is given in Fig. 2.11. In this case it is usually desirable to make a test exposure as if one were dealing with two separate negatives, as the difference in exposure may be far too great to be contained in a normal test series. In the example shown, the wall paper required only 10 sec. while the reflection of the window in the mirror required 4 min. The shading was done with a sheet of black paper into which a small oval was cut. The aperture is applied over the window area and kept moving slightly so as to prevent hard lines. Some retouching may be needed to complete the effect in the final print. Of course, a far more satisfactory result will be obtained by using a fill-in light for the interior.

Some control is possible by the local control of development, though such a procedure has only a limited application. One method is based on the exhaustion of the developer contained in the paper emulsion. In darker areas where the activity is greatest the exhaustion is greatest. Thus if a print, which shows lack of detail in the highlight is placed in a bath of fresh water shortly before the darker areas reached their required density, the development will continue more actively in the light areas and in some cases this added activity may be sufficient to provide the missing detail in the highlights. A somewhat similar effect is obtained if the print is allowed to remain without agitation during the second half of development. Considerably more local control is possible when developing a large print by a process of applying the developer with a sponge. Thus certain areas may be given more frequent applications of fresh developer than others.

Local control may also take the form of after treatment by applying a reducing agent to selected areas of the surface.

Printing effects

One means of reducing contrast slightly and at the same time softening excessively sharp detail is the use of a diffusion medium in the beam forming the image. It may take the form of an optical diffuser consisting of a disc of glass with moulded rings. If this is placed over the lens the amount of diffusion will be greatest at the full aperture of the enlarging lens. Diffusion may also be introduced with a layer of bolting silk stretched over a small embroidery hoop. It should be held at a midway point in the beam and kept gently in motion. The degree of diffusion can be varied by using different gauges of bolting silk. Voile, netting or even a piece of thin stocking will also serve the purpose.

If the netting is held very close to the paper surface or even placed in contact with it, a textured effect will be imposed over the image. A similar effect is shown in Fig. 15.4, though in this case the image formed by two layers of black nylon netting was photographed and the negative combined with a negative of a triple exposure portrait.

High contrast effects can be obtained by printing the negative on a contrast grade of printing paper. Line effects are obtained by making a low contrast positive which is then held in near register with the negative so as to give a relief effect, again using a high contrast printing material.

Multiple images can be made either by combining two negatives in the enlarger or by printing two or more negatives in succession. This procedure usually requires that the different images have been photographed against a black background when the negatives are sandwiched together or against a white background if a second image is to be printed over a dark area of the first image.

Presentation

The production of a good print is not the end of the story: to be fully appreciated it must be properly presented. The scale of the print is important and should bear some relationship to the probable viewing distance. Whereas a print of 10 × 8 in. is ideal for viewing at a handheld distance, it would make little impact at a distance of 3 or 4 ft. For this reason prints intended for exhibition on walls are normally of twice these dimensions. The effect of a photograph is much enhanced if it is mounted on a board which gives it an ample margin since this helps to isolate the tone range from surrounding objects.

The level of illumination is also important, though this, unfortunately, is something which is often out of the control of the photographer. The visual capacity to differentiate tonal contrast is related to the intensity of the illumination falling on the print. At high levels greater separation will be perceived between the darker tones thus giving the effect of greater overall contrast. The effective level of intensity falling on the print becomes greater when the surrounding illumination is considerably lower, which largely explains why projected colour transparencies appear so much more brilliant than a colour print viewed in ordinary room lighting. Almost the same effect will be obtained by spotlighting a colour print in a semi-darkened room.

Skilful retouching of a print by way of spotting, adding catch-lights, etc., can also add to the apparent brilliance of a print.

Index